P9-ECX-145

American Masters
from Bingham
to Eakins

# American Masters from Bingham to Eakins

The John Wilmerding Collection

Franklin Kelly

with Nancy K. Anderson, Charles M. Brock,
Deborah Chotner, and Abbie N. Sprague

National Gallery of Art, Washington
in association with Lund Humphries

cat. 3 (detail)

The exhibition was organized by the National Gallery of Art, Washington.

Exhibition dates
National Gallery of Art
9 May–10 October 2004

Copyright © 2004 Board of Trustees, National Gallery of Art, Washington All rights reserved. This book may not be reproduced, in whole or in part (beyond that copying permitted by Sections 107 and 108 of the U.S. Copyright Law, and except by reviewers from the public press), without written permission from the publisher.

Produced by the Publishing Office, National Gallery of Art, Washington
*www.nga.gov*

Judy Metro
*Editor in Chief*

Ulrike Mills
*Editor*

Wendy Schleicher Smith
*Designer*

Chris Vogel
*Production Manager*

Amanda Mister Sparrow
*Editorial Assistant*

This book was typeset in Adobe Caslon and Interstate, and printed on Phoenix Motion Xantur, 150 gsm, by Balding + Mansell, Norwich, England

Map, pages 108, 109: Wendy Schleicher Smith

Front cover: John Frederick Peto, *Take Your Choice* (detail), 1885, oil on canvas, John Wilmerding Collection (cat. 24)

Back cover: Thomas Eakins, *Portrait of Dr. William Thomson*, 1906, oil on canvas, John Wilmerding Collection (cat. 8)

Title page: Thomas Charles Farrer, *Mount Tom* (detail), 1865, oil on canvas, John Wilmerding Collection (cat. 10)

*Library of Congress Cataloging-in-Publication Data*

American masters from Bingham to Eakins : the John Wilmerding collection / Franklin Kelly ... [et al.].

    p.    cm.

"The exhibition was organized by the National Gallery of Art, Washington, exhibition dates, 9 May–10 October 2004."
Includes bibliographical references and index.

ISBN 0–89468–322–5 (pbk. : alk. paper)
ISBN 0–85331–903–0 (cloth)

1. Art, American—Exhibitions. 2. Wilmerding, John—Art collections—Exhibitions. 3. Art—Private collections—New Jersey—Princeton—Exhibitions. I. Kelly, Franklin. II. Wilmerding, John. III. National Gallery of Art (U.S.)

N6505.A6259 2004
759.973´074´753—dc22

2003025045

*British Library Cataloguing-in-Publication Data*

A catalogue record for this book is available from the British Library

Clothbound edition first published in 2004 by Lund Humphries, Gower House, Croft Road, Aldershot, Hampshire GU113HR, UK, and Suite 420, 101 Cherry Street, Burlington, VT 05401-4405, USA
*www.lundhumphries.com*

Lund Humphries is a part of Ashgate Publishing

10 9 8 7 6 5 4 3 2 1

# Contents

vii
Director's Foreword | *Earl A. Powell III*

viii
Acknowledgments | *Franklin Kelly*

3
Scholar, Teacher, Collector: John Wilmerding and American Art | *Franklin Kelly*

32
Catalogue | *Nancy K. Anderson, Charles M. Brock, Deborah Chotner, Franklin Kelly, Abbie N. Sprague*

152
Provenance, Exhibition History, and References

158
Bibliography of John Wilmerding's Published Works

162
Index

166
Photographic Credits

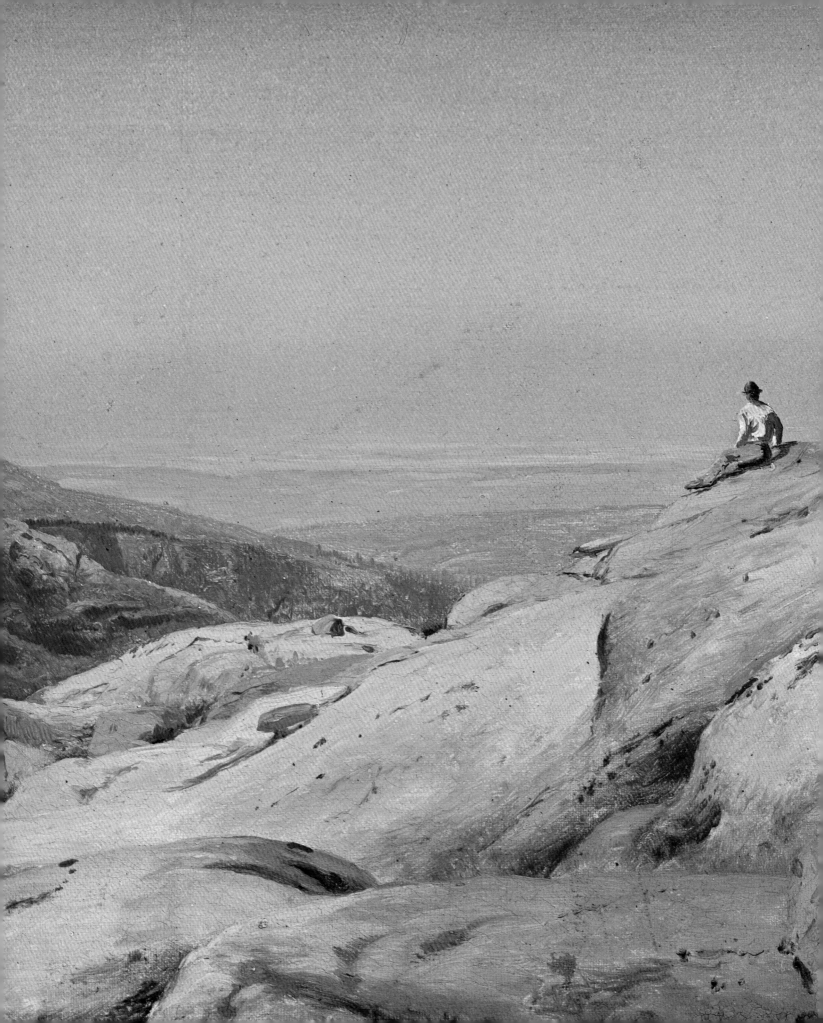

## Director's Foreword

Over the course of his career John Wilmerding has become one of the most respected and widely known authorities on American art. His many books and articles, which began appearing in the early 1960s and continue unabated today, have helped define the scholarly nature of the field as a whole and have also documented the work of key figures such as Fitz Hugh Lane, Winslow Homer, and Thomas Eakins. Wilmerding has organized many exhibitions on American art, perhaps most memorably the majestic *American Light: The Luminist Movement, 1850–1875*, held here at the National Gallery of Art in 1980. Through his teaching and his lectures he has introduced literally thousands to the wonders and complexities of our national art.

What is less well known is that John is also an important collector of American art and has assembled over the years a superb group of paintings and drawings from the mid-to-late nineteenth century. Other than friends and family members, relatively few have had the pleasure of seeing these works, because John has been characteristically modest about his activities as a collector. That he has now generously agreed to let the collection be seen and enjoyed by a wider public through this exhibition is indeed a cause for celebration.

It is also a special pleasure to welcome John once again at the National Gallery, where he served as curator of American art and senior curator from 1977 to 1983 and as deputy director from 1983 to 1988. Even though he left us more than fifteen years ago,

he has maintained close ties to the Gallery both professionally and personally. His return visits have been frequent, his advice and counsel have often been sought, and his many friendships have been happily continued. John has also ably served as a member of the advisory board of the Gallery's Center for Advanced Study in the Visual Arts and, more recently, as a member of our Trustees' Council. He has greatly helped enrich our collections of American art, both by steering potential donors our way and alerting us to important works on the market, and through his own generosity in giving Eakins' wonderful oil sketch *The Chaperone,* which is included in this exhibition, in honor of the Gallery's Fiftieth Anniversary.

The actual curator for this exhibition is, of course, John Wilmerding himself, but a number of Gallery staff members have contributed significantly to its realization and to the research and writing of this catalogue. John would surely join me in thanking the in-house curatorial team for this project: senior curator of American and British paintings, Franklin Kelly, and his departmental colleagues Nancy K. Anderson, Charles M. Brock, Deborah Chotner, and Abbie N. Sprague.

On behalf of the entire staff of the Gallery and the many visitors who will have the opportunity to enjoy these marvelous works of art, our warmest thanks go to John Wilmerding, scholar, teacher, and collector.

Earl A. Powell III
National Gallery of Art

# Acknowledgments

Many people helped with the organization of this exhibition and the production of this catalogue and it is a pleasure to acknowledge their assistance. At the National Gallery, Earl A. Powell III, the Gallery's director, has enthusiastically supported this project from its inception, as have Carol Kelley, deputy to the director, and Alan Shestack, deputy director. Thanks are also due to D. Dodge Thompson, chief of exhibitions; Naomi Remes, exhibition officer; Mark Leithauser, senior curator and chief of design; Gordon Anson, deputy chief of design and head of exhibition production; Jame Anderson, design coordinator; Judy Metro, editor in chief; Ulrike Mills, editor; Wendy Schleicher Smith, designer; Chris Vogel, production manager; Amanda Mister Sparrow, editorial assistant; Sara Sanders-Buell, permissions coordinator; Michelle Fondas, registrar for exhibitions; Gary Webber, senior art services specialist, Douglas Jackson, art services specialist; Sarah Fisher, senior conservator; Michael Swicklik, senior conservator; Judith Walsh, senior conservator; Carol Christensen, conservator; Pamela Betts, Culpepper Fellow in conservation; Steve Wilcox, frame conservator; Richard Ford, assistant frame conservator; Hugh Phibbs, coordinator of matting-framing services; Jenny Ritchie, matter-framer; Genevra Higginson, assistant to the director for special events; Elizabeth Croog, secretary and general counsel; Deborah Ziska, press and public information officer; Anabeth Guthrie, publicist; Faya Causey, head of academic programs; Ana Maria Zavala, academic programs administrator; Susan Arensberg, head, department of exhibition programs; Lyle Peterzell, photographer; Lorene Emerson, photographer; Neal Turtell, executive librarian; Ted Dalziel, reference assistant; and Thomas McGill, interlibrary loan assistant. In the department of American and British paintings my colleagues Nancy Anderson, curator, Charles Brock and Deborah Chotner, assistant curators, Anna O. Marley, former academic year intern, and Abbie N. Sprague, curatorial assistant, have my special thanks.

We also received valuable assistance from many outside the Gallery, including F. Michael Angelo, Scott Memorial Library, Thomas Jefferson University; Teresa A. Carbone, Brooklyn Museum of Art; Michelle Elligott, The Museum of Modern Art, New York; Andrea Henderson Fahnestock, Museum of the City of New York; Stuart Feld, Hirschl and Adler Galleries, New York; Linda S. Ferber, Brooklyn Museum of Art; Kathleen A. Foster, Philadelphia Museum of Art; Abigail Booth Gerdts, Lloyd Goodrich and Edith Havens Goodrich, Whitney Museum of American Art, Record of Works by Winslow Homer at the Graduate Center of the City University of New York; William H. Gerdts, City University of New York; Charles Greifenstein, College of Physicians, Philadelphia; Mark Henderson, The Getty Research Institute; Erica Hirschler, Museum of Fine Arts, Boston; Mary Landa, Wyeth Collection; Cheryl Liebold, Pennsylvania Academy of the Fine Arts; Colonel Merl M. Moore; Barbara Novak, Barnard College and Columbia University; Jules Prown, Yale University; Virginia Spiller, Old York Historical Society; Theodore E. Stebbins Jr., Fogg Art Museum, Harvard University; Glyn Vincent; Meredith Ward, Richard York Gallery, New York; Joan T. Washburn, Washburn Gallery, New York; Wendy Watson, Mount Holyoke Museum of Art; and Gretchen Worden, Mütter Museum, College of Physicians of Philadelphia.

Last, and of course in no way least, my heartfelt thanks to John Wilmerding for his friendship, guidance, and hospitality, and, most especially, for all that he has done for everyone who loves American art.

Franklin Kelly
Senior Curator of American & British Paintings
National Gallery of Art

# Scholar, Teacher, Collector
# John Wilmerding & American Art | Franklin Kelly

It is entirely possible that John Wilmerding was born to be a collector. Perhaps the urge to acquire was part of his genetic code, for collecting certainly runs in his family.[1] Wilmerding's great-grandparents, Henry Osborne Havemeyer and his second wife, Louisine Waldron Havemeyer, amassed an extraordinary group of European and oriental works of art that was eventually bequeathed to the Metropolitan Museum of Art in New York. The Havemeyer Collection, renowned in its own day, as it still is today, for its old master and impressionist paintings and its Chinese and Japanese precious objects, prints, and textiles, is among the most magnificent gifts the Metropolitan has ever received. One of the Havemeyers' daughters, Electra Havemeyer Webb (Wilmerding's grandmother), was a voracious and eclectic acquirer of American fine and folk paintings and sculptures, decorative arts, quilts, tools, vernacular objects, toys, buildings, and transportation vehicles (fig. 1). Her remarkable and vast collection was the genesis of the Shelburne Museum in Vermont (founded in 1947), which consists of a complex of structures—many of them nineteenth-century buildings that were disassembled and moved under Mrs. Webb's direction—including houses, shops, barns, schoolhouses, a covered bridge, a lighthouse, and even a 220-foot-long steamship.[2] Wilmerding fondly recalls growing up with many of his grandmother's possessions in his family's Long Island home and seeing other objects in the houses of various relatives (there were far too many for any one residence). He also remembers visiting the Webbs' grand New York apartment and seeing the paintings there, but only years later did he realize that they were by Edouard Manet (fig. 2), Claude Monet, Edgar Degas, Jean-Baptiste-Camille Corot, and other French painters, works his grandmother had inherited from her parents. For him, they represented simply part of the décor and were accepted as such. If thoughts of emulating his family in collecting entered Wilmerding's mind in those days, they were only fleeting. As he recalls, "I may have heard that my great-grandparents' collections were in the Metropolitan, but I had no idea what those collections were."

In the early 1950s, when Wilmerding went to boarding school, art history was all but unknown in American education below the collegiate level. Classes were offered in the standard disciplines, and Wilmerding remembers being particularly drawn to writing.

"I liked writing and storytelling and was interested in reading as a child. I suppose that was an inherited gene also, because my mother was a great book lover and I was conscious of books all around the house." His mother, suffering from diabetes, eventually lost her sight, and Wilmerding and other family members would read to her. "I realize that made a big impression on me in developing my fondness for the written word and for books as objects themselves. I remember reading to my mother a series of long articles in the *New York Herald Tribune* by Archibald MacLeish about what it was to be a writer. She enjoyed these articles a great deal, and they also engaged me and focused my interests on literature and writing."

When he entered Harvard University in 1956, Wilmerding intended to study American literature. Having heard from other students that the introductory course in art history, which was held in the basement of the Fogg Art Museum, was especially enjoyable, Wilmerding joined the class. Dubbed "Darkness at Noon," this class proved a turning point. "The instructors were great charismatic dynamos, including John Coolidge, the architectural historian (with an interest in American art, I later realized) and Seymour Slive, the eminent scholar of northern baroque art. Just to learn in this way was riveting. When the lights went out, there was this world of visual images that struck a nerve with me instantly, and the realization early on that you could look at façades or a ground plan—it didn't matter from where or when—and suddenly a whole culture came to life. That was the experience that set me on the track." With this awakened interest in art soon came greater awareness of, and curiosity about, the importance of collecting art in his own family background.

Wilmerding's mother had been exposed to art and collecting by her mother, Electra Webb, along with her Havemeyer grandparents, but she made no attempt to foster a love of art in him or his siblings. He considers this a rejection of sorts on her part of much of what her parents and grandparents expected of her, but he also believes that his mother had the instincts of a collector. "When she began to go blind at the end of her life, she assiduously collected, quite understandably, American music boxes. Here was something she could collect on her own terms. She knew they were beautiful objects and,

fig. 1
Installation view of *An
American Sampler: Folk Art
from the Shelburne Museum*
(15 November 1987–14 April
1988), National Gallery of Art,
Gallery Archives

fig. 2
Edouard Manet, *Blue Venice*,
1875, oil on canvas, Shelburne
Museum, Vermont

of course, she could hear their melodious sounds. Even though she did not follow the example set by her own mother, she knew and understood the joys and satisfactions of forming a collection, and this must have been conveyed to me."

Wilmerding continued to study literature, but he began to look for a way to combine that focus with his enthusiasm for art history. "At Harvard you were required to declare a major at the end of the freshman year, so you really had to make some decisions. I was fond of American literature and I also had a good fundamental knowledge of American history, but I was now absolutely gripped by the world of art history. I remember asking the senior tutor if it would be possible to combine a major in American literature, or modern literature, with art, but Harvard had nothing like that then; the only interdisciplinary major in the humanities was called 'History and Literature.' I did not want to do that; I wanted to study *art* history and literature and was firmly told that I could not." With his options thus limited, Wilmerding chose to major in art history. His fascination with wider issues of American culture and history, and especially American literature, remained undiminished, as it does to this day.

Wilmerding wrote a thesis on the American marine painter Fitz Hugh Lane. Again, family history played a role, although now also in regard to the influence of his father. "My taste for things American was clearly a family passion, and however committed or conscious, it came down from my mother's side. The fact is that the American subject I chose concerned sailing, and that was something I knew how to do well. I realized that my father had also had a major impact on me, even though he was a banker and really opposite to me. I was born and christened a junior, and when I published my first book, I debated about whether or not my scholarly identity should be John C. Wilmerding Jr. I decided instead to shorten my name to John Wilmerding, which, I now realize, was also a way of setting my name off from my father's. I suppose I was resisting being a carbon copy, or a repeat, a 'junior.' I went to Harvard instead of Yale, because all my family had gone to Yale. I knew, from looking at colleges with my father, that his influence on me was strong, and, indeed, he taught me a great deal, but I also knew that I was different in makeup and in ability. He was an outstanding athlete, which I am not; he was captain of the Yale hockey team and a varsity letter over and over again. One of the things that struck me when I went to visit Yale was seeing his photograph everywhere on the Yale fence. I thought I could never make it in his shadow."

Wilmerding's father was a superb sailor and brought his children up sailing. "In the summers when our family went on vacation to Fisher's Island, off the Connecticut coast—it was an easy commute for businessmen like my father in New York—I met and sailed against Carter and Angela Brown, and, of course, many other circles of friends,

my parents' friends, and so forth.[3] From our first summers there, almost from my first memories as a young child, my father got me in these tiny dinghies and catboats. He forced me first to learn to sail with other kids, in all kinds of conditions, to be confident, to be good at seamanship and boat handling. As soon as I was able he had me crew for him summer after summer in a larger racing boat, and he was always winning the races. He was a consummate sailor. There was an around-the-island race, a difficult and challenging race run against the Browns and other superb sailors, and my father almost invariably won that cup. He was a different personality on the water, as I think any sailor is. He was the most gentle, kindhearted, loveable man, but when he got on board, you were sworn at with words you never believed could come out of his mouth, and it was a shock.

These experiences ingrained in me a love of sailing, and, as I later understood, of seeing the water from Lane's viewpoint, seeing the landscape going by, noticing marks, paying attention to shoals and how to maneuver, how to work favorable winds. My understanding of sailing helped me evaluate paintings of sailing vessels from a practical point of view. I knew how to write about rigging and details of boat handling, and I was able to distinguish good painters like Lane from other marine painters. Lane knew exactly, in Horatio Greenough's sense of 'form and function,' just how to paint in a convincing way, how to paint a vessel sitting in the water, not on a cardboard surface."[4]

Wilmerding remembers his grandmother's collections—the American quilts, the Currier and Ives prints, the hooked rugs, and so on—being loaded on trucks to be delivered to Shelburne for the museum she was creating. He also remembers her great friendship with the Russian émigré Maxim Karolik, whose enthusiasm for American painting led him to form one of the greatest collections of American art ever assembled. Although Karolik had agreed to give most of his collection to the Museum of Fine Arts, Boston, he had kept many paintings, and these Mrs. Webb convinced him to sell to her. "It was the last collection she assembled," Wilmerding recalls, "and she was trying to come to terms with the achievements of American painters in the nineteenth century. She ended up with a small collection very similar to that of the Museum of Fine Arts in Boston, rich in Hudson River School paintings, works by Heade, Lane, and others."[5]

Wilmerding's interest in Lane, then, came from his fondness for sailing, from his grandmother's collecting activities, and also from a serendipitous encounter. A friend, Eloise Weld, was the daughter of the publisher of the *Gloucester Daily News*, and Wilmerding visited the Weld family home on Dolliver's Neck, a site that Lane had painted (fig. 3). When he mentioned Lane, Eloise's father, Phillip Weld, said, "There are lots of Lanes right here in Gloucester; he painted all around here. You should go to the Cape

fig. 3
Fitz Hugh Lane, *Fresh Water Cove from Dolliver's Neck, Gloucester*, early 1850s, oil on canvas, Museum of Fine Arts, Boston, Bequest of Martha C. Karolik for the M. and M. Karolik Collection of American Paintings, 1815–1865

Ann Historical Association." Weld introduced Wilmerding to the curator there, Alfred Mansfield Brooks, who was then quite elderly, "one of those long-lived New Englanders," he recalls, "whose grandfather actually knew George Washington." Brooks had an extensive knowledge of Gloucester history, and he also had the key to the association's building. As Wilmerding recounts, "He said, 'let me give you the key. Come out from Harvard whenever you want and look at Lane's works.' There were thirty or forty paintings, maybe a hundred drawings, scrapbooks, a wealth of information." Wilmerding made the most of this opportunity in writing his senior thesis, which would be his first monographic study of an artist.

Knowing of his grandmother Electra's fondness for Lane—she had acquired several works for Shelburne—Wilmerding sent her a copy of the thesis. In appreciation, she wrote to him: "Again, my congratulations and it is so very interesting to me and turning each page I realize how much work and thought you have put into it….I want to take my time and read and absorb all you say."[6] Wilmerding remembers not only feeling proud receiving her response, but also feeling a sense of connection now with her love of American art and culture. The thesis also became his first scholarly publication, appearing under the auspices of the Essex Institute, in Salem, Massachusetts, in 1964 as *Fitz Hugh Lane, 1804–1865, American Marine Painter*. Wilmerding's work on Lane led him into collecting.

The experience of working with the paintings and drawings by Lane at Cape Ann reinforced what Wilmerding had been taught at Harvard, namely the critical importance of coming to understand particular artists through close examination of the actual works of art they created. Slides and other reproductions could not substitute for the study of originals. He went to the Metropolitan for the first time to see the works his great-grand-parents had given, and his grandmother Webb sent him a catalogue of the Havemeyer collection. "She told me to be sure that my generation of the family kept that catalogue in print, and I had the sense that she was passing the baton of the collecting tradition and that I was now part of that tradition. I think my understanding of the joys of collecting began to grow then." In his research on Lane, Wilmerding regularly visited Vose Gallery and Childs Gallery, both on Newbury Street in Boston, to see paintings and prints by the artist that had turned up. "I remember in 1960, toward the end of my senior year, Charlie Childs called and said a new Lane painting had come in that I would surely want to know about, because it was one of the most beautiful he had ever seen. I went to the gallery, and instead of it being hung downstairs in the public spaces, it was upstairs in a private showroom. Of course, we all know well the carefully contrived drama of a dealer showing you something 'special,' with the velvet easels and curtains, and the lights perfectly adjusted by a rheostat, but that was my first experience of it. And there it was [*Stage Rocks and Western Shore of Gloucester Outer Harbor*, cat. 21] on an easel, with a hideous reproduction frame: the first work of art I ever acquired."

Having previously only gathered information for his thesis, Wilmerding had never paid any attention to the prices dealers were asking for works by Lane. "I timidly asked what it cost and Childs, after warning me that it was going to be expensive, said it was $3,500. That may not have been a cosmic price, but it was certainly a jolt, and I told Childs that I would have to think about it. Although I had an allowance and some other incomes, my resources were by no means unlimited. I talked to my father about it and, good banker that he was, he told me that if I wanted to do it I could, but it would mean limiting my traveling or other activities for a year or so. I was facing a choice, but I thought about it and bought the Lane."

The acquisition of one object, of course, does not make one a collector. Still, Wilmerding began to reflect on what he had learned about collecting—both from private individuals and from curators in museums—in his Harvard training. Here the influence of John Coolidge's teaching was especially strong. "He argued that if you were going to collect, and he hoped that everyone would as a natural part of their work, the first thing you acquired should be the best you could get for whatever amount of money you were willing to spend. That way, you established a level of quality that would help guide you in considering

other works in the future. I still feel that the work by Lane, if not the best thing in the collection, has held up to this day as being sort of central." Indeed, in more than forty years of living with the painting Wilmerding has never tired of it or been tempted to part with it. "It's never failed to excite me, it's never failed to be breathtaking when I look at it, and I never tire of describing it to visitors: the detail, the way that eighth-of-an-inch or so of light beyond the tree on the left-hand horizon suggests the space continues on, the quality of the brush, the fact that it's in perfect condition—you can talk about Lane's glazes and everything you want in his work. I have owned several other paintings by Lane beyond the two that I now have, a variety from all periods of his work, but they did not have the same impact on me and I inevitably realized that they simply did not hold up to this one, or to the little one, for that matter [cat. 22]."

Wilmerding's awareness of issues of condition when he made his first acquisition was, once again, due to his college training. As a student he frequently had the opportunity to look at paintings with conservators. With more and more works by Lane turning up and finding their way onto the market, he saw the results of harsh cleaning or of subjecting the paintings to relinings that flattened their delicate paint layers. "With Lane the execution is fundamental to what we think of as his best style. I knew that something was wrong with some of the restored works I saw, that they had changed in some way and were no longer quite as good. The condition of the first Lane painting became another touchstone for the collection. It is admittedly rare to find nineteenth-century American pictures in a comparable state of preservation, but I very much took such matters into consideration."

Wilmerding stayed at Harvard to do graduate work in art history. He made this decision primarily because of his growing love of art history, hoping he might one day become a professor himself. "I'd always had an instinct for teaching....I loved the idea of teaching. Early on I got a job as a teaching assistant, and I think I was very good at it. I really enjoyed it; it was very exciting to convey information, to persuade others. It was clearly an innate talent I had, a way of expressing yourself." The irony was that American art was not taught at Harvard. "Ben Rowland, this wonderful, kindly man, really encouraged a whole generation of scholars, just out of goodwill, because he had some interest in American art as a painter himself. He was a very talented watercolorist who corresponded with Edward Hopper and Charles Burchfield and many other artists of the 1930s, such as Charles Demuth. He also collected watercolors, and he was quite knowledgeable about at least twentieth-century American watercolor, even though his scholarly interests were in Italian medieval and Indian and Middle Eastern art. He wrote one of the Pelican books on Indian art and architecture and was a highly regarded scholar."[7] Rowland had

also overseen the republishing and annotating of a key text on nineteenth-century American art and culture, James Jackson Jarves' *The Art-Idea*.[8]

Most of Rowland's courses were either on Asian or European art, but on occasion he taught a course on American art. By good fortune, one such occasion had been during Wilmerding's junior year, and it helped cement his interest in the field. His preceptor for the class was Stuart Feld, who was completing a master's degree and would soon take up a curatorial position in the American Wing at the Metropolitan. Rowland did not teach an American course again for another five years, and most of Wilmerding's education in the subject came from courses taught in other departments. "Barbara Novak and Ted Stebbins and the rest of us took most of our courses in things American in the English department, which was staffed by famous names. I took poetry from Archibald MacLeish and I. A. Richards and visiting poets, and I studied history with H. Stuart Hughes, Samuel Eliot Morrison, and Arthur Schlesinger, and colonial American literature with Perry Miller. Like others, I had a firm grounding in American intellectual history, but that was the extent of my training in American art, really very minimal."

Harvard offered ample opportunity for taking courses in European art and architecture. For Wilmerding, "learning connoisseurship from professors such as John Coolidge, Jakob Rosenberg, and Seymour Slive, learning about style and comparison and quality," even though it was not applied to his specific field, was enormously beneficial. "Still, in those days the department was ambivalent about accepting students for graduate work in American art, and in fact, at certain points even tried to discourage us. When it came time to choose a dissertation topic and to consider the broader field of American art, I was told to think hard about what I was doing. It might have been Slive who said you really should not write about American art if you want to be taken seriously as an art historian. You should do something relevant to American art, like Dutch art, write in a solid field with a body of literature that is well established, and if you do it well, you can do American art 'out of your back pocket.'" Nevertheless, Wilmerding, like others—he mentions in particular Barbara Novak, Jules Prown, William H. Gerdts, Theodore E. Stebbins Jr., and Nicolai Cikovsky Jr.—resisted and went ahead with his plan to write on an American topic.

With the arrival of Maxim Karolik's collection at the Museum of Fine Arts (more than 330 pictures were given by him in the late 1940s and the early 1950s), there was now a veritable treasure trove of material by American artists in Boston from which to choose subjects (fig. 4). In those years only a small portion of the Karolik Collection was on view, but Wilmerding and other Harvard graduate students were given access to works in storage by the curators in the museum's American art department. "I went in

fig. 4
View of gallery of mid-
nineteenth-century American
landscape paintings and
decorative arts, Museum
of Fine Arts, Boston, 2003

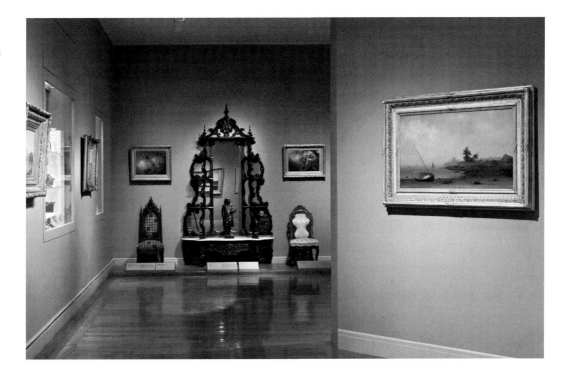

and pulled out racks of works by Albert Bierstadt and Martin Johnson Heade, which is what Stebbins did, and there was his book.[9] Jules Prown was able to do exactly the same in writing a book on John Singleton Copley, in fact, almost the definitive Copley, because almost all the pictures were right there.[10] We had access—and we did not realize until much later what an incredible opportunity it was—to material of a primary nature, that is to say, the works themselves on which almost nothing had been written…articles here and there, but virtually nothing comprehensive."

In 1965, before leaving Cambridge, Wilmerding made his second acquisition, the *Mississippi Boatman* by George Caleb Bingham (cat. 1), an artist whose work he knew from the Karolik Collection. Buying the painting by Lane had been a logical outgrowth of his thesis, but the work by Bingham represented a very different kind of painting from roughly the same time period. "Binghams were already rare by then, and I knew how important his works were in the history of American art. I also knew how few boatmen pictures existed, and I knew enough to realize their importance as classics. Again, chance played a role; on one of my regular pilgrimages to Newbury Street I stopped at the Voses and they said, 'Oh look, we've just gotten a George Caleb Bingham in.' I don't think they knew I was collecting. I did not know I was collecting—it was the decision to buy the Bingham that made me a collector. I went from acquiring a work I knew extremely well to adding something very different."

Inquiring about the price, Wilmerding was stunned to learn it was $15,000. "This was truly staggering, and it was my first exposure to dealers attaching astronomical prices to very rare things. Vose said that Larry Fleischman at Kennedy Galleries in New York had already made a proposal to have the painting shipped down, and it was obvious it was going to be sold within hours or days if I did not make a move." Having to make a decision under the pressures of time and competition from another potential buyer and at the top of the market was a new experience for Wilmerding. "I certainly did not have that kind of money easily at hand. My mother had died, but my father was still alive and had remarried, and I went home and told him about this. By then he knew that I had found my own path; I had gone into art history and was clearly going to teach, not into business or banking as he had. He accepted that and we had a nice détente. We talked about some money that I had inherited from my grandparents and my mother. Once again, the banker in him prevailed. He said: 'If you think this is worth what it is and worth having, it's your decision.' He did not even indicate by his tone that it would be an unwise thing to do. I took the money out and, as Mrs. Malaprop might have said, I bit the bull by the horns and bought it."

Wilmerding chose to write his dissertation on the history of American marine painting and completed his doctorate in 1965. "It was a good topic for me, because it obviously built on my work on Lane but also expanded into other periods, both earlier and later, than the mid-nineteenth century. I knew that once I started looking for teaching jobs I would have to demonstrate a solid, wide-ranging knowledge. It was especially helpful to think and write about twentieth-century works; I had not done much of that before." The dissertation led to Wilmerding's first major book, published in 1968.[11]

Wilmerding also began looking for a teaching position. He was well qualified to compete for the best jobs—and they were plentiful in those years—but he recalls worrying nevertheless. "Like any graduate student just finishing up, I lived in fear, wondering if I'd get something that was right, that would be a solid start to my career, all those sorts of things. My experience as an art historian, up to that point, had been entirely as a student. One does get attached to a place like Cambridge, and Harvard manages to send you out into the world believing that you'll never be happy anywhere else, and that it will take a lifetime to overcome that feeling. I remember at every opportunity combing through catalogues of various places where I might like to go. As it turned out, in 1965 there were three or four major openings for an Americanist. One was at the University of Michigan, but David Huntington was competing for that and got the job. I did get offers from Yale University, Brandeis University, and Dartmouth College. Yale had appeal for its size and its long history in American art and culture. But Jules Prown was already teaching there,

and although the opening called for an assistant professor, when I looked at the job description more closely I saw that the position was mainly to help senior faculty teaching humanities courses. Brandeis was tempting, but having spent nine years in Cambridge, staying close to home seemed too easy, and rightly or wrongly, I also did not have the sense that it would be the best place to begin a career in American art. The possibilities at Dartmouth were more open-ended, and although that was a bit daunting in itself— because one could not be sure where they would lead—there was definitely a real sense of opportunity. I went up to interview, gave the job talk, and was warmly received. I quickly realized that although the school was looking for a modernist to offer courses in late eighteenth-, nineteenth-, and twentieth-century European art, I would be able to fold American art into my teaching. It would not be exclusively American art, but no one could expect that in those days; such a position really did not yet exist anywhere."

In the end, the offer from Dartmouth seemed the most promising. Three senior members of the department would be retiring shortly, and the college was interested in hiring junior faculty who would have tenure-track options. Wilmerding recalls, "You were basically told you could create your own curriculum, and even though it meant going back to a remote part of northern New England, Dartmouth was in the Ivy League and there-fore had a larger world of associations and possibilities. I may have had certain reservations, but I chose Dartmouth, and it absolutely proved the correct choice."

Wilmerding and the other junior faculty who joined him in the coming years did indeed reshape the basic curriculum of the art history department. As he recalls, "It was great fun. We began to teach our upper-level courses, making a niche for ourselves. It was a very exciting period, with a group of wonderful colleagues who were on the same wave-length, fresh with doctorates, and eager to break into their fields. Meanwhile, as I worked to establish my own scholarly credentials, I realized that others of my generation had found jobs as well. Barbara Novak had gone to Columbia University; Ted Stebbins, who had first finished law school and then studied art history, was now at the Yale University Art Gallery as a curator, but also with teaching duties….Bill Gerdts was a curator at the Newark Museum and then went to teach at the University of Maryland. All of us began to sense that a group of colleagues was emerging who were going to define the course of teaching American art, and to some extent being curators of American art. We had all had the opportunity of doing exhibitions early in our training. I was able to organize three small exhibitions at the DeCordova Museum in Lincoln, Massachusetts, that in a sense got my museum career started…work by Lane, Robert Salmon, and William Bradford. We were able to make a mark early on, and some of us had begun to collect.[12]

Friends such as Bill Gerdts and Ted Stebbins increasingly pursued forming collections, and we began to meet collectors in this esoteric little world, such as John Davis Hatch, Graham Williford, and Henry Melville Fuller, whose collection eventually went to the Currier Gallery of Art in Manchester, New Hampshire. We loved talking to each other, sharing information, and generally enjoyed our mutual interests. There were these pockets of collectors, many of whom were buying primarily either sketches or drawings by Hudson River School artists. Whenever we had the opportunity, whether it was in New York or Boston, Cambridge or elsewhere in New England, we'd all get together and compare notes…it was mutual reinforcement."

Wilmerding considers his first awareness of the work of Frederic Edwin Church in the fall of 1965, just as he arrived at Dartmouth, one of the key incidents in forming his identity as a scholar and collector. "I heard from David Huntington about this all but unknown artist, Frederic Church, who was not well-represented in the Karolik Collection. David was busy organizing support to save Olana, Church's wonderful estate on the Hudson River (fig. 5). We all went to see it, and it was one of those watershed moments that makes you understand the importance of preserving the past. It was also another gathering of both young and more senior enthusiasts for American art in a common cause. The campaign to save Olana was the beginning, really, of a group of cohorts who loved American art. We worked together to encourage respect for the field, and we visited each others' colleges to lecture. Our books began to come out and there was this sense that we were claiming—or perhaps reclaiming is a better word—a place for American art."

In the mid-1960s more and more collectors became intrigued by nineteenth-century American art, and there were more dealers to sell to them. As interest grew in certain artists, most especially Church, the hunt was on and paintings were being rediscovered. Wilmerding observes, "you have to give credit to the great dealers of that period, Harry Shaw Newman, Charlie Childs, Bob and Morton Vose, Larry Fleischman, Bob Weimann, and Victor Spark. They all collaborated and often did things jointly as they went back and forth between New York and Boston. Many of them had sold to Karolik, so they had great credibility with new collectors of American art." The dealers also turned to the growing group of Americanists, seeking out their expertise and helping to fund their exhibition and research projects. "They believed in connoisseurship and the importance of quality, and they recognized the greatness of American art—they were way ahead of their time. They were powerful forces who also were stimulating collectors, and they were eager to open their archives, provide photographs and leads, and so forth."

fig. 5
Olana, home of Frederic Edwin
Church, south façade, looking
at main entrance; bell tower
at left, dining room with
nursery balcony above at right,
servants' quarters in back-
ground on right, Olana State
Historic Site, New York State
Office of Parks, Recreation and
Historic Preservation

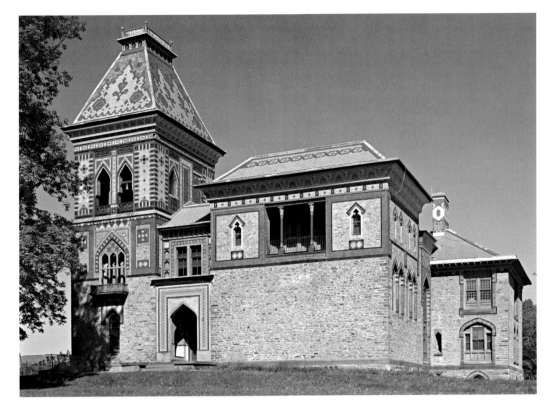

New American pictures were being discovered seemingly every other day, and they remained inexpensive compared to old master or impressionist paintings. Among college friends with whom Wilmerding had kept in touch was Stuart Feld, who had been working as a curator in the Metropolitan's American Wing but had left to become a dealer. It was Feld who sold Wilmerding his third nineteenth-century painting, and, in the years to come, many, many more. One day in 1967, after a fruitful day of scouting for pictures in New Jersey, Feld returned to his apartment in New York with several finds. Among them was Heade's *Sunlight and Shadow: The Newbury Marshes* (cat. 15). Wilmerding happened to visit Feld that evening and recalls, "there was the Heade, uncleaned and unframed, propped up on the front hall table. Because of the Karolik Collection, which had dozens of Heades, I knew his work well. What struck me about this one then, as it does now, was that it was not only one of the most beautiful I had ever seen, but also one of the most unusual. It had the cool and the lurid, the yellow and the storm, it was sublime and beautiful at the same time. That was the first time I realized I could buy something that went a little against the grain. Of course I asked Stuart if he would sell the Heade, and I have forgotten what I paid, but it was perhaps $2,500, again, enormously reasonable." Both sides were satisfied with the outcome; Wilmerding had the painting and Feld, as he later

told his friend, sold all the pictures he had found in New Jersey in twenty-four hours and doubled his money. Feld went on to join New York's Hirschl and Adler Galleries and helped transform it into one of the powerhouse dealers in American fine and decorative arts.

Feld also showed Wilmerding a beautiful small painting of a wine glass with an orange slice by John Frederick Peto. It was the first time he had seen a work by the artist, who would years later engage his scholarly attention. At the time Wilmerding had no interest in collecting still lifes, but he was nevertheless struck by the painting's power. "Its colors seemed almost to glow and it was much more softly painted than the hard-edged paintings by [William Michael] Harnett that were then canonical. No one paid much attention to Peto in those days, other than Alfred Frankenstein, who, in *After the Hunt,* lumped him in with several others as followers of Harnett. As with the Heade, I was drawn to the fact that this was something different from the norm, and I think it also helped me broaden my interests."[13]

The Lane, Bingham, and Heade paintings were the foundations of Wilmerding's collection, and he has never thought of parting with any of them. Over the years, however, many other paintings came and went as his focus changed and evolved. "I've had a South American Church, a Church of the Holy Land, a John Quidor, a large Bierstadt and a smaller one of a rainbow over Niagara, lots of other works that were useful in teaching.[14] Dartmouth had a good but small collection of American art, enough for teaching, but not comprehensively. In northern New England you cannot send the students into town to go to the big art museum. We went on many road trips to places like Olana, the Currier, the Hyde Collection, and Saint Johnsbury. I knew how important and rewarding it is to have regular access to original works of art, and much of my collecting while I was at Dartmouth had a pedagogical impetus. I bought several works—like the big pictures by Church and Bierstadt—that I knew would quite literally not fit in my house, and arranged with the Hopkins Center to display them there on loan, so students could see them. It occurred to me that without spending a lot of money I could acquire at least small-scale works by major American artists. I got my first Eakins portrait, and then a whole group of American genre paintings and landscapes. Now I was buying as an art historian and a collector, and I would bring these pictures to class, and when I gave lectures I would show students the small-scale works, for instance, Lane's small picture of Brace's Rock (cat. 22) and a small moonlit work by Robert Salmon, and ask them to identify these images and discuss them.[15] I also acquired several small Thomas Cole studies for some of his most famous works, the sketch for *Desolation,* the sketch for *The Ox-Bow,* and these were superb for teaching, for showing the handling of paint and the role of the sketch, and so on."[16]

In 1977 Wilmerding left Dartmouth to become curator of American art and senior curator at the National Gallery. Throughout his career he had participated in projects with many museums, but this was his first full-time museum position. He knew that his activities as a collector would have to change; he would no longer be teaching, which eliminated the need for the wide scope of pictures he had acquired. He also knew that the Gallery had strict guidelines for curators in terms of collecting. Preparing for the move to Washington, Wilmerding reassessed his group of pictures, winnowing it down considerably. Many had to go, including a few with which he parted only reluctantly. "I was moving into an even smaller house in Washington, but I could not ask Carter Brown to take my big pictures by Church and Bierstadt on loan, because that would not have been appropriate, and I could not afford to give them away. The painful but logical thing to do was to trade them, along with lots of others that I did not mind giving up, for something else. Nevertheless, I also realized there was a positive side, because in exchange I might find something spectacular. I have never been a collector with infinite pockets; in fact, most of what I have acquired, with the odd exception like the Bingham, has been pretty reasonably priced or has been possible through trading. I think collecting with certain restraints is much more challenging and in the end more exhilarating than if you have unlimited resources, because you are forced to make much tougher decisions. If you can have anything you want, you may end up not wanting anything you have."

Parting with several paintings did indeed allow Wilmerding to acquire something very special, namely Winslow Homer's *Sparrow Hall* (cat. 18). In Wilmerding's lifetime Homer's oils had never been inexpensive, and although he had owned a number of works on paper by the artist (for example, cat. 17), he never believed an oil would be within his reach. *Sparrow Hall*, although expensive, was relatively reasonable compared to what a painting by Homer with a more familiar subject would command. Yet it is a key and rare painting from a crucial moment in the artist's career, when he was reforming the very substance and style of his art while in Cullercoats, England, on the North Sea. It is beautiful in its own right, with echoes of Homer's earlier works featuring women and children, but it also has a toughness and solidity of form that looks ahead to his great pictures from the final two decades of his career. Many collectors, especially those concerned with only acquiring works that will hold their market "value," thus protecting their "investment," shy away from works they judge to be different from what they expect of a particular artist. Wilmerding's acquisition of the Heade marsh picture and his first encounter with Peto's work had taught him early on to judge a painting based on its own merits, and his extensive knowledge of the history of American art helped him appreciate the historical

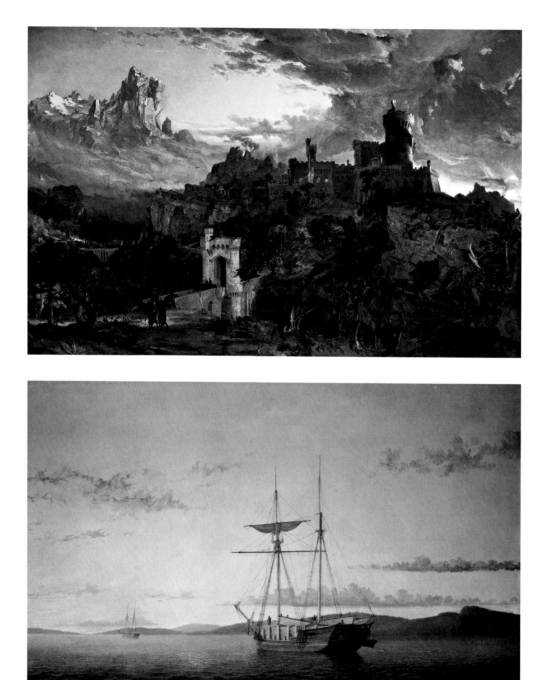

fig. 6
Jasper Francis Cropsey, *The Spirit of War*, 1851, oil on canvas, National Gallery of Art, Washington, Avalon Fund

fig. 7
Fitz Hugh Lane, *Lumber Schooners at Evening on Penobscot Bay*, 1863, oil on canvas, National Gallery of Art, Washington, Gift of Mr. and Mrs. Francis W. Hatch Sr.

importance of different moments in an artist's career. For him, acquiring the work by Homer was an easy decision.

Once he began working at the National Gallery, Wilmerding was obliged to discuss anything he considered purchasing for himself with Charles Parkhurst, the assistant director and chief curator, and with Carter Brown. If a particular work was judged to be at a level of quality and historical importance that made it appropriate for the Gallery's permanent collection, he, like any other curator who collected, would have to give the museum the first option to buy. It is rare, however, that a museum has the funds to purchase everything it would like at any given moment. Often collectors who are friends of an institution are encouraged to acquire desirable works, in the hope they might eventually donate them. Wilmerding understood this perfectly well and recognized that his collecting would now be on two parallel tracks. On the one hand, as a curator he would be seeking out the finest American paintings and attempt to find the means for the Gallery to acquire them; on the other, for his own acquisitions, he would have to factor in how they might fit into the Gallery's collection, if and when they some day became gifts. There was no formal commitment or promise of future gifts, but Wilmerding acknowledges that the context for his collecting had changed importantly.

Prior to Wilmerding's appointment there had not been a department of American art at the National Gallery. William P. Campbell, the assistant chief curator, had a special interest in American art, had acquired many significant paintings for the Gallery's collection, and had organized some exhibitions. With a mandate from Carter Brown to develop a systematic plan for American art at the Gallery, Wilmerding considered the best ways to proceed. He hired two assistant curators to help him and regularly made good use of the talents of the various interns who found their way to the department. He also worked hard to locate potential acquisitions. When the Gallery opened in 1941, fewer than a dozen American paintings were part of the collection, and although the number had grown by the time of Wilmerding's arrival, the representation was hardly definitive. "Instead of buying things for myself, I was more and more using the Gallery's funds to buy major pictures for the museum; there was Cropsey's *The Spirit of War* (fig. 6), again, not a 'typical' work—the Gallery already had the greatest example of that in *Autumn on the Hudson River*, 1860—but a work of excellent quality and one that showed the impact of Cole's dramatic allegorical style on the next generation." Carter Brown, Wilmerding's old sailing competitor, was eager to add an outstanding work by Fitz Hugh Lane to the collection. "I considered all the pictures that I knew were in private hands and went after *Lumber Schooners at Evening on Penobscot Bay* (fig. 7), one of the classic late pictures. We were starting to broaden the collection; the Sturges collection came in, and

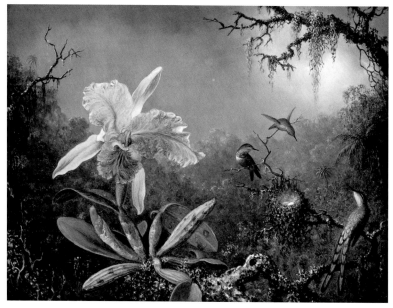

fig. 8
Eastman Johnson, *The Brown Family*, 1869, oil on paper mounted on canvas, National Gallery of Art, Washington, Gift of David Edward Finley and Margaret Eustis Finley

fig. 9
Martin Johnson Heade, *Cattleya Orchid and Three Brazilian Hummingbirds*, 1871, oil on wood, National Gallery of Art, Washington, Gift of the Morris and Gwendolyn Cafritz Foundation

fig. 10
Installation view of *American Light: The Luminist Movement, 1850–1875* (10 February – 15 June 1980), National Gallery of Art, Gallery Archives

that helped enormously, and I felt we were making progress in filling in gaps, but in ways that complemented what the Gallery already had."[17] Other important pictures entered the collection under Wilmerding's guidance, including the Gibbs-Coolidge set of Gilbert Stuart's portraits of the first five American presidents, Eastman Johnson's *The Brown Family* (fig. 8), and Heade's *Cattleya Orchid and Three Brazilian Hummingbirds* (fig. 9).

Although the National Gallery had mounted an impressive series of monographic exhibitions in the 1950s and early 1960s devoted to American artists, it had been less active during the decade before Wilmerding's arrival.[18] The extraordinary success of *The Treasures of Tutankhamen* in 1976–1977 had convinced Carter Brown of the drawing power of "blockbuster" exhibitions. Now there was increased incentive throughout the Gallery to propose ambitious exhibitions, and Wilmerding's American department was no exception. "I envisioned a program of exhibitions over the next decade, both large and small monographic shows, thematic shows, and also a private collection show." The first project Wilmerding undertook, in 1980, was *American Light: The Luminist Movement, 1850–1875*, a sprawling gathering of more than 250 paintings, drawings, and photographs by artists ranging from Washington Allston to Thomas Eakins (fig. 10). "As I look back, I did *American Light* at the midpoint of my career. It was the climax of everything I had done up to that point as a scholar, collector, and writer. It became for me a great summary show whose time had clearly come. Most of my colleagues had been working in the same period and with the same material and I invited a half-dozen of them to write for the catalogue. In a way it was a 'state of the field' for the time.[19] It also represented a new course for the National Gallery

in terms of American exhibitions, as it was not monographic, but thematic, reevaluating a lot of material that previously only specialists really knew much about."

*American Light* was a popular success, drawing almost 320,000 visitors (fig. 11). Artists such as Heade and Lane, let alone Francis Silva or William Bradford, were hardly household names in 1980, and the exhibition proved a revelation to many who saw it. It brought into focus the achievements of a group of artists who had been all but ignored by academia and museums. For Wilmerding, this was deeply satisfying, because he felt *American Light* opened a "window into a period in America when we created an original art—not only that, but an optimistic art, a beautiful art."

Following *American Light* Wilmerding turned his attention to organizing an exhibition devoted to the private collection of Jo Ann and Julian Ganz Jr. of Los Angeles (fig. 12). "I think it was an old friend from sailing days, Don Hoopes, who introduced me to the Ganzes, who were then transforming their collection from Ash Can paintings

and American impressionists to one focused on the mid-nineteenth century, and they were beginning to acquire a really impressive group of paintings and sculptures. We hit it off and became great friends, and that led to the idea of the exhibition." From his work as a curator, Wilmerding also knew how important it was to form relationships with collectors, and he encouraged the Ganzes in their pursuit of great American paintings and offered the best advice he could when asked. The relationship that he established between the Gallery and the Ganzes has endured to the present. Julian currently serves as a trustee, and over the years he and Jo Ann have committed several important works from their collection to the Gallery.

Wilmerding often joked after beginning work as a curator that there was no time to write his own books. The demands of caring for a collection, organizing exhibitions, writing catalogues, and running a department filled every available minute, and there were no sabbaticals. As a way of compensating, he started collecting book forms and trompe l'oeil books in various shapes and sizes. "My interest in books, which began in childhood, led me to acquire a great painting by Peto of books (cat. 24). Peto

fig. 11
John Wilmerding and
Rosamund Bernier discussing
Frederic Edwin Church's
*Twilight in the Wilderness*
during the making of the film
*American Light: The Luminist
Movement, 1850–1875*,
National Gallery of Art,
Gallery Archives

fig. 12
Installation view of *An
American Perspective:
Nineteenth- and Twentieth-
Century Art from the
Collection of Jo Ann and
Julian Ganz Jr.* (4 October
1981–15 February 1982),
National Gallery of Art,
Gallery Archives

fig. 13
Installation view of *Important
Information Inside: The
Still-Life Paintings of John F.
Peto* (16 January–19 June
1983), National Gallery of Art,
Gallery Archives

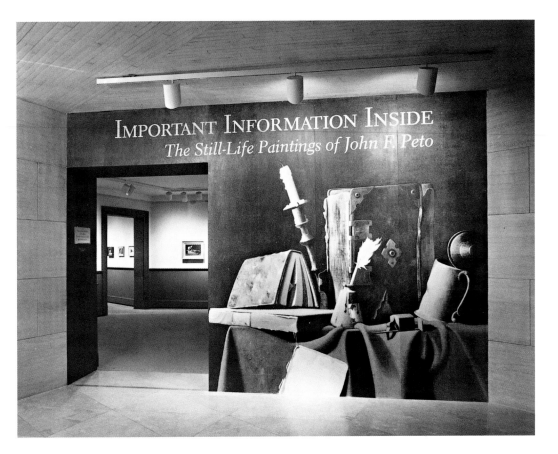

also intersected with American folk art, which I had grown to love from my grandmother's collections. The interest in Peto continued with the exhibition I organized in 1983 (fig. 13). Peto still was not well known and continued to be perceived as in Harnett's shadow, and I felt there was a real disconnect in our understanding of his work solely through reproductions, and not from appreciating the actual pictures. Bringing the objects together for the exhibition is another kind of collecting. I'd like to think that small show made a large impact in restoring Peto's reputation."

When he first started at the National Gallery, Wilmerding took stock of not only its collection of American paintings, but also of its works on paper. There were outstanding holdings of watercolors by Homer and prints by James A. M. Whistler, but little else. "From my contacts with other collectors, and from my own collecting of drawings during various times, I knew how important works on paper were to a complete understanding of American art. In honor of the Bicentennial, Ted Stebbins had organized a touring exhibition and written an exhaustive book on American drawings, and not one work from the

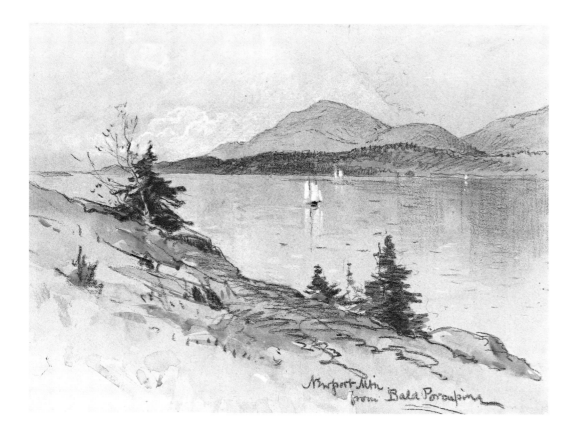

Gallery's collection was included in the 360 works illustrated.[20] Working with colleagues in the department of prints and drawings, I went over all the privately held collections of American drawings that I knew of." Years earlier Wilmerding had met John Davis Hatch, then the director of the Albany Institute and also a pioneering collector of American drawings (figs. 14, 15). "We visited Hatch's home in Massachusetts, studied his collection, and made a proposal that would bring those drawings to the Gallery. It established a solid, broad base there of American drawings, with a dozen or so very important works. With this foundation one could build and expand the collections, which is exactly what has been done in the years since."

fig. 14
George Henry Smillie,
*Newport Mountain from Bald
Porcupine*, unknown date,
black and white chalk and
watercolor on blue paper,
National Gallery of Art, John
Davis Hatch Collection

fig. 15
Rembrandt Peale, *Dr. John
Warren*, c. 1806, black, white,
and light brown chalk on dark
brown paper, National Gallery
of Art, Washington, John
Davis Hatch Collection,
Andrew W. Mellon Fund and
Avalon Fund

fig. 16
Thomas Eakins, *The Architect
(John Joseph Borie, III,
1869–1926)*, 1896–1898, oil on
canvas, Hood Museum of Art,
Dartmouth College, Hanover,
New Hampshire, Gift of Abby
Aldrich Rockefeller

Wilmerding's interest in the work of Thomas Eakins, which stemmed from his years at Dartmouth, where he had often admired the artist's *The Architect (John Joseph Borie, III)* (fig. 16) in the college's art gallery, resurged during his time in Washington. "I became fascinated by Eakins' works and began trying to acquire them. It was frustrating, though, because none of the great early subjects like the rowing scenes was available, and indeed little else of quality was. The bust-length portraits came up from time to time, and I bought many of them, but they were pretty dour. At one point I had, I think, six of them, and I hung them in my dining room, perhaps in emulation of my grandparents' hanging of Rembrandt and Rembrandt school portraits in their dining room. Guests complained that eating with all those depressed-looking sitters gave them indigestion, and I can understand why. I also had some interesting sketches, including two related to Eakins' pictures of William Rush working on his allegorical figure of the Schuylkill River. One was *The Chaperone* (cat. 9), which I gave to the Gallery, and one was of Rush himself pounding the mallet as he carved the statue. Another portrait ultimately ended up in the Princeton University Art Museum."

In 1983 Wilmerding was appointed the National Gallery's deputy director, with responsibility for oversight of all its curatorial, education, publications, exhibitions, and conservation departments. Given these increased administrative duties, there was even less time for his own scholarly work, but he remained closely engaged with the Gallery's American department. In 1985, when he learned that Rembrandt Peale's wonderful portrait of his brother Rubens was going to be sold at auction, he mounted a campaign for the

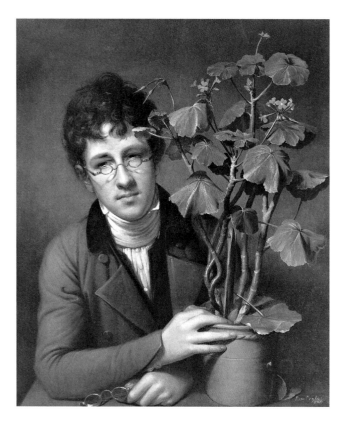

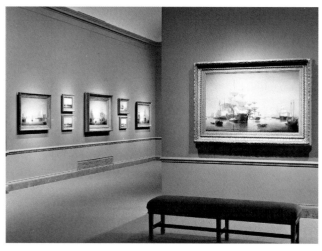

Gallery to acquire it. On 5 December of that year, *Rubens Peale with a Geranium* (fig. 17) became the first acquisition made through the Gallery's newly established Patrons' Permanent Fund. It was purchased at slightly over $4 million, a record price at the time for an American painting.[21]

In 1987 Wilmerding organized *Andrew Wyeth: The Helga Pictures,* presenting to the public for the first time more than 240 works depicting one model, Helga Testorf—images done over a span of fifteen years of the artist's career. Popular fascination with this series, which Wyeth had created in virtual secrecy, grew to a fever pitch at the time of the exhibition. It was thronged with visitors and became the subject of unprecedented national and international media attention. The exhibition went on to five other major American museums before an extensive tour abroad, making it the best-attended show of Wilmerding's career, although not, as he freely notes, one of the best-received critically.

The coda for Wilmerding's career at the National Gallery represented a return to the subject of his first art-historical scholarship, Fitz Hugh Lane (fig. 18). He organized an exhibition of the artist's finest paintings that opened at the Gallery in May 1988 and then traveled to the Museum of Fine Arts, Boston. By the time the exhibition was on view in Washington, Wilmerding had accepted an offer from Princeton University to return to his first love, teaching. He considers the timing fortuitous. "I had been at the Gallery for a decade, had done the shows I had set out to do, and made some important acquisitions. I was ready for something new, which Princeton offered, and to be able to close out my career in Washington with a Lane exhibition on the National Gallery's grand scale was a good way to end."

Joining Princeton's faculty in the fall of 1988, Wilmerding entered yet another phase in his collecting. With easy access from Princeton to major collections of American art in New York, Philadelphia, and Washington, there was no need to reassemble the kind of teaching collection he had gathered at Dartmouth. By now prices for works by key

fig. 17
Rembrandt Peale, *Rubens Peale with a Geranium*, 1801, oil on canvas, National Gallery of Art, Washington, Patrons' Permanent Fund

fig. 18
Installation view of *Paintings by Fitz Hugh Lane* (15 May – 5 September 1988), National Gallery of Art, Gallery Archives

nineteenth-century American artists were soaring to levels that even the best-informed previously would have thought impossible.[22] Wilmerding carefully considered what he had, what he wanted to keep, and what he wanted to look for in the future. Having spent many summers on Mount Desert, in Maine, he had become devoted to the island's scenic beauty, and he now began to seek out images of it from all periods. A few had come into the collection already, including Church's *Newport Mountain, Mount Desert* (cat. 4) and *Fog off Mount Desert* (cat. 3), and many more soon followed. Most of what he acquired were drawings and watercolors, and these form a remarkable group in themselves (see cats. 29–51). Opportunities for paintings were rarer, although Wilmerding did acquire a fine work by Jervis McEntee of the view from the summit of Green Mountain (cat. 23).

While teaching at Princeton, Wilmerding began to think about what he had accomplished in his more than thirty years of collecting, and the direction he might take in the future. Other than family members and close friends, very few even knew that he was a collector—he had always tried to keep that separate from his work as a teacher, scholar, and curator. Since accepting the position at the National Gallery in 1977, he had refused all requests to lend works that he owned to special exhibitions, feeling that it would be improper, and he did not change that policy after going to Princeton. Nevertheless, he was mindful of his family history of sharing their treasures with the public, and aware of the fact that now, as a collector himself, he was part of that tradition. As he says, "I thought about what I had collected in the past and what should come next. I had the outstanding core works in the collection, the Lane, the Bingham, and the Heade marsh scene, and those had been joined by the Church oil and by four Heade still lifes. Those works represented a very high standard of excellence, but they also were, in a very real sense, embodiments of what I personally believed to be central to the achievements of nineteenth-century American painters. In addition, they represented the very period in which I had done almost all of my scholarly work. I had established a smaller, but I think equally solid group of works from later in the century, the Homer oil, the Peto, and a few others. Opportunities to add to the collection at a comparable level were limited. I began to think about how I could pull it all together, so that I would feel that the collection had a sense of completeness. I think an idea was forming that once that point was reached, it might be time for an exhibition and catalogue."

Some more recent additions to the collection have added strength to its center in the mid-nineteenth century, but have also built out from that core in exciting ways. One of these is John F. Kensett's arresting *An Ilex Tree on Lake Albano, Italy* (cat. 20). As Wilmerding observes, "In the most obvious sense it's a picture of delicious greens, and those greens are among my favorite colors, so instinctively when I first saw it years ago,

it just zapped me in the eye. But on that first encounter I also had somewhat mixed feelings; as a kind of 'treescape,' I thought of it in the context of a more traditional Hudson River School aesthetic. It seemed to go against the grain of the landscapes that I liked most and that held the collection together. This was also a picture of light seen through the trees, but with Ruskinian truth to nature and with a certain measure of Kensett's friend Asher Durand's style. Even though the image lodged itself in my mind, I passed over it, and it went off to another collection. By the time it was available again years later, I had come to realize that in a funny, even obverse way, it would work with the rest of the collection. The composition was not at all traditional, but something quite different, and beautiful and special in its own way."

Another such picture is Thomas Farrer's *Mount Tom* (cat. 10). "Once again, I had first seen this work some time ago, and, like the Kensett, it stuck in my mind. I had never been especially drawn to the high moment of American pre-Raphaelite landscape, and although this certainly related to that, it was also different in subtle ways. This seemed a less brittle, softer form of pre-Raphaelite painting and it made absolute sense with the Kensett and the Haseltine watercolors (cats. 35–38, 48, 49)." Two paintings fairly recently acquired, one by Joseph Decker and the other by Adelheid Dietrich, have also added to one of the strengths of Wilmerding's collection, still-life painting, and have brought greater variety. Dietrich's *Still Life of Flowers* (cat. 6), although similar in certain respects to Heade's floral compositions (see cats. 12–14), is painted with an almost hyper-real intensity that gives it a very different feeling. Decker's *Still Life with Crab Apples and Grapes* (cat. 5) is more solidly rooted in a later nineteenth-century aesthetic. Although Wilmerding sees some relationship to an early work such as Bingham's *Mississippi Boatman*—as he says, "The solid geometries of these pieces of fruit on the plate remind me of the way the figure and the objects are so carefully placed in the Bingham"—he also sees its darker coloring and more somber mood as working perfectly with his pictures by Peto and Eakins. "I have always loved the harder style of works from the first part of Decker's career, like the one of plums in the Gallery's collection [*Green Plums*, c. 1885], and I was pleased to be able to find such a fine work from the same period."

For Wilmerding the most pressing lacuna in his collection was a major painting by Eakins; he had owned many but had not kept one. Privately owned works of any significance by the artist were exceedingly rare, and the few that came onto the market were extravagantly priced.[23] Once again, serendipity played a role in solving the problem. Wilmerding's house in Princeton had no wall space for large pictures, or so he thought, until one day he noticed an expanse of bare wall in the stair hall. The spot was not ideal for a painting; the lighting was not good and the space could not be easily viewed, but it

could accommodate something fairly large. He thought little more of it until, on a visit to Hirschl and Adler Galleries, he happened into a stairwell where large pictures, including Eakins' portrait of Dr. William Thomson (cat. 8), were stored. "There it was, no doubt a picture that I had passed by many times before, but now I looked at it with new eyes, because I knew had a place to put it. It is amazing, and more than a little bit humbling, to realize how one can overlook things, often for insignificant reasons. At Dartmouth I had bought paintings I did not have room for, considering their importance, and now I was reminded of that, and I looked at that picture and saw how great it was. It was just what I had wanted all along, a sympathetic portrait of the greatest humanity and beauty."

Although Wilmerding has added important works to the collection recently, including Eakins' exquisite watercolor, *Drifting* (cat. 7), the pace has slowed. Prices continue to escalate, but he also feels he has now assembled the very pictures he most wants to own. "I have more and more come to feel the collection has reached its ideal form. After all these years, and after all the pictures that have come and gone, I sense a certain logic and balance in the way all these wonderful things relate to one another and how the collection feels as a whole. Carter Brown loved to use the term 'critical mass' to describe the state when a group of works of art in an exhibition or a collection attain, both in terms of numbers and in quality, a true sense of coherence. Perhaps that's what it is in my case…the collection has reached its critical mass, and nothing further needs to be done now but to let it be seen and enjoyed by others."

Wilmerding has always been captivated as a collector by things other than American paintings and drawings. Like his grandmother Webb, he has a great love for American folk art, quilts, trade signs, and whimsical objects. He has long been fond of pop art, admiring in particular its bright colors, bold forms, and sense of humor. During his undergraduate days he acquired a number of limited edition serigraphs and prints by artists such as Roy Lichtenstein and Robert Indiana.[24] That interest has reawakened recently with the purchase of several small-scale pop-art sculptures and maquettes. He makes regular forays into New York to visit dealers, ever on the lookout for that next object to consider. Collecting is indeed in John Wilmerding's blood; he could not stop looking for works of art even if he wanted to, and there is surely little chance of that.

1.
As he says: "It's probably in the genes...I couldn't help it." This essay is based both on conversations between the author and John Wilmerding at his home in Princeton, New Jersey, on 14 and 15 April 2003, and on some twenty-five years of acquaintance and friendship. Quotations, unless noted otherwise, are from the April conversations.

2.
See *http://www.shelburnemuseum.org/index.htm*, 5 June 2003.

3.
Wilmerding's boyhood friend, J. Carter Brown, would later become the director of the National Gallery of Art.

4.
Wilmerding was referring here to the principles the sculptor espoused in his *The Travels, Observation, and Experience of a Yankee Stonecutter* (New York, 1852).

5.
See Nancy C. Muller, *Paintings and Drawings at the Shelburne Museum* (Shelburne, Vt., 1976).

6.
Letter of 3 May 1960, National Gallery of Art Archives.

7.
Benjamin Rowland, *The Art and Architecture of India: Buddhist, Hindu, Jain* (London and Baltimore, 1953).

8.
James Jackson Jarves, *The Art-Idea* (1864), ed. Benjamin Rowland (Cambridge, Mass., 1960).

9.
Theodore E. Stebbins Jr., *The Life and Works of Martin Johnson Heade* (New Haven and London, 1975).

10.
Jules David Prown, *John Singleton Copley* (Cambridge, Mass., 1966). For a reminiscence of Prown's training at Harvard, see the introduction to his *Art as Evidence: Writings on Art and Material Culture* (New Haven and London, 2001), 1–11. William H. Gerdts has also written about his experiences at the university; see his "A Personal Re-Collection," in Susan Danly and Bruce Weber, *For Beauty and for Truth: The William and Abigail Gerdts Collection of American Still Life* [exh. cat., Mead Art Museum, Amherst College, and Berry-Hill Galleries] (Amherst, Mass., and New York, 1998), 12–13.

11.
*A History of American Marine Painting* (Boston and Toronto, 1968).

12.
*Fitz Hugh Lane, The First Major Exhibition* [exh. cat., DeCordova Museum, Lincoln, Mass., and Colby College Art Gallery, Waterville, Me.] (Lincoln, Mass., 1966); *Robert Salmon, The First Major Exhibition* [exh. cat., DeCordova Museum] (Lincoln, Mass., 1967); and *William Bradford, Artist of the Arctic* [DeCordova Museum and New Bedford, Mass., Whaling Museum] (Lincoln, Mass., 1968).

13.
Alfred Frankenstein, *After the Hunt: William Harnett and Other American Still Life Painters, 1870–1900* (Berkeley and Los Angeles, 1953).

14.
The paintings he refers to were Church's *The Cordilleras: Sunrise*, 1854 (private collection), and *Jerusalem from the Mount of Olives*, 1870 (Nelson-Atkins Museum, Kansas City, Mo.); Quidor's *Tom Walker's Flight*, c. 1856 (Fine Arts Museums of San Francisco); and Bierstadt's *The Great Trees, Mariposa Grove, California*, 1876 (private collection); and *Niagara*, c. 1869 (private collection).

15.
The painting by Salmon was *Moonlight Coastal Scene*, 1836 (Saint Louis Art Museum).

16.
Both sketches are now in private collections. *Desolation* is the final painting in Cole's five-part series *The Course of Empire*, 1836 (New-York Historical Society); *View from Mount Holyoke, Northampton, Massachusetts, After a Thunderstorm (The Oxbow)*, 1836, is in the Metropolitan Museum of Art.

17.
The bequest of Frederick Sturges Jr. in 1978 added five superb mid-nineteenth-century paintings to the Gallery's collection: John Casilear's *Lake George*, 1857, Asher B. Durand's *Forest in the Morning Light*, c. 1855, and *A Pastoral Scene*, 1857, Francis William Edmonds' *The Bashful Cousin*, c. 1841–1842, and John F. Kensett's *Beach at Beverly*, c. 1869/1872. Sturges had previously given the Gallery another work by Kensett, *Beacon Rock, Newport Harbor*. All of these works were apparently first owned by Sturges' grandfather, the important New York collector Jonathan Sturges (1802–1874).

18.
The monographic exhibitions included *A Retrospective Exhibition of the Work of George Bellows*, 1957, *Winslow Homer: A Retrospective Exhibition*, 1958, and *Thomas Eakins: A Retrospective Exhibition*, 1961.

19.
In addition to Wilmerding, the catalogue authors were Lisa Fellows Andrus, Linda S. Ferber, Albert Gelpi, David C. Huntington, Weston Naef, Barbara Novak, Earl A. Powell III, and Theodore E. Stebbins Jr.

20.
Theodore E. Stebbins Jr., *American Master Drawings and Watercolors: A History of Works on Paper from Colonial Times to the Present* (New York, Hagerstown, San Francisco, and London, 1976).

21.
Wilmerding's interest in "the painting led to an essay with a lengthy discussion: "America's Young Masters: Raphaelle, Rembrandt, and Rubens," in *Raphaelle Peale Still Lifes* [exh. cat., National Gallery of Art] (Washington, 1988), 73–93.

22.
In May 1989, for example, Frederic Church's *Home by the Lake*, 1852 (now known as *The Home of the Pioneer*, collection of Jo Ann and Julian Ganz Jr.), had sold at Sotheby's for $8.25 million, at the time an auction record for an American painting.

23.
The strength of the market for Eakins' works was demonstrated dramatically in 1990, when the Amon Carter Museum bought *Swimming*, 1885, from the Modern Art Museum of Fort Worth for $10 million.

24.
He gave those prints to Dartmouth upon his departure from the college in 1977.

# Catalogue

*Nancy K. Anderson* | NA

*Charles M. Brock* | CB

*Deborah Chotner* | DC

*Franklin Kelly* | FK

*Abbie N. Sprague* | AS

*Note to the Reader*
Dimensions of works of
art in this catalogue
are given in centimeters
followed by inches.
Height precedes width.

# I

## Mississippi Boatman

George Caleb Bingham | 1811–1879
1850, oil on canvas, 61 x 44.5 (24 x 17 1/2)

George Caleb Bingham was born in Virginia but moved at an early age with his family to Franklin, Missouri.[1] Following the death of his father in 1823, Bingham's mother again moved, taking the family to Arrow Rock in Saline County, Missouri. Bingham's interest in art is said to have been inspired by an itinerant portrait painter, and he began his own career as a portraitist in the early 1830s. In 1838 he went to Philadelphia to study and also visited Baltimore and possibly New York. While in Philadelphia, Bingham saw paintings by William Sidney Mount that prompted him to attempt genre scenes based on his Missouri experiences. The first was apparently *Western Boatmen Ashore* (location unknown), which was exhibited at the Apollo Gallery in New York in 1838.

During the 1840s Bingham began regularly showing riverside paintings and other genre subjects at the American Art-Union (the successor to the Apollo Gallery), the National Academy of Design in New York, and elsewhere, gaining widespread recognition. In conceiving his paintings, Bingham drew on a variety of art-historical sources, ranging from antique sculpture, to old master paintings, to works by contemporary American artists. Although imbued with a sense of casual, everyday life, his works nevertheless are so carefully structured that they achieve an almost classical mood of gravity and stasis. As John Wilmerding has observed:

No matter the variety of posture or complexity, Bingham was able to distill both a visual order and palpability of space and form which spoke directly to the period's aspirations for harmony between the real and the ideal and between man and nature. To achieve this purity of design and volume in his compositions Bingham relied primarily on a few fundamental geometries for his arrangements of figures in space. These were in linear and planar terms the horizontal and the triangle, but more importantly, the solid geometries of pyramid and sphere, purely classical in their serenity, individuality, and dignity.[2]

Well-known paintings such as *The Jolly Flatboatmen*, 1845 (Manoogian Collection, on loan to the National Gallery of Art), and *Watching the Cargo* (fig. 1) are indeed built on precisely this type of compositional foundation, which helps counter the seeming banality of their subjects by making clear reference to the elevated principles of high art.[3]

Bingham's most productive years as a genre painter were from roughly 1845 to 1855, with his finest works created before his style changed markedly after studying in Düsseldorf, Germany, from 1856 to 1859. His paintings were in high demand, not only for exhibition and sale but also as models for the engravings that were circulated by the Art-Union to its thousands of members. Among the venues that eagerly sought his pictures was the Philadelphia Art-Union. Bingham sent three pictures there in 1851: *Cattle at Daybreak—Stable Scene*, 1850 (Museum of Art, Carnegie Institute, Pittsburgh), *Landscape and Cattle*, 1850 (location unknown), and *Mississippi Boatman*. In a letter to his Missouri friend, James S. Rollins, the artist wrote: "I sent three pictures to Philadelphia this winter, two of them sold very readily, the other not being a well selected subject I expect to keep."[4] Considering that *Mississippi Boatman* is one of Bingham's riverside genre paintings, which

fig. 1
George Caleb Bingham, *Watching the Cargo*, 1849, oil on canvas, State Historical Society of Missouri, Columbia

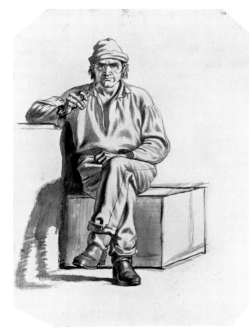

fig. 2
George Caleb Bingham, *Boatman*,
1849, brush, black ink, and
wash over pencil on paper,
sketchbook, Lent by the People
of Missouri; Bingham Trust,
Acquired through the generosity
of Mercantile Trust Company, N.A.

are today his most admired works, his characterization of it as "not being a well selected subject" requires examination.

The man depicted in *Mississippi Boatman* derives from the central figure in *Watching the Cargo* of the previous year, which, in turn, was based on an 1849 drawing (fig. 2). Seated atop a wooden crate, the figure is posed identically in all three pictures, but the individual in *Mississippi Boatman* is clearly a different person than the man depicted in the other two works. To judge from his graying hair and heavily lined face, he is more advanced in years.[5] He is also more disheveled, with an almost shabby-looking shirt (at least compared to the jauntier red one sported by the figure in *Watching the Cargo*), heavily worn trousers with a knee patch and a hole in the lower left leg, scuffed boots, and a sagging watch cap. It is the facial expression, however, that most powerfully distances the man in *Mississippi Boatman* from his younger prototype. In *Watching the Cargo* and its related drawing, the man looks out at us alertly and somewhat quizzically with his eyebrows slightly raised and his lips taut, neither smiling nor frowning. Although more intensely focused than the simpler fellow who sits below him, let alone the buffoonish character trying to blow a fire into life behind him, he seems appropriately cautious rather than openly

hostile at the prospect of our approach. Someone, after all, has to safeguard the cargo until it can be loaded on a boat that will transport it downstream, and he seems resigned to the task.

The mood is wholly different in *Mississippi Boatman*. Changing now to a vertical canvas, Bingham eliminated the expanse of scenery at the right of *Watching the Cargo* and brought the figure closer to the picture plane, thereby making the man loom far larger before us. With his eyes located above the midpoint of the canvas, he literally looks down on us, and his scowling mouth and hooded eyes hardly suggest a friendly interest. As viewers, we have come further into the pictorial space than in *Watching the Cargo*.[6] A charged tension of a kind one rarely encounters in Bingham's art is present. We perceive a provocative, even confrontational scene, which may explain why the artist deemed the subject problematic and the picture's salability questionable. Certainly what he offered here was far different from the benign cattle and farm scenery that comprised the subjects of the other pictures he sent to Philadelphia in 1851. Given that Bingham intentionally made the picture the way it is, we may well wonder why he did so.

The boatmen in Bingham's river pictures are usually young men, and they were perceived by Easterners as a "type" of frontiersman that conveyed ambiguous meanings. As Elizabeth Johns has observed:

The rivermen who worked the boats, keeping the craft in the middle of the river, steering to avoid snags and dangerous currents, and protecting the cargo, were generally young and unattached. They were perceived by fellow citizens, particularly Easterners, in terms considerably different from the trapper. Boatmen had a reputation neither for hardiness, nor for fearlessness against Indians and privation, nor even for near savagery, but for disrespect for social order that they expressed in roughhousing, carefree idleness, and drunken revelry on shore. To travelers and Eastern commentators, especially to the respectable family, they were figures of disdain.[7]

Older men appear in several of Bingham's frontier genre pictures of 1850, including *The Wood-Boat*, 1850 (Saint Louis Art Museum), *Shooting for the Beef*, 1850

(Brooklyn Museum of Art), and *The Squatters* (fig. 3). Sometimes leaning on long staffs, at other times smoking old-fashioned clay pipes, they establish a note of ironic detachment, as if they were observing their surroundings with a skepticism born of a lifetime of hard lessons. The younger men around them appear blissfully, or even ignorantly, unaware of anything beyond the particularities of the moment. If they are concerned about tomorrow, or the next day, or indeed their own futures, nothing in their expression or demeanor tells us so. On the other hand, the older men, although not actively engaged in the events unfolding around them, carefully witness them.

Only in *Mississippi Boatman*, at least among Bingham's known genre paintings, are we confronted by one such man alone, without other figures who establish a broader narrative.[8] In engaging this figure so directly, we wonder about the nature of his life and the circumstances that have brought him to this place and this moment in time. The need to guard cargo explains why he is where he is. But Bingham, in *Watching the Cargo*, had already explored that narrative and, as we have seen, in *Mississippi Boatman* he reinvented the work's central figure to create something very different.

The pose and expression of the man in *Mississippi Boatman* surely would have reminded many in Bingham's audience of John Vanderlyn's celebrated *Caius Marius Amidst the Ruins of Carthage* (fig. 4). In that painting, Marius, a defeated Roman general, sits stoically contemplating his fate. Vanderlyn's Marius, although based on ancient sculpture, was also indebted to the great French neoclassicist Jacques-Louis David's figure of Brutus in his *The Lictors Bring Brutus the Bodies of His Sons* (fig. 5). In both David's and Vanderlyn's paintings, the primary theme is the resigned acceptance of the tragedies of life. In Bingham's painting the age of the boatman, the fact that he is left alone to guard the cargo (while, presumably, his younger compatriots are off in town enjoying themselves), his worn clothes, and his wearied expression suggest that this is a man who realizes that no matter what the promises of youth may have offered, the realities of maturity now determine his course. Perhaps he has been left behind because the others simply did not want an older man along slowing them down; perhaps he was outvoted; or perhaps, his carousing days long over, he just volunteered. Whatever the case, this boatman, staring out at us with his fixed gaze and brooding like

fig. 3
Below: George Caleb Bingham, *The Squatters*, 1850, oil on canvas, Museum of Fine Arts, Boston, Bequest of Henry Lee Shattuck in memory of the late Ralph W. Gray

fig. 4
Right: John Vanderlyn, *Caius Marius Amidst the Ruins of Carthage*, 1807, oil on canvas, Fine Arts Museums of San Francisco, Gift of M. H. de Young

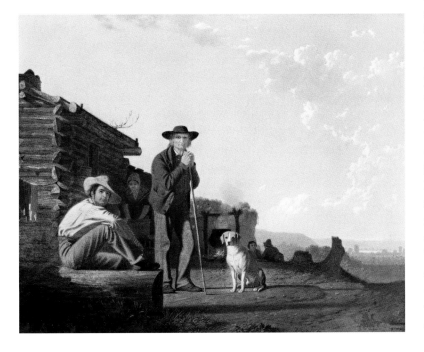

fig. 5
Jacques Louis David, *The Lictors
Bring Brutus the Bodies of His
Sons,* 1789, oil on canvas, Musée
du Louvre, Paris

Marius or Brutus, seems to have accepted his lot. He has grown old in a young man's job and all that is left to him now is the waiting.

When Bingham painted his great river pictures of the 1840s and 1850s, the way of life he depicted was already fading. Steamboats were increasingly used to transport cargo, as well as passengers, and the rough-and-tumble character of the riverside towns was giving way to more civilized and law-abiding behavior. Men from the flatboats that had ruled the rivers were increasingly unwelcome and even shunned. The growing pains of the new nation forced a reclassification as undesirable on many of those who had before seemed essential to national progress. In spite of Bingham's use of such characters to advance his art and his reputation, he was surely aware of the anachronisms he promoted. He knew people engaged in frontier trade and must have seen how their lives were changed by more "civilized" social and business practices. The *Mississippi Boatman,* then, may be his

personal comment on the inevitable progress of civilization. On the one hand, this boatman may represent the very essence of the frontier spirit, the rugged individual willing to make his living on the edges of civilized society, but on the other, he is emblematic of a passing way of life, a casualty of the move toward a more refined society.[9]

In the America of 1850 there was no longer any guarantee for the promise of an unlimited frontier. Political events of the moment, most notably the Compromise of 1850, championed by the Whigs' revered Henry Clay, were concerned with accommodating the political and social needs of both the North and the South, but those accommodations were risky at best.[10] At the heart of the debate was the issue of slavery, and whether or not it could be allowed to expand into new territories. Applications for statehood by Western and Midwestern territories were especially problematic, because each new state admitted to the Union would shift the balance of

power between the pro- and antislavery factions. Clay's Missouri Compromise of 1820 attempted to equalize those interests, but by the late 1840s the strains resurged.

It is certain that Bingham was politically engaged in these issues; elected to the Missouri House of Representatives in 1848, he consistently opposed the spread of slavery into new territories. Yet precisely how his paintings may or may not reflect this engagement is open to interpretation. In the case of *Mississippi Boatman* we best leave open the possibilities of national commentary on specific political issues. Nevertheless, given the unsettled nature of the times, it is not hard to image that this man was indeed thinking troubling thoughts. Like the eerily dark sky in Frederic Church's *Twilight, Short Arbiter 'Twixt Day and Night* (fig. 6) of the same year, 1850, the darkly scowling visage of this grizzled boatman seems equally appropriate to the moment.[11] | FK

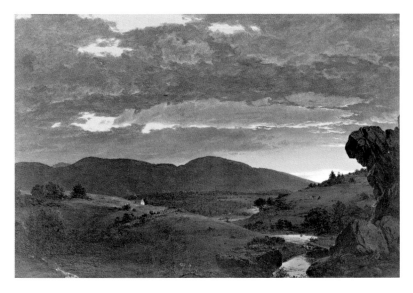

fig. 6
Frederic Edwin Church, *Twilight, Short Arbiter 'Twixt Day and Night*, 1850, oil on canvas, The Collection of the Newark Museum, Purchase 1956, Wallace M. Scudder Bequest Fund

1.
The standard source on Bingham's life and art is E. Maurice Bloch, *George Caleb Bingham, The Evolution of an Artist and a Catalogue Raisonné*, 2 vols. (Berkeley and Los Angeles, 1967); the catalogue was revised and updated as *The Paintings of George Caleb Bingham: A Catalogue Raisonné* (Columbia, Mo., 1986). See also Michael Edward Shapiro et al., *George Caleb Bingham* [exh. cat., Saint Louis Art Museum] (Saint Louis and New York, 1990).

2.
"Bingham's Geometries and the Shape of America," in exh. cat. Saint Louis 1990, 175–176.

3.
A critic for *The Literary World* (23 October 1847), 277, faulted Bingham for arranging the rugged characters in his riverboats in this manner: "In composition, Mr. B. should be aware that the regularity of the pyramid is suitable to scenes of the utmost beauty and repose"; quoted in Elizabeth Johns, *American Genre Painting: The Politics of Everyday Life* (New Haven and London, 1991), 85–86.

4.
Letter of 30 March 1851, James S. Rollins papers, folder 16, Western Historical Manuscript Collection, University of Missouri–Columbia and the State Historical Society of Missouri. Rollins, a Missouri politician who served two terms in the United States House of Representatives, was a great supporter of Bingham and his art and something of a father figure to him.

5.
He was described in the *Philadelphia Art-Union Reporter* 1, no. 51 (January 1851), as "An old man smoking his morning pipe, at the Riverside." Although it is difficult to be certain, the ripples formed by snags in the river visible just beyond the flatboat in the background seem to suggest a flow from left to right in the picture's space. If the Mississippi is here flowing from north to south, as it does for all but a tiny part of its expanse, the writer correctly characterized the time as morning, for the light would be coming from the east.

6.
His countenance, in fact, is very similar to that of the man in *Fur Traders Descending the Missouri* (originally known as *French Trapper and His Half Breed Son*), 1845 (The Metropolitan Museum of Art, New York), who also puffs on a pipe and wears a similar striped shirt. In *Fur Traders* the older man's challenging, aggressive expression is contrasted by the dreamy, half-smiling face of his son. A similar visage is seen on the standing figure in *The Squatters* (fig. 3).

7.
Johns 1991, 83.

8.
In another painting with a single figure, *Mississippi Fisherman*, c. 1851 (Jamee and Marshall Field), the man is shown in profile, seated on a bank and quietly tending his pole.

9.
Nancy Rash, in *The Painting and Politics of George Caleb Bingham* (New Haven and London, 1991), 89–90, discusses *Watching the Cargo* as an image of the decline of the boatmen's way of life.

10.
As Elizabeth Johns has shown, cider barrels could allude to Whig politics in the 1840s and 1850s (Bingham himself was an ardent Whig); Johns 1991, 50. It seems unlikely, however, that the barrels in *Mississippi Boatman* contain cider; shipping cider to the east, with its bountiful orchards, would have made little economic sense.

11.
For a discussion of Church's painting and its relationship to the political events of 1850, see the author's *Frederic Edwin Church and the National Landscape* (Washington, 1988), 26–34.

F. CHURCH.

*T. Cole.*

## 2

## Portrait of Thomas Cole

Frederic Edwin Church | 1826 – 1900
c. 1845, pencil on paper, 17.5 x 15.2 (6 7/8 x 6)

Frederic Church began his career as a landscape painter under singularly favorable circumstances.[1] Born in Hartford, Connecticut, he was the son of a wealthy, prominent family that made certain he had "every advantage" once they were reconciled to his chosen profession.[2] There could have been no greater advantage for an aspiring American landscape painter of the 1840s than an apprenticeship with Thomas Cole (1801–1848), nor a more appropriate place to

begin than near the Hudson River in the shadows of the Catskill Mountains. That is precisely what the Hartford collector Daniel Wadsworth, a friend of Church's father Joseph, helped arrange in the spring of 1844.

Wadsworth had been one of Cole's first important patrons and continued to acquire his paintings in the 1840s; he had considerable influence on the artist, who had previously declined to accept pupils. On 8 May 1844 Wadsworth wrote from Hartford to Cole in Catskill, New York, that "a gentleman of respectability of this city has a son between seventeen and eighteen years of age, who has evinced considerable talent for landscape painting & who has a strong desire to pursue the art....Will it be convenient and agreeable to you to receive him into your own family as a pupil or if not have him board near you and give him the advantage of your instruction[?]"[3] Cole's reply is unlocated, but he clearly agreed, because Church himself wrote on 20 May to his prospective teacher. Elated by his good fortune, Church promised, "If unremitting attention and activity can accomplish anything, it shall not be my fault if I am not a worthy pupil of so an distinguished artist." To this vow of industriousness, he added one of serious purpose: "My highest ambition lies in excelling in the art [of landscape painting]. I pursue it not as a source of gain or merely as an amusement, I trust I have higher aims than these."[4]

Church joined the Cole family in Catskill in the summer of 1844. He boarded with them, for three dollars a week, at Cedar Grove, the estate of John Alexander Thompson, the uncle of Cole's wife Maria.[5] As Henry Tuckerman observed, "A more genial and instructive home than his [Cole's] society and domestic life afforded, can scarcely be imagined for a young artist...."[6] There was no formal course of study, but Cole did outline his methods in a letter to another potential student: "I have always treated my students as friends as well as pupils and should be unwilling to instruct anyone who I cannot meet on such [moral grounds]....The terms on which I took my other students was 300 per annum for this: I will furnish you with a painting room, give you necessary instruction and admit you to my studio at

suitable hours. In the summer season you will at times accompany me in my sketching excursions."[7] Whatever practical instruction Cole may have given Church had value, but the deeper lessons he conveyed about the purposes of landscape painting and the role of the artist in society would have greater and lasting importance. As Tuckerman observed in explaining the origins of Church's mature vision of landscape, it was "impossible that an artist could live with Cole without deriving from his pure and earnest love of beauty, and reverent observation, invaluable suggestions."[8]

Church never forgot his debt to his teacher. Late in life he wrote, "Thomas Cole was an artist for whom I had and have the profoundest admiration."[9] Church's great masterpieces of the 1850s and 1860s are one indication of that admiration. This small, surely drawn portrait of Cole is more personal, but no less telling, evidence of his fondness for his teacher. Cole appears as if reading or deep in thought. In another drawing of him by Church from around the same period (fig. 1), he is shown in profile, and here the intention seems focused on recording the details of his physical appearance. The present work, in spite of its attentiveness to Cole's features, appears to be

more concerned with conveying something of his personality, and even of his artistic vision. For Cole, the intellect was paramount in creating great works of art. He wrote, "If the imagination is shackled, and nothing is described but what we see, seldom will anything truly great be produced in either Painting or Poetry."[10] It was that side of Cole that Church sought to celebrate here, and he succeeded splendidly. | FK

fig. 1
Frederic Edwin Church, *Thomas Cole*, 1846, pencil and ink on paper, National Portrait Gallery, Smithsonian Institution, Washington

1.
This entry draws on material from Kelly 1988, 1–3.

2.
Henry Willard French, *Art and Artists in Connecticut* (Boston and New York, 1879; reprint New York, 1970), 128. Church's father had hoped his son would follow him into business; once he accepted his son's desire to be an artist, he arranged for lessons in Hartford with two local artists, Benjamin H. Coe (1799–after 1883) and Alexander H. Emmons (1816–1884).

3.
For Wadsworth's letter, see J. Bard McNulty, ed., *The Correspondence of Thomas Cole and Daniel Wadsworth* (Hartford, Conn., 1983), 74.

4.
Archives of American Art, Smithsonian Institution, Washington, microfilm roll ALC2.

5.
See Ellwood C. Parry III, *The Art of Thomas Cole: Ambition and Imagination* (Newark, N.J., 1988), 151, 187, 299–300. Cole shared the expenses of running the house with Thomson, who was known to the family as "Uncle Sandy." Cole's account book records that he was paid $300 a year for instructing Church.

6.
Henry Tuckerman, *Book of the Artists; American Artist Life* (New York, 1867; reprint New York, 1967), 373.

7.
Letter to Frederick W. Minée, 16 December 1847, Library, Detroit Institute of Arts; quoted in Parry 1988, 300.

8.
Tuckerman 1967, 373.

9.
Letter to John D. Champlin, 11 September 1885, Archives of American Art, Smithsonian Institution, Washington, microfilm roll DDU1.

10.
Letter to Robert Gilmor, 25 December 1825, quoted in Louis L. Noble, *The Life and Works of Thomas Cole* (1853), ed. Elliot S. Vesell (Cambridge, Mass., 1964), 63.

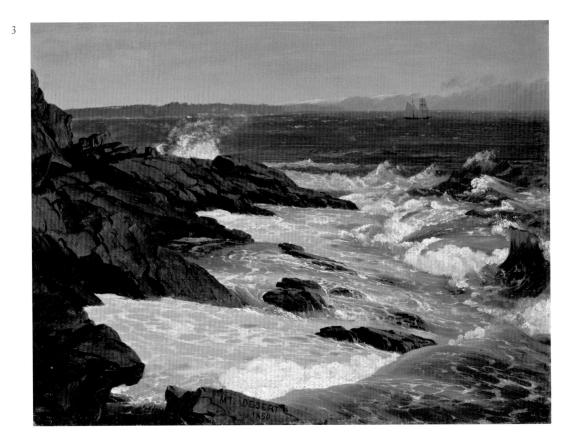

# 3

## Fog off Mount Desert

Frederic Edwin Church | 1826–1900
1850, oil on academy board, 29.2 x 39.4
(11$^1$/$_2$ x 15$^1$/$_2$)

# 4

## Newport Mountain, Mount Desert

Frederic Edwin Church | 1826–1900
1851, oil on canvas, 54 x 79.4 (21$^1$/$_4$ x 31$^1$/$_4$)

In the summer of 1850 Church traveled to Maine, the first of many visits he would make to the state over the course of his life. His destination was the island of Mount Desert, where his teacher Thomas Cole had gone in August 1844 when Church was beginning his apprenticeship with him.[1] Cole and his friend and fellow painter, Henry Cheever Pratt, traveled and sketched extensively on the island, and he surely discussed his experiences with his pupil after his return in September. Church may well also have seen Cole at work on the largest and most important picture to result from his Maine trip, *View across Frenchman's Bay from Mt. Desert Island, after a Squall*, 1845 (Cincinnati Art Museum).

The precedent of Cole's engagement with Mount Desert scenery must have been one impetus for Church's trip to Maine, but another influence was significant as well.[2] According to a contemporary account: "Church, Gignoux, and Hubbard have gone to the coast of Maine, where, it is said, that the marine views are among the finest in the country.

None of these artists, we believe, have hitherto attempted such subjects, and we look forward to the results of this journey. The exhibition of the magnificent Achenbach last year in the Art-Union Gallery seems to have directed the attention of our younger men to the grandeur of Coast scenery."[3]

The German painter Andreas Achenbach's stormy *Clearing Up—Coast of Sicily*, 1847 (Walters Art Gallery, Baltimore), was especially celebrated at the time, and if Church and his fellow artists were seeking a place where they could find comparable surf and rocks, Mount Desert was an ideal choice.[4] After arriving on the island via steamer from Castine, Church eagerly began sketching the dramatic scenery. He soon sought out the area around Otter Cliffs on the island's eastern side, with the view of Frenchman Bay that Cole had painted, hoping to find great waves pounding the rocky shore. One morning his wish came true:

We were out on "rocks" and "peaks" all day. It was a stirring sight to see the immense rollers come toppling in, changing their forms and gathering in bulk, then dashing into sparkling foam against the base of old "Schooner Head," and leaping a hundred feet into the air. There is no such picture of wild, reckless, mad abandonment to its own impulses, as the fierce, frolicsome march of a gigantic wave. We tried painting them, and drawing and taking notes of them, but cannot suppress a doubt that we shall neither be able to give the actual motion nor roar to any we may place upon canvas.[5]

In using such words such as "immense," "wild," and "fierce," Church was invoking the traditional language of the sublime, with its stress on nature's most powerful and potentially destructive forces. Cole had used similar terms in his own description of the scene at Sand Beach, where he saw "a tremendous overhanging precipice, rising from the ocean, with the surf dashing against it in a frightful manner. The whole coast along here is iron-bound, threatening crags, and dark caverns in which the sea thunders."[6] It seems that what Church was seeking on Mount Desert, at least in part, was to study effects of agitated water in preparation for the most dramatic work of his early career, a now unlocated painting of 1851 called *The Deluge* that depicted the biblical Flood.[7]

Church's letters from Mount Desert, published in fall 1850 in the *Bulletin of the American Art-Union*, make it clear that he did many pencil drawings on the island and also painted some oil sketches out-of-doors. He had made plein-air oil sketches before, but the ones executed on Mount Desert reveal a new confidence and sureness in painting in the open air. *Fog off Mount Desert* is one such sketch, a brilliant demonstration of paint handling and close observation.[8] From a vantage point below Otter Cliffs, Church combined a scene of waves breaking on the coastal rocks in the foreground with an expansive view across Frenchman Bay to Schoodic Point, a peninsula on the mainland northeast of Mount Desert. Remarkably fluid and completely convincing in its depiction of the textures and colors of water, sand, rocks, fog, and sky, *Fog off Mount Desert* has an impact that belies its small size. As John Wilmerding has aptly observed, "This small painting is a marvel of vision and execution, nearly effortlessly fusing immediate and intimate facts with grander forces."[9]

Church clearly thought well of *Fog off Mount Desert*, for he sent it to the Art-Union for exhibition in 1851. In the catalogue it was described as follows: "Fog off Mount Desert Island, Me. 16 x 12. The water extends in the foreground, while through the fog, in the distance, vessels are indistinctly seen."[10] That Church would submit a small-scale sketch such as this for public display and sale was indicative not only of his confidence in it, but also of the growing demand for his work.[11] With rising fame came more and more orders for pictures and, beginning in the early 1850s, Church sometimes painted larger, highly finished works that were not publicly exhibited, presumably because they went immediately to their new owners' private collections. This seems to have been the case with *Newport Mountain, Mount Desert* (cat. 4), which has no known nineteenth-century record of exhibition.[12]

Church completed several works inspired by Mount Desert scenery in 1851, including the present painting, *Lake Scene in Mount Desert* (private collection), and *Otter Creek, Mt. Desert* (fig. 1). A larger, more dramatic canvas, *Beacon, off Mount Desert*

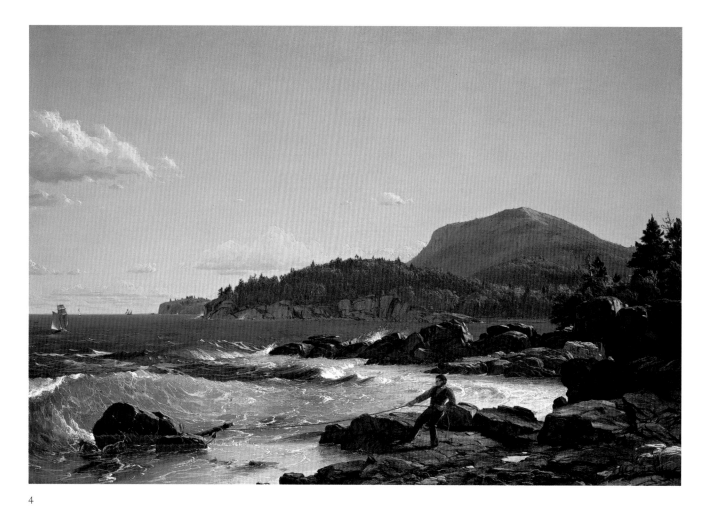

4

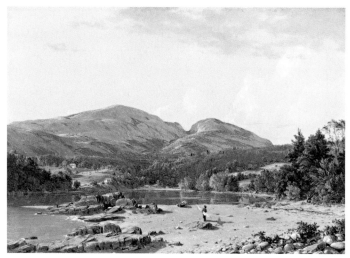

fig. 1
Frederic Edwin Church, *Otter Creek, Mt. Desert,* 1850, oil on canvas, Museum of Fine Arts, Boston, Seth K. Sweetser Fund, Tompkins Collection, Henry H. and Zoe Oliver Sherman Fund and Gift of Mrs. R. Amory Thorndike

fig. 2
Frederic Edwin Church, *Newport Mountain, Mount Desert Island* (recto), 12 September 1850, pencil on paper, Olana State Historic Site, New York State Office of Parks, Recreation and Historic Preservation

fig. 3
Frederic Edwin Church, *Mt. Desert Island from Sheep Porcupine Island* (recto), August 1850, pencil and gouache on paper, Olana State Historic Site, New York State Office of Parks, Recreation and Historic Preservation

fig. 4
Frederic Edwin Church, *Mt. Desert Island from Bald Porcupine Island* (verso), August 1850, pencil and gouache on paper, Olana State Historic Site, New York State Office of Parks, Recreation and Historic Preservation

fig. 5
Frederic Edwin Church, *Mt. Desert Island from Great Porcupine Island* (recto), August 1850, pencil on paper, Olana State Historic Site, New York State Office of Parks, Recreation and Historic Preservation

*Island* (private collection), shows an expansive view at sunrise off the waters of Seal Harbor, with only a small stone outcropping and a simple signal marker in the foreground. *Beacon* was as extravagantly praised in 1851 as *Deluge* was criticized. It was, as one critic observed, "a strong and truthful picture, with more imagination in its reality than the effort at the Deluge by the same artist."[13] Church's smaller Maine paintings received less attention, overshadowed by the critical responses to *Beacon* and *The Deluge*, but they represented an important advance in his work. *Otter Creek* and *Newport Mountain* are especially notable for their sense of freshness and immediacy, in part because in painting them in his studio Church employed many of the same techniques he had used in plein-air studies such as *Fog off Mount Desert*. Wilmerding writes, "*Otter Creek* has a bright, spontaneous touch and an unembellished directness of observation; the immediacy of the firsthand experience carries over into the distilled end result."[14]

The slightly larger *Newport Mountain* was based on several pencil sketches Church had made in August and September 1850 (figs. 2–5). The view moves from a rocky foreground with breaking waves similar to those seen in *Fog off Mount Desert*; the vantage point is close to that in Cole's *View across Frenchman's Bay*, although looking south rather than north. The distinctive rocky profile of Newport Mountain (now known as Champlain Mountain), rising over 1,000 feet above the sea and the highest point on the eastern shore of the island, dominates the middle distance at the right; beyond are the cliffs of Schooner Head.[15] Church's preliminary drawings of the scene show that he first approached it from the more distant vantage point of the Porcupine Islands (see figs. 3–5). For the final drawing, which covers two sketchbook pages, he returned to Mount Desert and sketched from a position just south of Bar Harbor, near the mouth of Bear Brook.[16] He added further descriptive notations: "New Port Mountain, Mt Desert Island, Sep 12th 1850. Grey green moss not common. Nearly all the trees are birches—white stemmed." The pinkish colors of the sky and the sunlight illuminating the westward faces of the rocks indicate the time is late afternoon:

"one feels that the brisk wind and dry air are accurate reflections of a clearing northwesterly, and completely characteristic of an early autumn day in northern New England…evident here in the bright autumnal tints of the trees across the middle ground."[17]

The prominence given to the figure in the foreground, who hauls the remnants of a sailboat's mast in by means of a rope, is unusual in Church's work. Similar figures appear in *Otter Creek, Mt. Desert* and in the 1852 *Grand Manan Island, Bay of Fundy* (Wadsworth Atheneum, Hartford), and they add a note of narrative interest. In *Newport Mountain* the wreckage poignantly reminds the viewer of the dangers of the sea, dangers that the several vessels in the distance might well face one day, too. In Achenbach's *Clearing Up—Coast of Sicily,* a spar and a tattered American flag are dashed on the foreground rocks, details clearly added by the artist to lend the picture greater appeal for its New York audience. Church's flotsam may have been inspired by the German artist's canvas, but he carefully avoided the dangers of imitation that had apparently entrapped others. A writer for the *Bulletin of the American Art-Union* cautioned: "There have been cases where imitation—perhaps unconscious—of the German painter showed itself in an application of the warm coloring of the Sicilian shore to the colder rocks and sands of this region. It would be better to imitate only the fidelity with which natural appearances had been studied in this foreign work, and which made it one of the most striking pictures we have ever seen."[18]

No such charge could be brought against Church's paintings of Maine inspired by his 1850 visit. Vibrantly colored, surely drawn, and beautifully realized, they are also so carefully observed in their capturing of specifics of atmosphere and geography as to be thoroughly imbued with an indelible sense of place. | FK

1.
Cole's visit to the island is most extensively discussed in Wilmerding 1994, 27–43.

2.
For Church's 1850 visit to Mount Desert, see the author's "Lane and Church in Maine" in Wilmerding 1988, 129–156, and Wilmerding 1994, 69–103.

3.
"Chronicles of Facts and Opinions: American Art and Artists," *Bulletin of the American Art-Union* (August 1850), 81. Church's traveling companions were Régis François Gignoux (1816–1882) and Richard William Hubbard (1816–1888). David C. Huntington, in *The Landscapes of Frederic Edwin Church: Vision of an American Era* (New York, 1966), 30, speculated that Gignoux and John F. Kensett accompanied Church to the island (see also Wilmerding 1994, 105, which repeats Huntington's speculation). The *Bulletin,* however, clearly states Hubbard was the third member of the party, and there is no doubt that he visited Mount Desert, because a now unlocated painting by him, entitled *View of Sandy Beach, Mount Desert,* was exhibited at the National Academy of Design in 1851.

4.
On Achenbach's painting, see William R. Johnston, *The Nineteenth-Century Paintings in the Walters Art Gallery* (Baltimore, 1982), 162.

5.
"Mountain Views and Coast Scenery, By a Landscape Painter," *Bulletin of the American Art Union* (November 1850), 24. Although this letter and three others discussing the trip are unsigned, they may be reasonably attributed to Church. For instance, the writer refers to painting "an old hull of a boat and some rocks" one foggy morning, a picture that is readily identifiable as Church's *An Old Boat,* 1850 (Thyssen-Bornemisza Collection). Moreover, the places he describes visiting on the island accord with the locations recorded on the many drawings he made while there.

6.
Journal entry for 3 September 1844; quoted in Howard S. Merritt, *Thomas Cole* [exh. cat., Memorial Gallery of the University of Rochester] (Rochester, N.Y., 1969), 40.

7.
For a discussion of *The Deluge,* see Kelly 1988, 37–38.

8.
A related oil sketch, *Rough Surf, Mt. Desert Island, Maine,* is in a private collection in Massachusetts; for a reproduction and discussion see Wilmerding 1994, 81–82.

9.
Wilmerding 1994, 82.

10.
Mary Bartlett Cowdrey, *American Academy of Fine Arts and American Art-Union, 1816–1852* (New York, 1953), 72. This description does not perfectly fit the painting here (there is only one "vessel"), but no other work presently known is a more likely candidate than cat. 3. The Art-Union purchased the painting for $32 and sold it for $50 to Samuel W. Bridgham, a New York City broker.

11.
He had begun showing works that were clearly identified as "sketches" at the Art-Union and the National Academy of Design as early as 1849. This practice did not sit well with some observers. As one reviewer noted in 1850 of his *Sunset* (location unknown), "Another sketch. We must again blame the Art-Union for purchasing sketches, or ordering such a number of paintings of one artist, that he is obliged to make sketches to supply the orders..."; see "Visit to the Art-Union," *The Daguerreian Journal* (November 1850), 39. The feeling that Church's oil sketches are not an important part of his oeuvre has persisted to this day for some. In 1984, when the author was working at another museum and proposed *Fog off Mount Desert* as a possible purchase for the collection, it was not deemed significant enough to warrant consideration.

12.
The painting appeared at auction at Sotheby's in New York in 1983, with no information provided about its prior history. The author was contacted early that year about the painting by Grete Meilman, then associate head of American paintings at Sotheby's, and was told that the consignors of the painting believed it to be by Winslow Homer (the frame had a Homer label), which it obviously was not. Gerald L. Carr, then working at Olana, subsequently provided the specific identification of Newport Mountain based on Church's drawing of the subject.

13.
"The Fine Arts: The National Academy," *The Literary World* (19 April 1851), 320.

14.
Wilmerding 1994, 84.

15.
See Wilmerding 1994 and Pamela J. Belanger, *Inventing Acadia: Artists and Tourists at Mount Desert* [exh. cat., The Farnsworth Art Museum] (Rockland, Maine, 1999), 56–58.

16.
Exh. cat. Rockland 1999, 58.

17.
Wilmerding 1994, 86.

18.
"Chronicle of Facts and Opinions, American Art and Artists: Movements of Artists," *Bulletin of the American Art-Union* (August 1850), 81.

cat. 4 (detail)

# 5

## Still Life with Crab Apples and Grapes

Joseph Decker | 1853 – 1924
1888, oil on canvas, 21 x 35.6 (8¼ x 14)

Joseph Decker emigrated with his family from Württemberg, Germany, to the United States as a teenager. Working first as a house and sign painter, he attended night classes at the National Academy of Design in New York and by the 1870s was exhibiting his paintings at that institution and at the Brooklyn Art Association. In 1879–1880, he studied in Munich with Wilhelm Lindenschmidt (1829–1896), a respected history painter. During his thirty-year career, Decker created landscapes, genre scenes, and a few portraits, but his most numerous subjects (more than half his total works) and those for which he is now best known are still lifes.[1]

*Still Life with Crab Apples and Grapes* comes from the first half of Decker's career, when his style was crisp and hard-edged and his colors were forceful, even bordering on harsh. Commenting upon a still life shown at the National Academy of Design in 1885, a critic complained: "And what has got into Mr. Decker's head with cholera coming on to offer us his hard green pears and harder peaches? What can be his idea of pictorial art, when he presents to us, as pictures, such unrelieved and impossible masses of raw green and rawer red?"[2]

Such an observation might easily have been used by the same unsympathetic critic to describe the present image, painted by Decker just a few years later. The artist has arranged the fruit on a reflective, glasslike surface. Each spherical shape of apple or grape shines, spotlighted against a dark background. The objects have a gravity that belies their commonness. Decker has also managed to create a study in contrasts. While the grapes he depicts are robust, virtually perfect specimens of cultivated fruit, the crab apples are varicolored, poked, and pockmarked, and one is even roughly cut open. Together these objects are arrayed across an indeterminate surface, creating a composition of syncopated rhythm. Painted in an era in which still lifes were very popular, Decker's works stand out because of their relative simplicity and their combination of drama and naturalism.[3]

Perhaps because he took to heart the criticism of his hard manner as being too "literal," Decker reinvented his oeuvre after 1890. The works he showed after this time were softer in focus and atmospheric and more mellow in palette, so different from his earlier paintings that they were, at first, thought to be by another hand altogether. Although the later images brought a more positive critical response than those of a decade or two earlier, the artist never achieved financial success. His most famous patron was the American collector, Thomas B. Clarke, for whom Decker repaired porcelain objects. The artist's true notice came only after his rediscovery by the art historian Alfred Frankenstein in 1949 and his subsequent appreciation after a 1968 exhibition at the Yale University Art Gallery, in which his work was included. Today, the quiet power of Decker's understated but intensely observed still lifes is undeniable. | DC

1.
For biographical information on the artist, see Helen A. Cooper, "The Rediscovery of Joseph Decker," *The American Art Journal* 10 (May 1978), 55–71.

2.
"The National Academy of Design," *Studio* 2 (April 1885), 210.

3.
Of Decker's contemporaries, fellow Brooklyn resident Levi Wells Prentice (1851–1935) perhaps comes closest in his approach to crisp, close-up still life. Prentice's objects, however, are depicted in such an idiosyncratic manner that they are wonderfully artificial in appearance—quite unlike Decker's.

# 6

## Still Life of Flowers

Adelheid Dietrich | 1827 – 1891
1868, oil on wood, 36.5 x 26 (14 3/8 x 10 1/4)

At the corner of the canvas, just in front of her name, the artist has written "gem./v.," the abbreviation for the German "gemalt von," painted by. It is an inscription that Dietrich used throughout her career and a connection with the country whose artistic traditions shaped her work.

Born in Wittenberg, Germany, Adelheid was the daughter and pupil of the painter Eduard Dietrich (1803–1877). Between 1850 and 1870, her paintings were included in numerous German exhibitions.[1] It is not known when she came to this country or where she lived, or whether she, in fact, ever resided in the United States. Her works were shown at the Brooklyn Art Association from 1866 until 1873, but they were invariably listed as lent by their owners rather than by the artist herself, thus providing no documentation of an American address.[2] The catalogue listing her contribution to the Chicago Interstate Industrial Exposition in 1876 gives her home as Erfurt (Germany).[3] Dietrich's paintings were also included in San Francisco exhibitions between 1875 and 1893,[4] but whether they were purchased in that city or on the East Coast (as was this example), or in Europe by well-to-do, well-traveled Californians is as yet undetermined.

Some fifty works by Dietrich are known.[5] Nearly all are flower paintings, most of them oil on canvas, some oil on panel, and a few watercolors. The images vary in size and content, with several favored compositions that are revisited throughout the decades. Her earlier works are perhaps slightly less well-composed and precise in execution than her later images. All, however, are characterized by a crystalline intensity and are painted in the finest detail and with extraordinary technical facility. These botanical subjects are much in the manner of seventeenth-century Dutch still-life painters, particularly as filtered through the eyes of nineteenth-century northern European artists, such as Johann Wilhelm Preyer (1803–1889) of Germany.[6] By the mid-nineteenth century Americans were quite taken with the work of German artists. Paintings by Preyer and others were shown at the Düsseldorf Gallery, established in New York City in 1849 to showcase the work of German and German expatriate artists.

*Still Life with Flowers* includes about a dozen varieties of grasses and blooms of varied colors and textures. In its baroque profusion this work is typical of Dietrich's floral subjects and the sense of abundance that characterizes much still life in the second half of the nineteenth century. Perhaps the best-known American painter working in this Victorian mode is Severin Roesen (1816–1872), who was also German-born and noted for his images of overflowing groupings of fruit and flowers. While Dietrich's images share Roesen's exuberance, they also have an exquisite grace and delicacy that generally exceed his productions. Dietrich often painted complex works, some with flower-strewn rocks seen against blue skies, but her most effective still lifes seem to be her smaller, more compact compositions, placed in quiet interiors. The present example, and others of around this date, often utilize a wonderfully illusionistic glass vase at the center of the arrangement and a single source of light illuminating the blossoms against a dark background.[7] Dietrich died in Erfurt, Germany.[8] | DC

1.
Ulrich Thieme and Felix Becker, *Allgemeines Lexikon der Bildenden Künstler* (Leipzig, 1913), 9: 257–258.

2.
She exhibited at least one work every year, except 1872, between 1866 and 1873. All appear to have been floral subjects. Clark S. Marlor, *A History of the Brooklyn Art Association with an Index of Exhibitions* (New York, 1970), 174.

3.
James L. Yarnall and William H. Gerdts, *Index to American Art Exhibition Catalogues from the Beginning through the 1876 Centennial Year*, 6 vols. (Boston, 1986), 2:1045. I am grateful to Col. Merl Moore for providing this reference.

4.
Dietrich's work was included in the Carnival Loan Collection of the Old Ladies Home in 1880, in a benefit for the Society of Decorative Arts of California in 1881, and in a benefit for the Children's Free Ward and Building Fund of Hahneman Hospital in 1893. See Ellen Schwartz, *Nineteenth-Century San Francisco Art Exhibition Catalogues* (Davis, Calif., 1981), 58.

5.
See *www.artnet.com* and the Inventory of American Paintings at *http://siris-artinventories.si.edu*.

6.
Preyer visited Holland in 1835 and studied the works of Jan van Huysum and Rachel Ruysch. See William H. Gerdts and Russell Burke, *American Still-Life Painting* (New York, 1971), 61.

7.
The number of paintings by Dietrich that have turned up in America indicates that she had a substantial following. The only critical mention the author discovered, however, questions the value of the artist's precision: "Again, most persons can look at the little better than the large, and admiration of minute finish is much readier than for large and sublime thought. Meissonier and Adelheid Dietrich have many more admirers than Delaroche or Kaulbach or Schwanthaler." E.E.F., "Periodical Belles-Lettres and Criticism," *The Galaxy: A Magazine of Entertaining Reading* 16, no. 1 (New York, July 1873), 81.

8.
K.G. Saur, *Allgemeines Künstler-Lexikon* (Munich and Leipzig, 2000), 27:298–299.

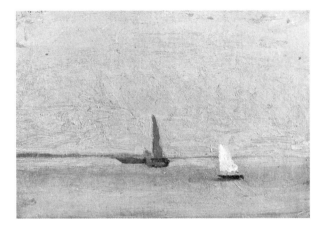

fig. 1
Thomas Eakins, *Ships and Sailboats on the Delaware: Study*, 1874, oil on canvas, Courtesy of the Pennsylvania Academy of the Fine Arts, Philadelphia, Charles Bregler's Thomas Eakins Collection, purchased with the partial support of the Pew Memorial Trust and the Henry S. McNeil Fund

fig. 2
Thomas Eakins, *On the Delaware*, 1874, oil on canvas, Wadsworth Atheneum, Hartford, Gift of Henry E. Schnakenberg

fig. 3
Thomas Eakins, *Ships and Sailboats on the Delaware*, 1874, oil on canvas, Philadelphia Museum of Art, Gift of Mrs. Thomas Eakins and Miss Mary Adeline Williams

# 7

## Drifting

### Thomas Eakins | 1844–1916
### 1875, watercolor on paper, 23.8 x 41.9 (11 1/8 x 16 1/2)

The genesis of the watercolor *Drifting* has been traced to a sailing race that Eakins attended on the Delaware River in August 1874 and that he described in a letter to his fiancée, Kathrin Crowell: "Monday I went down to Gloucester with Hen [Henry Schreiber] to make a study of splatterdocks [a yellow water lily] in Little Timber Creek & when we were done we got up to Gloucester in time to see the largest race ever seen on the Delaware & which I had forgotten all about. I think there must have been upwards of two hundred sail boats [sic]."[1] That day Eakins apparently made a small on-the-spot oil sketch of the subject (fig. 1) that captures simply and directly the play of light across the water and on the sails of the boats. Eakins' initial sketch reduced the scene to a few basic elements: the shoreline; a tall, dark sail silhouetted against the sky with the hull of another boat positioned at an oblique angle behind it; and a small boat with a white sail in the right foreground.

Eakins later made two paintings of the subject. In *On the Delaware* (fig. 2), he anchors his composition with a tall sail at the center just as he does in the oil sketch. But he deviates from the sketch by making the composition more horizontal and by reducing the size of the small boat with the white sail and moving it farther away from the center to the right. In widening the arrangement, he also places a small rowboat in the foreground at the very left edge to counterbalance a host of sailboats added to the middle ground at the right side. Apparently still dissatisfied, Eakins further modified the composition in *Ships and Sailboats on the Delaware* (fig. 3) by zooming in on the right two-thirds of *On the Delaware*, thereby enlarging the elements slightly, shifting them to the left, and leaving the center empty. The rowboat is retained but moved somewhat

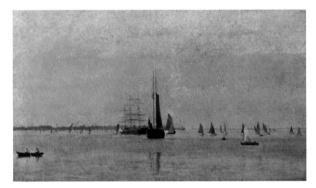

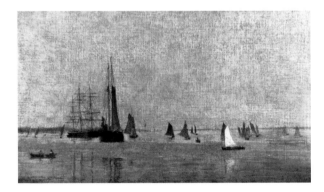

farther away from the left edge and toward the center of the picture.

*Drifting* is based closely upon *Ships and Sailboats on the Delaware*; the watercolor sheet is the same size as the painting and its central image is identical in all respects to the oil. There are differences, however, in the scale and in the way the works are framed. Eakins executed *Drifting* on a slightly smaller scale and left a generous border around the central image for matting, as indicated by the light, ruled pencil lines and the placement of his signature well inside the edge of the sheet. These lines indicate that the bottom edge of the watercolor was intended to be a bit higher than in the oil, thus narrowing the horizontal proportions of the composition and heightening its panoramic effects.

Reflecting the high regard in which Eakins held *Ships and Sailboats on the Delaware* and *Drifting*, in early 1875 he sent the former to his teacher Jean-Léon Gérome in Paris for inclusion in the Paris Salon and entered the latter in the eighth annual exhibition of the American Society of Painters in Water Color at the National Academy of Design in New York. At this time he described the works in a letter to Earl Shinn: "It is a still August morning 11 o'clock. The race has started down from Tony Brown's at Gloucester on the ebb tide. What wind there is from time to time is astern & the big sails flop out some one side & some the other. You can see a least little breeze this side of the vessels at anchor. It turns up the water enough to reflect the blue sky of the zenith. The row boats and clumsy sail boats [sic] in the fore ground [sic] are not the racers but starters & lookers on."[2] This thorough approach to such a difficult and subtle visual problem—how to capture the almost imperceptible effects of winds, tides, and light on drifting boats barely moving on still water—was characteristic of the technical virtuosity and high ambition that infused Eakins' art throughout the 1870s.

The degree of detail in the painting and watercolor goes well beyond the broad gestures of the initial oil sketch, and Eakins doubtless used other pencil studies, perspective drawings, and possibly even photographs, although none is known today.

The necessity of employing a wide range of systematic and rigorous studies, even photographic ones, had been a major part of Eakins' training at the École des Beaux-Arts under the tutelage of Gérome. For his rowing pictures of the early 1870s, such as *The Pair-Oared Shell*, *The Biglin Brothers Racing*, and *The Biglin Brothers Turning the Stake*, Eakins had relied to a great degree on detailed perspective drawings to bring the various components—boats, oars, reflections, even the ripples of the waves—into proper spatial relationships. Although *Ships and Sailboats on the Delaware* and *Drifting* would not have required the complex calculations needed to depict the foreshortening of the racing shells in the rowing images, Eakins may have used perspective sketches to calibrate the wave patterns and the recession in space toward the horizon line found in both. The extraordinary detail in these works may also owe something to Eakins' experiments with photography.[3] Henry Schreiber, Eakins' companion on the day he witnessed the boating scene on the Delaware River that initially inspired the works, was a photographer who is generally thought to have first provided Eakins with the means and knowledge to use the medium for studies. Schreiber, therefore, possibly could have made photographs of the race for Eakins. (The study of "splatterdocks" that Eakins mentions in his August 1874 letter may, in fact, refer to a Schreiber photograph rather than a drawing by Eakins).

The place of watercolors in Eakins' oeuvre is difficult to characterize.[4] He executed fewer than thirty works in the medium, most between 1873 and 1882. This was a period when the status of watercolors rose significantly in the United States, and many of Eakins' watercolors such as *Drifting* were not conceived as independent works or studies for paintings, but rather as works done after paintings. It may be surmised that the artist was simply creating watercolor copies of his oils to take advantage of the new vogue for the medium. While they forsake any semblance of spontaneity and mirror the meticulous rigor of the paintings, however, the luminescent quality of the watercolors is very different from the oils they often follow. The watercolors are suffused with light supplied by the white ground of the paper

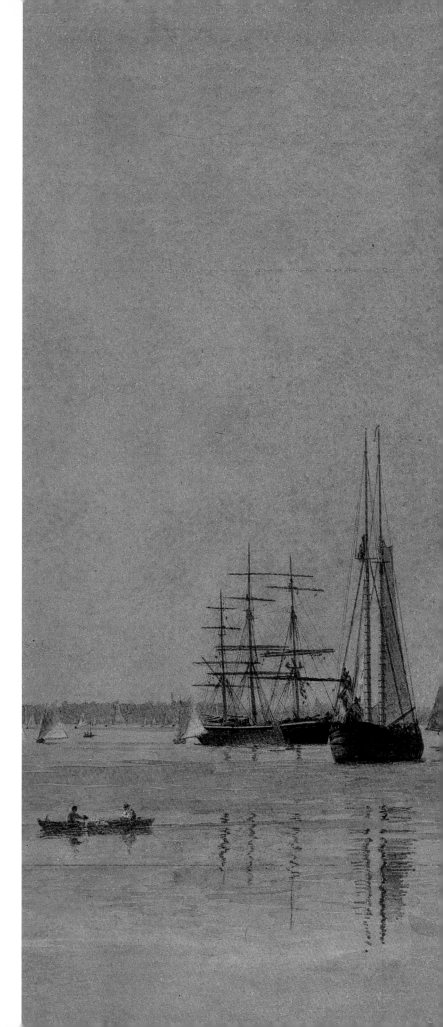

and feature subtle atmospheric effects, qualities that frequently eluded Eakins in his great subject paintings, whose dark tonalities troubled the artist and were often the target of contemporary criticism. This is particularly evident in the glowing sky of *Drifting*, which, as Kathleen Foster has observed, is "the only watercolor Eakins painted where the human figure appears clearly subordinated to the interest in light plus landscape."[5] Eakins' interest in watercolor waned when he turned away from subject and landscape paintings and toward portraiture later in his career. | CB

1.
Eakins to Kathrin Crowell, 19 August 1874, Bregler Collection, Pennsylvania Academy of the Fine Arts, as quoted in Darrel Sewell, ed., *Thomas Eakins* [exh. cat., Philadelphia Museum of Art] (Philadelphia, 2001), 391 n. 36.

2.
Eakins to Earl Shinn, 30 January 1875, Richard T. Cadbury Papers, Friends Historical Library, Swarthmore College, Pennsylvania, as quoted in Theodor Siegl, *The Thomas Eakins Collection* (Philadelphia, 1978), 58–59.

3.
On Eakins and photography see W. Douglas Paschall, "The Camera Artist," in exh. cat. Philadelphia 2001, 239–256.

4.
On Eakins' watercolors see Kathleen A. Foster, "Makers of the American Watercolor Movement: 1860–1890" (Ph.D. diss., Yale Univ., 1982), 1:193–262, and Donelson F. Hoopes, *Eakins Watercolors* (New York, 1971).

5.
Foster 1982, 1:216.

# 8

## Portrait of Dr. William Thomson

Thomas Eakins | 1844–1916
1906, oil on canvas, 172.7 x 122.6 (68 x 48¹/₄)

Thomas Eakins became acquainted with members of Philadelphia's distinguished medical community while still a student at Central High School, where his classes in natural history, chemistry, and physics were taught by physicians.[1] Thirteen years after he graduated from Central High, Eakins chose Professor Benjamin Howard Rand, M.D., his former instructor in chemistry, as the subject of his first formal seated portrait.[2] Eakins' interest in medical science, sparked by gifted teachers like Dr. Rand, continued throughout his life. Two of his most important works, *The Gross Clinic,* 1875 (Jefferson Medical College, Thomas Jefferson University, Philadelphia), and *The Agnew Clinic,* 1889 (University of Pennsylvania School of Medicine, Philadelphia),

fig. 1
*Dr. William Thomson,* photograph, Thomas Jefferson University Archives/Special Collections, Scott Memorial Library, Philadelphia

celebrate innovative physicians whose intellectual and technical achievements Eakins clearly admired. It is not surprising, therefore, that the subject of the artist's last formal seated portrait, William Thomson, was also an eminent Philadelphia physician. In this instance, however, Eakins' relationship with one of the city's most prominent ophthalmologists may have been more personal.[3]

William Thomson (1833–1907) (fig. 1) was born in Chambersburg, Pennsylvania, the son of Alexander Thomson, a district judge, and his wife, Jane Graham.[4] As a young boy, Thomson suffered from a severe eye infection that kept him confined to a darkened room for nearly two years.[5] Unable to play outdoors with other children, he spent much of his time inside learning to play the piano by ear. Though his eyesight was permanently impaired, he finished his schooling and eventually entered Jefferson Medical College, earning his degree in 1855.

At the outbreak of the Civil War Thomson joined the United States Army as an assistant surgeon. He served in the Army of the Potomac near Washington until 1862 when he joined General George B. McClellan's headquarters as chief of staff to the medical director. Present throughout the Peninsula Campaign and at Antietam, Thomson was later placed in charge of Douglas Hospital in Washington. Under his leadership Douglas became a model for numerous other military hospitals.[6] During his tenure in Washington, Thomson also pioneered photomicrography, demonstrating, with his colleague William F. Norris, the uses of photography in the study of wounds and in the preservation and distribution of surgical records.[7]

Following the war, Thomson returned to private practice and continued his study of photography and optics. As medicine moved from general to specialized application, Thomson was one of the first physicians to limit his practice to ophthalmology—the treatment of diseases of the eye. In 1868 he became affiliated with Wills Eye Hospital in Philadelphia and in 1873 with Jefferson Medical College. During a career that extended into the twentieth century, Thomson rose from lecturer on diseases of the eye to full professor

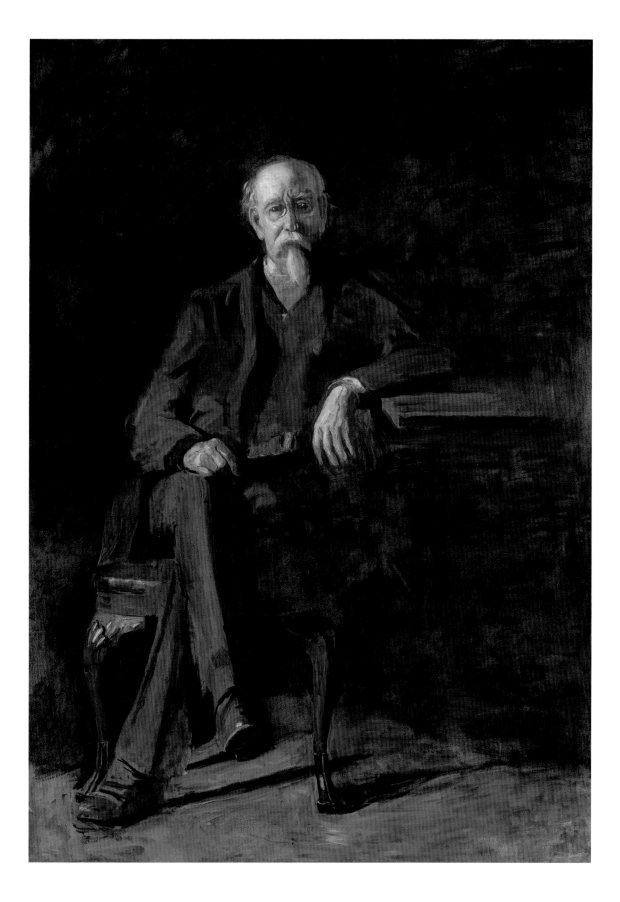

fig. 2
Thomas Eakins, *Dr. William Thomson*, 1907, oil on canvas, The College of Physicians of Philadelphia

of ophthalmology. Thomson's eminence within the field was confirmed when Dr. Samuel D. Gross, the subject of Thomas Eakins' most celebrated painting, *The Gross Clinic*, asked him to write the chapter on diseases of the eye for the fifth edition of his classic textbook, *A System of Surgery*.[8]

It is not clear when Thomas Eakins met William Thomson, but they were acquainted at least fifteen years before the artist began the studies that eventually resulted in two large paintings (cat. 8, fig. 2). A shared interest in photography and the study of optics suggests a natural intellectual affinity between the two men, but surviving case books indicate that Eakins was also Dr. Thomson's patient as early as 1890.[9]

According to Samuel Murray, perhaps the artist's closest companion during his final years, Thomas Eakins was blind when he died in July 1916.[10] It is unclear when Eakins began to lose his sight, but it seems highly likely that he consulted Dr. Thomson

regarding his condition. Eakins may not have shared the extent of his impairment with even his most devoted friends, however, for Murray later reported that he did not realize the artist had actually lost his sight until the dinner bell rang one evening and Eakins set out in the wrong direction for the dining room.[11] It is thus possible that the confidences Thomson and Eakins shared regarding the artist's deteriorating vision account, in part, for Eakins' wish to paint the doctor's portrait. Such a relationship may also account for the extraordinary empathy conveyed in the first version of the portrait, likely begun in 1906, and the thoughtful melancholy of the second, completed early in 1907.[12]

As Kathleen Foster noted in her comprehensive study of the Charles Bregler Collection of Eakins' material at the Pennsylvania Academy of the Fine Arts, a number of drawings related to Eakins' portrait of Dr. Thomson survive.[13] Several of these drawings are perspective studies that deal primarily with the placement of furniture and other objects in the paintings. A series of pinholes discovered in the earlier portrait during conservation treatment in 1973 suggests that preparatory drawings were used to block in the basic elements of the table, chair, and figure.[14] In the first version of the portrait these elements are rendered with broad, gestural strokes.

It has been suggested that the earlier version of the portrait—which is six inches shorter than the second version—was abandoned when Eakins decided to add several professional "attributes" (including an eye chart) and determined that he had not allowed enough space on the original canvas.[15] Examination of the earlier painting with infrared reflectography, however, has raised the possibility that the first version of the portrait may have been intended from the outset as a step to the later, more detailed work.

Before Eakins began painting the figure in the first version, he marked off the canvas with a grid.[16] He then structured the basic composition with quick strokes of dark paint applied at critical points. These "placement strokes" remain visible in infrared examination even though some were later covered with

additional layers of paint. Dark demarcations of this type are present at the bottom of Dr. Thomson's feet, at the edges of his hands, on either side of his left forearm, at his left shoulder, near his eyebrows, and below his mustache. There are no indications from the infrared examination that details present in the later painting, including the eye chart and the oriental carpet, were ever part of the plan for the first version of the portrait. It is thus possible that Eakins wished to address the fundamental issue of Dr. Thomson's pose—the placement of his arms, legs, and hands—in a preliminary work before adding details of furniture, carpeting, clothing, and medical objects in a subsequent painting.

The loosely but skillfully painted figure at the center of the first version of the portrait appears identically posed in the second with one notable exception—Dr. Thomson no longer looks directly at the viewer. In the later painting, he looks down and slightly to the side—away from the viewer. It is the direct engagement with the viewer (and earlier with Eakins) that is the defining feature of the first version of the painting.

Scholars have often remarked that during the last years of his life Eakins focused almost exclusively on portraits—psychological studies of individuals the artist asked to pose for him.[17] Over time these portraits became increasingly spare. Frequently the compositions included only an isolated individual at the center of a dark void. John Wilmerding has written that these late portraits may be seen as autobiographical, for in the intellectual lives of his sitters Eakins often found the mirrored reflection of his own concerns.[18]

In the first version of the Thomson portrait only one medical attribute is present. Dr. Thomson holds an ophthalmoscope, a device now familiar for examining the interior of the eye. In the second version of the portrait Eakins added an eye chart, thus utilizing a pictorial device for defining professional expertise that he had employed in numerous earlier portraits.[19] He also added an elaborately patterned oriental carpet, books, a lamp, and numerous details of costume, including a bow tie, watch

chains, and a ring. Though more detailed and complete, the final portrait also seems more distant— Dr. Thomson appears lost in his own thoughts.

Seven decades before Eakins began his portrait of Dr. Thomson, Ammi Phillips (1788–1865), a prolific itinerant painter, completed what may be the first portrait of an American ophthalmologist, *Dr. Peter Guernsey, the Eye Doctor* (fig. 3). The painting has been described as "the earliest portrayal of an American surgeon in the process of examining a patient."[20] Like Dr. Thomson, Dr. Guernsey holds an instrument and is surrounded by professional attributes— surgery textbooks.[21] In the Phillips painting, however, a patient is also present. At the far right is the startling profile of a man whose left eye is being held open by Dr. Guernsey and an unseen assistant. Though Dr. Guernsey faces the artist (and the viewer), a painful encounter seems just moments away.

There is little doubt that the painting of Dr. Guernsey by Ammi Phillips was a commissioned work and that the portrait of Dr. Thomson by Eakins was not. Though the two images have, ironically, much in common, they are separated not only by time and technical expertise, but also by the intellectual engagement between artist and sitter that is, perhaps, the most compelling feature of Eakins' portrait.

fig. 3
Ammi Phillips, *Dr. Peter Guernsey, the Eye Doctor*, c. 1828, oil on canvas, Dr. Richard Della Penna and Dr. Mearl Naponic, San Diego

William Thomson was seventy-three years old when Eakins began to paint his likeness. He died less than a year later, in August 1907. Eakins himself was sixty-two when the two men began the sessions that would result in two large portraits. He would live another decade but would never paint another full-length portrait. Both men were nearing the end of professional lives that had linked rigorous intellectual inquiry with practical application, and both must have been aware of their waning abilities.[22]

Eakins appears to have given the second, more formal portrait to Dr. Thomson's family. The first remained in his studio until his death. The hint of melancholy that characterizes the final portrait seems absent from the first. Dr. Thomson's unflinching gaze engages the viewer as it surely did Eakins. It seems singularly appropriate that two men who had spent much of their lives absorbed in the study of optics would, in Eakins' portrait, look directly and empathetically at each other. More than artist and sitter, or even doctor and patient, William Thomson and Thomas Eakins were innovative thinkers who shared a passion for the complexities of vision. | NA

For assistance with this entry we wish to thank Kathleen A. Foster, Philadelphia Museum of Art; Gretchen Worden and Charles Greifenstein, The College of Physicians of Philadelphia; and F. Michael Angelo, Jefferson Medical College, Thomas Jefferson University, Philadelphia.

1.
See Elizabeth Johns, *Thomas Eakins: The Heroism of Modern Life* (Princeton, 1983), 53–54.

2.
The portrait of Professor Rand (1874) is owned by Jefferson Medical College, Thomas Jefferson University, Philadelphia. For information about Rand and the Eakins portrait see Julie S. Berkowitz, *"Adorn the Halls": History of the Art Collection at Thomas Jefferson University* (Philadelphia, 1999), 134–140.

3.
A label (probably once attached to the stretcher of the painting), identified by Kathleen Foster as written by Charles Bregler (a friend of the artist who assisted Mrs. Eakins following her husband's death), reads, "The Oculist/Portrait of Dr. William Thompson [sic]/Preliminary Study Painted by/Thomas Eakins." For a discussion of portraits by

Eakins interpreted as typological images see Kate Kernan Rubin, "Thomas Eakins, The Veteran," *Yale University Art Gallery Bulletin* 39 (Winter 1984), 20–24, and Nicolai Cikovsky Jr., "The Art Student (Portrait of an Artist)," *American Paintings from the Manoogian Collection* [exh. cat., National Gallery of Art] (Washington, 1989), 126–131.

4.
For biographical information about William Thomson (b. 28 January 1833, d. 3 August 1907) see S. Weir Mitchell, "Memoir of William Thomson, M.D.," *Transactions of the College of Physicians of Philadelphia*, 3d series, vol. 31 (1909), lxi–lxxi; Howard A. Kelly and Walter L. Burrage, *Dictionary of American Medical Biography* (New York and London, 1928), 1208–1209; Harold D. Barnshaw, "The Portrait of Dr. William Thomson by Thomas Eakins," *Transactions and Studies of the College of Physicians of Philadelphia*, 4th series, vol. 38 (1970), 40–43; Lorenz E. Zimmerman et al., "William Thomson (1833–1907): Military Surgeon, Pioneer Photomicrographer, Clinical Ophthalmologist," *American Journal of Ophthalmology* 69 (1970), 487–497; Julie S. Berkowitz, *The College of Physicians of Philadelphia Portrait Catalogue* (Philadelphia, 1984), 210–213.

5.
Mitchell 1909, lxii, wrote that Thomson suffered an ulcerated cornea when he was about eight years old and was treated with copper sulfate.

6.
According to Mitchell 1909, lxiii, Thomson was left in charge of more than two thousand dead and wounded Union and Confederate soldiers following "the gallant fight at South Mountain." As a result of this experience he proposed two reforms that were quickly adopted. "These made a radical change in the character of field hospital supplies and led to the formation of division hospitals, to prevent any confusion during and after an engagement. These measures proved of such value in the Army of the Potomac that they were adopted throughout all the armies by order of the Secretary of War, and remained in force with little or no change, until our forces were disbanded."

7.
Thomson's early interest in photography led to his collaboration with another Jefferson Medical College graduate, John H. Brinton, who had established the Army Medical Museum in Washington. Thomson's photographic expertise led to the formation of a photographic bureau within the museum. A full-size portrait of Dr. Brinton completed in 1876 by Thomas Eakins (on loan to the National Gallery) is owned by the National Museum of Health and Medicine of the Armed Forces Institute of Pathology in Washington.

8.
Samuel D. Gross, *A System of Surgery: Pathological, Diagnostic, Therapeutic, and Operative*, 5th ed. (Philadelphia, 1872).

9.
Some, though not all, of Dr. Thomson's case books are preserved in the archives of The College of Physicians in Philadelphia. Thomas Eakins is listed as a patient in the index for the volume dated 1890. The actual case book, recording Eakins' treatment, appears not to have survived.

10.
Samuel Murray (1869–1941) was Eakins' favorite student and shared a studio with the artist beginning in 1892. Murray attended Eakins day and night during the final weeks of his life. See Michael W. Panhorst, *Samuel Murray: The Hirshhorn Museum and Sculpture Garden Collection* (Washington, 1982).

11.
Murray's comments are reported in Margaret McHenry's privately printed *Thomas Eakins Who Painted* (1946). McHenry based her book on extensive interviews with Eakins' students, family, and friends. Murray's comments regarding Eakins' blindness appear on page 135. Also of note is McHenry's reference to the ill effects suffered by Eakins and Murray after both drank milk containing formaldehyde. At one time formaldehyde was added to milk as a preservative. The practice was suspended when the chemical was determined to be highly toxic. It is possible that this event, which McHenry describes as "formaldehyde poisoning" (see page 141) also contributed to Eakins' failing vision.

12.
The second version of the portrait of Dr. Thomson was included in the annual exhibition at the Pennsylvania Academy of the Fine Arts, 21 January–24 February 1907.

13.
Kathleen A. Foster, *Thomas Eakins Rediscovered: Charles Bregler's Thomas Eakins Collection at the Pennsylvania Academy of the Fine Arts* (New Haven, 1997). The drawings are reproduced and discussed on pages 422–425 and the two versions of the portrait on 220–224. The final version of the portrait of Dr. William Thomson was given to The College of Physicians in Philadelphia by the sitter's family in 1909, where it remains.

14.
We thank Kathleen Foster for sharing with us conservation reports prepared by Theodor Siegl in 1973 when he examined and treated the first version of the Thomson portrait.

15.
See Foster 1997, 220–224.

16.
Three vertical lines divide the width of the canvas into four equal sections. Five horizontal lines divide the height into six equal sections. The canvas is thus divided into twenty-four squares. An earlier examination at the Philadelphia Museum of Art in 1973 (prior to relining) noted the location of eleven pinholes. When the locations of these holes are projected to the front of the canvas, the points correspond to important junctures within the figure, the chair, and the table. The presence of the grid suggests the existence of a number of preliminary drawings, some of which may not have survived. In this painting, the grid seems to have served Eakins as a

placement device rather than as a transfer mechanism. For an example of an oil study with a visible surface grid intended to serve as a transfer aid, see *Study for "Negro Boy Dancing"* in the collection of the National Gallery of Art (1985.64.16). For assistance with the examination of the painting with infrared reflectography we thank Michael Swicklik, senior conservator, and Kristin Holder, technician, at the National Gallery.

17.
Foster 1977, 220, notes in addition that after 1906 half of Eakins' male sitters were physicians.

18.
See in particular Wilmerding, *"Portrait of John N. Fort,"* 2–16; Wilmerding, "Thomas Eakins' Late Portraits," 108–112.

19.
See, for example, portraits of Dr. Benjamin Howard Rand (1874), Frank Hamilton Cushing (1895), and Professor Henry A. Rowland (1897).

20.
Ira M. Rutkow, *American Surgery: An Illustrated History* (Philadelphia, 1998), 503.

21.
Rutkow (*American Surgery*, 503) writes: "Among the volumes occupying Guernsey's bookshelves are the works of Benjamin Rush (1745–1813), Samuel Cooper's (1780–1848) *Practice of Surgery*, Pierre Desault's (1738–1795) *Treatise on Fractures, Luxations, and Other Affections of the Bones*, John Eberle's (1787–1838) *Treatise of the Practice of Medicine,* and, most significantly, Benjamin Traver's (1783–1858) *Synopsis of the Diseases of the Eye and Their Treatment* (1825).

22.
See Wilmerding, *"Portrait of John N. Fort,"* 3, for a discussion of Eakins' focus on the head and hands of many of his sitters.

# 9

## The Chaperone

Thomas Eakins | 1844 – 1916
c. 1908, oil on canvas, 46.3 x 36.2 (18 1/4 x 14 1/4)
National Gallery of Art, Gift of John Wilmerding,
in Honor of the 50th Anniversary of the National
Gallery of Art

In 1877 Thomas Eakins painted a canvas showing
the early (and, by Eakins' day, long forgotten)
Philadelphia ship carver and sculptor William Rush
(1756 – 1853), working from a nude female model
in sculpting a life-size allegorical figure.[1] The only
other figure present in the painting is an elderly
woman knitting in an eighteenth-century chair.
Eakins was known for his depictions of Philadelphia
friends and associates engaged in various activities
and only rarely took interest in subjects from the
past. In this instance Eakins altered historical fact
to serve his own ends, for there is no evidence the
sculptor had worked from a nude model. Eakins
believed study from the nude was essential and
he stressed this in his teaching at the Pennsylvania
Academy of the Fine Arts. The 1877 painting of
Rush thus may have been intended to suggest that
working from the nude was not unprecedented in
Philadelphia and, in fact, had a venerable tradition.
The inclusion of the elderly woman chaperone legit-
imized the activity of posing nude, making it clear
that this model was a virtuous young woman from
a good family.[2] Even so, for many Philadelphians of
Eakins' time the idea of such a person posing nude
would still have carried an unmistakable implication
of scandal.[3]

    In 1886 Eakins was forced to resign his position
at the Pennsylvania Academy, in part because his
unrelenting emphasis on working from the nude had
become a controversial topic in staid Philadelphia.
Rumors circulated that Eakins had indulged in
improper, even immoral behavior. The dismissal
affected him deeply and he increasingly withdrew

from Philadelphia art circles to pursue his art independently. By the early 1900s he was all but forgotten; when the famous portrait painter John Singer Sargent visited Philadelphia in 1903 and asked to meet Eakins, his baffled hostess could only reply, "And who is Eakins?"[4]

In 1908 Eakins returned to the subject of William Rush in several paintings. The most complete version (fig. 1), for which the present work is a study, retains the principal elements from the 1877 oil, but with significant changes. The figure of Rush is stockier and not so well-dressed; he looks more like an artisan or a workman. The other major change involves the chaperone, who is no longer a finely dressed, elderly white woman in an elegant chair, but a black woman wearing a bandanna and sitting in a simple wooden chair. Eakins presumably made the oil sketch for this figure from life, but we do not know her identity.[5] Nevertheless, Eakins gave her a quiet dignity that is markedly distinct from the less sympathetic images of African Americans found in all too many works by his contemporaries.[6]

Perhaps Eakins chose to include this woman in his reconsideration of the Rush theme because of some personal affection he felt for her. But her inclusion, regardless of the immediate reasons

behind it, undeniably gives the painting a different nuance. In the 1877 version the chaperone was believed by Eakins' friends and by reviewers to be a close relative of the young woman posing, perhaps even her mother.[7] Her presence, then, was in part protective, ensuring that the sculptor remained honorable and did not in any way take advantage of his model. Although the black woman in the 1908 canvas still serves that purpose, her race makes it clear that she and the model are not related. Indeed, these women seem to exist in two completely separate worlds within the picture, functioning as virtual opposites: one white, the other black; one brightly lit, the other in shadow; one nude, the other clothed; one standing stiffly, the other seated comfortably; and one doing nothing (although posing), the other quietly working. That the chaperone is so fundamentally different and set apart from the model might suggest that the emotional equilibrium of the 1877 painting, in which the figures seemed to exist as three independent entities, has been slightly tipped toward the relationship between the two white women. Interestingly, in other paintings of Rush that Eakins probably began around this same time (for example, *William Rush and His Model*, c. 1908, Honolulu Academy of Arts), the chaperone disappears and the sculptor (who now resembles Eakins himself) actually makes physical contact with the nude model by offering her his hand as she steps down from the platform.[8] This contact, though seemingly proper and innocent, introduces the possibility of physical intimacy between the two, bringing yet other levels of meaning to the Rush images. Might one see Eakins' alteration of the chaperone as the result of his desire to bring artist and model into some new and more personal relationship? By first replacing the relative with the more anonymous black woman, and then by removing the chaperone altogether, Eakins took away the chief impediment to such intimacy between artist and model. Or did he? As the artist's gentlemanly demeanor in *William Rush and His Model* seems to indicate, the ultimate barrier lies with the artist himself, who must always hold his artistic enterprise above the pursuit of personal pleasure. No close family member, or even a

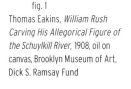

fig. 1
Thomas Eakins, *William Rush Carving His Allegorical Figure of the Schuylkill River*, 1908, oil on canvas, Brooklyn Museum of Art, Dick S. Ramsay Fund

trusted family servant, was needed standing guard, for the artist would serve as his own chaperone. That reading actually would accord more properly with what we know of Eakins' use of the nude in teaching and would make the late Rush pictures pointed reassertions of his innocence of wrongdoing in the Pennsylvania Academy scandal years earlier.

There may have been another reason Eakins changed the race of the chaperone. Throughout his career he had painted black individuals pursuing various activities, as in *Will Schuster and the Black-man Going Shooting,* 1876 (Yale University Art Gallery), and although he was not immune to the prejudices of his era, his images of blacks tended on the whole to be positive. Late in life, when he was increasingly disillusioned, Eakins may have come to identify not only with William Rush, but also with others who had been the victims of society's preju-dices. Perhaps that is why in the 1908 painting (see fig. 1) the two figures that actually seem most closely allied are not Rush and the model, but Rush and the chaperone. They seem virtual counterparts, each working with their hands, each intently creating something finished out of unformed raw materials. Each labors in the shadows, unlike the model, who stands inactive in brilliant light. It is as if they exist on the sidelines of a society that largely ignores them and only rarely honors them or their creations. As Eakins wrote in 1906: "The life of an artist is precarious. I have known very great artists to live their whole lives in poverty and distress because the people had not the taste and good sense to buy their work. Again I have seen the fashionable folk give commissions of thousands to men whose work is worthless."[9] Successful artists might dress like gen-tlemen, work in fancy studios, and reap society's rewards, but others who were more deserving might (like Eakins) suffer only contempt and neglect. For Eakins to draw a parallel between the unappreciated and marginalized artist and the lot of African Americans would not have been to minimize the latters' struggles. Rather, it served to highlight the injustice and capriciousness of society generally, wherever it was brought to bear.

In the thirty years between his first painting of Rush and his return to the theme, so much had changed for Eakins and his art that he clearly could not treat the subject of an artist at work in quite the same way again. He had seen himself discredited as a teacher, had been deemed old-fashioned as an artist, and had been forgotten by his native city. The energy and vitality that characterized the 1877 *Rush* and seemed to affirm the legitimacy of making art are absent in the 1908 version, as if they had ebbed from Eakins himself. Perhaps that was why the sub-ject had to be recast, why new studies such as this had to be made, and why the character of two of the three figures had to be transformed. If the story he wished to tell was still fundamentally one about himself, his art, and his beliefs, that story now had for him a very different conclusion. | FK

1.
This painting, *William Rush Carving His Allegorical Figure of the Schuylkill River,* 1877 (Philadelphia Museum of Art), has been much discussed in the literature on Eakins; see Johns 1983, 82–114. This entry is based on one by the same author in the National Gallery of Art Systematic Catalogue, *American Paintings of the Nineteenth Century,* Part 1 (Washington, 1996), 185–189.

2.
Eakins often complained that his students could not learn to portray beautiful forms if they were only exposed to "coarse and flabby types" who came from broth-els. He even asked the Pennsylvania Academy to advertise for respectable female models who could be "accompanied by their moth-ers or other female relatives"; see Kathleen A. Foster and Cheryl Leibold, *Writing About Eakins* (Philadelphia, 1989), 343. Eakins also believed that any student enrolled in a life class should be willing to pose nude if asked. See also Johns 1983, 99.

3.
See Johns 1983, 102–103.

4.
Lloyd Goodrich, *Thomas Eakins,* 2 vols. (Cambridge, Mass., 1982), 2:222.

5.
Johns 1983, 113, says the woman was a servant in the Eakins household, without further speculation as to why he included her.

6.
For a discussion of Eakins' images of blacks see Guy C. McElroy, *Facing History: The Black Image in American Art, 1710–1940* [exh. cat., Corcoran Gallery of Art] (Washington, 1990), xix, 84–87.

7.
Johns 1983, 99.

8.
The figure's resemblance to Eakins has been pointed out by many scholars, notably Goodrich 1982, 2:247, and Johns 1983, 109–110, and has been the subject of much speculation.

9.
Quoted in Lloyd Goodrich, *Thomas Eakins: His Life and Work* (New York, 1933), 133–134.

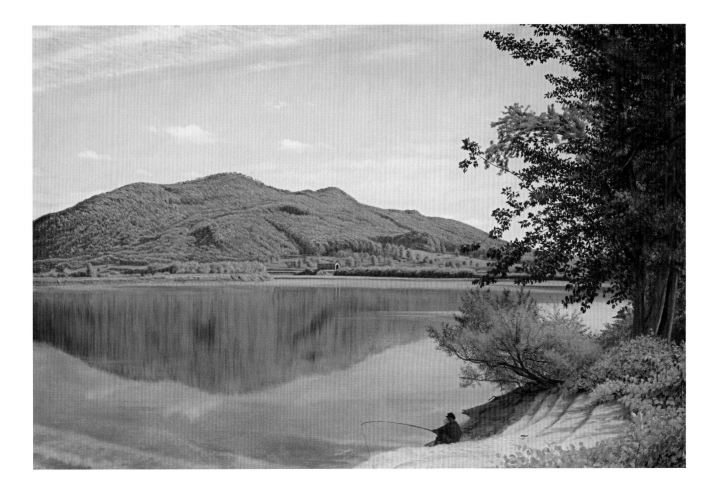

# IO

## Mount Tom

Thomas Charles Farrer | 1839 – 1891
1865, oil on canvas, 40.6 x 61.6 (16 x 24 1/4)

Thomas Charles Farrer came to this country around 1858, with little formal education but with a knowledge of the pre-Raphaelite precepts of John Ruskin that he absorbed while he was Ruskin's drawing student at the Working Men's College, London. After a brief return to England, Farrer settled in New York in 1861. There, in January 1863, he and a group of five other young men founded the Association for the

Advancement of Truth in Art (see cats. 33, 34, 39 – 41).[1] Their movement was dedicated to artists striving for the utmost fidelity to nature and followed Ruskin's oft-quoted exhortation to depict the world around as it appeared, "rejecting nothing, selecting nothing."[2]

*Mount Tom*, a painstakingly accurate and unromanticized representation of a well-known site, was painted in the summer of 1865 when Farrer and his wife made a trip to Northampton, Massachusetts.[3] By that time, this area of the Connecticut River Valley was a popular tourist destination, enjoyed for the mountaintop vistas of neatly cultivated fields along the river as well as for the civilized amenities of the charming towns in the area. Even before he came to this country, Farrer would have known of the valley's attractions because it was visited by

numerous British travelers in the 1830s and 1840s, several of whom wrote glowing accounts of their impressions.[4] An additional reason for Farrer to come to the area may have been his acquaintance with Charles Eliot Norton (1827–1908), the noted American scholar and pre-Raphaelite enthusiast, who was staying at nearby Ashfield at the time.

The group of Northampton-area views Farrer created in the summer of 1865 was shown in that town the following October, at the home of Colonel J.B. Parsons, with whom the Farrers were staying. *Mount Tom* was praised in the local press as "very fine" and the "favorite of many visitors."[5] When it was exhibited in Brooklyn a year and a half later with other works by Farrer, it engendered a more mixed reaction. While the *New York Times* critic lauded the great care with which it was painted, he thought the overall impression was not "an artistic realization of the scene" and that many elements were stiff and unnatural.[6] Yet a reviewer in the Brooklyn press felt the landscape was "full of the tender light and genial influences of actual nature."[7] In addition to *Mount Tom*, two other views of the area are currently known. *View of Northampton from the Dome of the Hospital* (Smith College Museum of Art) is a panoramic, bird's-eye view of the city landmarks and fields beyond. The recently discovered *Mount Holyoke* (fig. 1) is, like *Mount Tom*, painted

straight-on and close-up, making the most of the contrast between the textured, forested hillsides and the glassy expanses of river below. Both of these images, more straightforward and nonformulaic in their compositions than standard Hudson River School landscapes, contain human elements (boaters, fisherman) that seem to reinforce the sense that the works are direct, personal recordings of the scene in which the artist was immersed. The two works are identical in size and show mountain masses that appear to mirror each other, as if the paintings were intended to hang as pendants.[8]

Mount Holyoke was the more celebrated of the two peaks in the nineteenth century, with a splendid prospect most illustriously documented in Thomas Cole's *View from Mount Holyoke, Northampton, Massachusetts, after a Thunderstorm (The Oxbow)*, 1836 (The Metropolitan Museum of Art, New York). Yet Mount Tom, on the western side of the Connecticut River, was also deemed "well-worth climbing, and not disappointing the highly-raised anticipation of the tourist."[9] Farrer, however, chose to situate himself at the foot of these mountains, rather than to gaze outward from their apexes. In *Mount Tom*, he captures the harshness of the light and the stillness of the air on a late summer day, when no breeze ruffles the surface of the water and the fisherman is grateful for a bit of shade on the riverbank.[10] The angler, it should be noted, is wearing a hat that appears from its shape (though not its color) to be a Union soldier's cap. This detail of a pastoral image, painted just a few months after the Civil War ended, may allude to the well-earned leisure of blessed peace. The artist would have had a personal connection to the reference: although an Englishman, he served for a few months in the Union Army, in spring and summer 1862, because of his strongly held antislavery views.[11]

Farrer has created a powerfully well-observed landscape, quite unlike the gentler and more atmospheric views that were common at the time. The lack of any visual filter and the crispness and particularity of the image, with which some critics had found fault, eventually disappeared from Farrer's work. After teaching and exhibiting throughout the 1860s, he left

fig. 1
Thomas Charles Farrer, *Mount Holyoke*, oil on canvas, Mount Holyoke College Art Museum, South Hadley, Massachusetts, Elizabeth Peirce Allen Acquisition Fund and the Warbeke Art Acquisition Fund

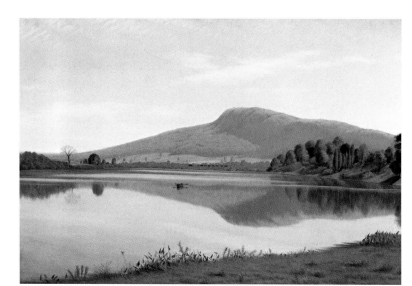

America at the end of the decade.[12] He returned four years later with a style that, as was commented, was "very much modified. He has entirely lost whatever hardness was shown in his early work...[while retaining] in its full strength his remarkable skill in faithful drawing...[and gaining] in color, in composition, and incalculably in subtlety and refinement."[13] Today, American collections are perhaps more likely to hold works by Henry Farrer (1843–1903), an accomplished watercolorist, etcher, and Thomas' younger brother, than paintings by the elder artist. The limited number of works by T. C. Farrer that are known, however, are extraordinarily vivid images of the American land.[14] Farrer, who was born in London, died there as well. | DC

1.
See Linda S. Ferber, "'Determined Realists: The American Pre-Raphaelites and the Association for the Advancement of Truth in Art,'" in Ferber and William H. Gerdts, *The New Path: Ruskin and the American Pre-Raphaelites* [exh. cat., Brooklyn Museum of Art] (Brooklyn, 1985), 11–37. For the most complete information on Farrer's life, see Annette Blaugrund's biography in the same volume, page 154.

2.
John Ruskin, *Modern Painters* (Kent, England, 1888), 1:417.

3.
Information regarding Farrer and his stay in Northampton was first discovered by Betsy Burns Jones in the late 1970s, in connection with her research on the then unattributed *View of Northampton*. See Jones' discussion of the painting in *Masterworks of American Painting and Sculpture from the Smith College Museum of Art* (Northampton, Mass., 1999), 74–77.

4.
See Jill A. Hodnicki, "The Connecticut Valley in Literature: A Delightful Excursion," in *Arcadian Vales: Views of the Connecticut River Valley* [exh. cat., George Walter Vincent Smith Museum] (Springfield, Mass., 1981), 15.

5.
*Northampton Free Press* (13 October 1865).

6.
"Art Matters," *New York Times* (3 April 1867), 8.

7.
"The Art Exhibition," *Brooklyn Daily Union* (28 March 1867)1.

8.
It appears that *Mount Holyoke* may have been painted at some later time since it is not mentioned in any of the known 1865 reviews of Farrer's Northampton-area paintings.

9.
Rev. J. C. Stockbridge, "Valley of the Connecticut," in *Picturesque America*, Wm. C. Bryant, ed. (New York, 1874), 2:79, as quoted in exh. cat. Springfield 1981, 24.

10.
Farrer's warm-toned landscape may have been an especially accurate reflection of local conditions at the time. The *Hampshire Gazette* complained of "close, stifling, muggy, dusty, hot" weather unusual for early fall (5 September 1865) and that the "streams are lower than they ever were before known to be...many wells that never failed are now dry" (26 September 1865).

11.
Exh. cat. Brooklyn 1985, 154.

12.
Farrer taught classes at Cooper Union. He exhibited at the Brooklyn Art Association and the National Academy of Design between 1861 and 1872 (and once again in 1884).

13.
"Art Matters," *New York Times* (14 April 1873).

14.
The Museum of Fine Arts, Boston, owns two paintings by Farrer, *A Buckwheat Field on Thomas Cole's Farm,* 1863, and *Twilight,* 1864. The Fogg Art Museum, Harvard University Art Museums, owns a Farrer copy of J.M.W. Turner's *Fighting Temeraire.* Other examples of his drawing and painting are reproduced in exh. cat. Brooklyn 1985, nos. 1–12, 154–166.

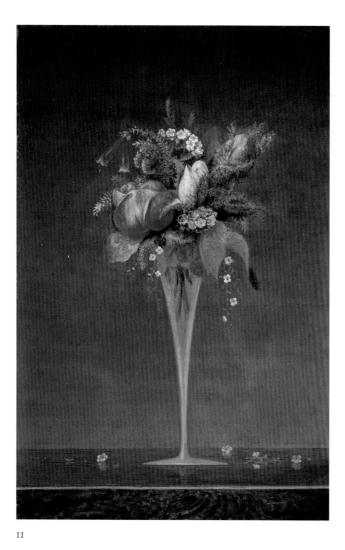

11

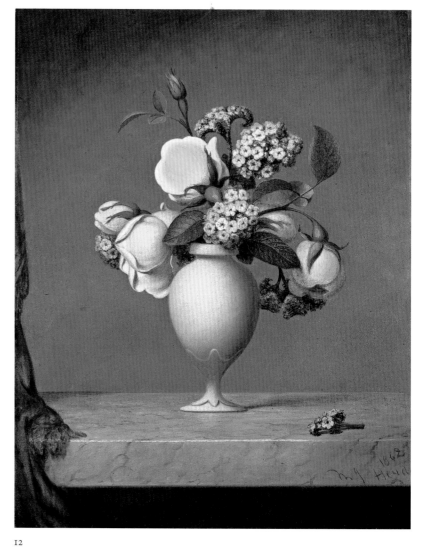

12

## 11

### Still Life with Wine Glass

Martin Johnson Heade | 1819–1904
1860, oil on board, 28.3 x 17.8 (11$\frac{1}{8}$ x 7)

## 12

### Roses and Heliotrope in a Vase on a Marble Tabletop

Martin Johnson Heade | 1819–1904
1862, oil on board, 35.2 x 27 (13$\frac{7}{8}$ x 10$\frac{5}{8}$)

## 13

### Apple Blossoms in a Vase

Martin Johnson Heade | 1819–1904
1867, oil on board, 35.6 x 30.5 (14 x 12)

## 14

### Still Life with Roses, Lilies, and Forget-Me-Nots in a Glass Vase

Martin Johnson Heade | 1819–1904
1869, oil on canvas, 26 x 21 (10$\frac{1}{4}$ x 8$\frac{1}{4}$)

Martin Johnson Heade was one of the most original and idiosyncratic American painters of the nineteenth century.[1] The quiet, limpid mood of his paintings and his method of exploring unusual subjects and compositions in extended series of works, along with his dual allegiance to both still life and landscape, resulted in a unique style that distinguished him from his contemporaries. Heade worked in the Tenth Street Studio Building and exhibited regularly at the National Academy of Design in New York, but he never achieved the acclaim of artists like his friend and colleague, Frederic Church. Indeed, his approach was in many ways antithetical to Church's popular Hudson River School paintings with their grand dramatic compositions derived from myriad sketches and studies.

During the 1860s Heade, along with George Cochran Lambdin (1830–1896), emerged as the first important flower specialist in American painting.[2] Heade's interest in floral still lifes coincided with his earliest explorations of marsh scenes (see cat. 15). Over his remaining career Heade would devote his efforts alternately to creating still lifes and landscapes, becoming the only American painter of his era to produce a significant body of work in both genres.[3]

*Still Life with Wine Glass* is the earliest known flower painting by Heade and presents the basic formal elements of his style. The subtle organic asymmetries of the tea roses and fuchsia are contrasted with the handcrafted symmetries of the tall vase that contains them, as well as the flat plain of the tabletop on which the vase rests. The lines of the table extending across the picture, in conjunction with the atmospheric background, create an odd sense of scale; the back edge of the tabletop reads almost as a distant horizon before which the flowers seem to loom impossibly large.

In the similarly composed *Roses and Heliotrope in a Vase on a Marble Tabletop*, a soft light from the left defines the pristine ovoid of the tinted Parian-ware vase and casts a shadow behind it. The curtain on the left is pulled back to reveal the vibrant violet blossoms of the heliotrope and the rich creamy pinks and yellows of the rose petals. This gesture adds a note of both drama and decorum and provides a

subtle visual threshold for the painting. The foreground is more logically ordered and the viewer's attention deftly drawn toward the flower arrangement. By helping better to define the form and volume of the vase and more clearly articulating the space of the tabletop, these techniques and devices largely resolve any discrepancies in scale that might make the subject less convincing.

Heade further refined his approach in *Apple Blossoms in a Vase*, enlarging the arrangement of flowers and placing them against a dark background. He also more accurately depicted (almost to the point of trompe l'oeil) the wood grain of the tabletop and the pattern of reflections on it. Finally, Heade's mastery of still life is perhaps most apparent in *Still Life with Roses, Lilies, and Forget-Me-Nots in a Glass Vase*. In this dynamic, baroque composition, flowers twist and project into space and radiate toward the edges of the canvas in a manner that bears comparison with the great prototypes for Heade's tabletop subjects found in seventeenth-century Dutch painting.

Heade's simultaneous pursuit of both still life and landscape painting created crosscurrents of influence between the two genres. The extension of the tabletops across the compositions of all four still lifes evokes comparisons with the flat tidal plains found in the haystack paintings of the 1860s (see cat. 15). More specifically, regarding *Roses and Heliotrope in a Vase on a Marble Tabletop*, Theodore Stebbins has observed: "The gentle play of warm

tones—the bluish-pink roses and warm tan tabletop—against the coolness of the convincingly three-dimensional vase, the white roses, the heliotrope, and the gray background recalls equally subtle light effects in his *Stranded Boat,* 1863 (Museum of Fine Arts, Boston), of the following year."[4] In addition, *Still Life with Roses, Lilies, and Forget-Me-Nots in a Glass Vase* reflects something of the dark, ominous mood in Heade's thunderstorm subjects.[5] For instance, the play of the white lilies against the dark background is very similar in effect to the white sails against the dark waters and skies seen in *Approaching Thunderstorm,* 1859 (The Metropolitan Museum of Art, New York), and *Thunderstorm on Narragansett Bay,* 1868 (Amon Carter Museum, Fort Worth). Furthermore, the overwhelming vitality of the flowers, which almost appear to be actually moving or growing, foreshadows the animated qualities of Heade's tropical orchid subjects of the early 1870s, such as *Cattleya Orchid and Three Brazilian Hummingbirds* (see page 20, fig. 9).

In addition to their relationship to landscape painting, Heade's still lifes also carry figurative associations. Heade presents his bouquets theatrically, almost like solo performers looming above an audience on a bare stage. The Victorian vases with their sensuous shapes and distinctive styles evoke female forms, and the expressive force of the floral arrangements suggests analogies with a singer performing an aria or an actress delivering a soliloquy.[6] This anthropomorphic quality becomes even more pronounced in Heade's paintings of orchids and magnolias of the 1870s, 1880s, and 1890s; the art historian John I. H. Baur once observed that works like *Giant Magnolias on a Blue Velvet Cloth* (fig. 1), with their "fleshy whiteness," resemble "odalisques on a couch."[7]

Although no universal lexicon existed, the bouquets in Heade's still lifes have been interpreted using the language of flowers made popular during the Victorian era.[8] Stebbins, for instance, has suggested that in *Still Life with Wine Glass,* Heade "depicts a lover's bouquet: the summer flowers he has included represent the intoxication of love in terms of the popular vocabulary of the period, yet the height and fragility of the vase and the fallen forget-

fig. 1
Martin Johnson Heade, *Giant Magnolias on a Blue Velvet Cloth,* c. 1890, National Gallery of Art, Washington, Gift of The Circle of the National Gallery of Art in Commemoration of its 10th Anniversary

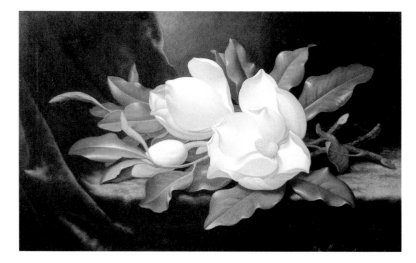

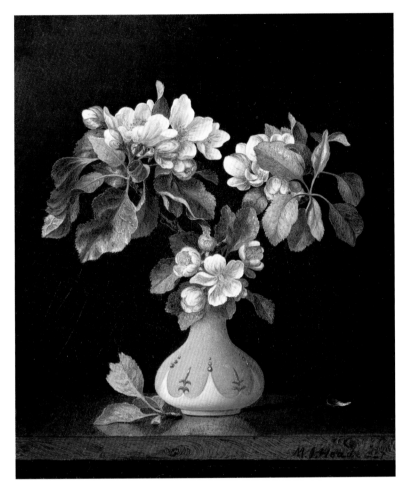

13

14

fig. 2
Martin Johnson Heade, *Apple Blossoms and Hummingbird,* 1871, Addison Gallery of American Art, Phillips Academy, Andover, Massachusetts

me-nots on the table imply a bittersweet ending."[9] Fallen leaves and blossoms are found in the other three still lifes and similar narratives of loss could be proposed for them as well. The contemporary critic Henry Tuckerman, while decrying the popular flower language of the day as "fanciful and hack-neyed," still viewed flowers as "radiant hieroglyphics, sculptured on the earth's bosom" and wrote that Heade's apple blossoms "embodied the very soul of vernal bloom and tenderness."[10] Ultimately, however, any attempt to create an interpretive structure for these works must concede that, as Stebbins readily admits, "We know virtually nothing about what Heade intended to convey through his choices of flowers or vases."[11]

The singular qualities of Heade's still lifes derive in large part from the almost obsessive way he reworked his motifs in series. This method is especially evident in the eighteen known apple-blossom

subjects he painted from the mid-1860s to the early 1880s.[12] In this series, Heade explored numerous permutations of the basic patterns of flowers found in *Apple Blossoms in a Vase*.[13] Among the variations were a simple vase holding a few blossoms, a floating branch hovering implausibly in the sky, a close-up of blossoms with a hummingbird (fig. 2), and a branch of blossoms on a tabletop. A branch may be slightly extended, new blossoms and leaves added, or the basic blossom patterns rotated or composed in slightly different ways, yet all these works contain some elements of the flowers almost exactly as they are seen in the 1867 painting. The fact that many of these pictures remained in Heade's possession and were later inherited by his relatives indicates that they were executed for personal and artistic reasons more than commercial ones.[14]

Heade's habit of working serially had profound consequences for his style. As he explored and

rearranged his motifs, the initial concern with depicting objects realistically in time gave way to a thorough analysis of the formal, abstract qualities of his compositions. The result is a style that combines detailed realism with refined abstraction. Scale and space become vaguely indeterminate and forms are slightly disassociated from the things they depict. There is no evidence that his contemporaries saw these effects as peculiar, but many modern viewers have found Heade's style disquieting, even comparing it to surrealism.[15]

As Stebbins has asserted, Heade was an irreverent iconoclast whose "fierce pride and…independence" placed him largely outside the mainstream of late nineteenth-century American art.[16] Rather than being perceived as disquieting or surreal, the singular qualities of Heade's still lifes may perhaps be better understood as an expression of the artist's own insistent individualism. Indeed, these four examples readily demonstrate that although Heade worked in series, he rarely repeated himself, going to great lengths to ensure that each of his still lifes was unique and stood alone. | CB

1.
Any discussion of Heade is indebted to the scholarship of Theodore E. Stebbins Jr., whose groundbreaking catalogue raisonné, *The Life and Works of Martin Johnson Heade* (New Haven and London, 1975), has been revised and reissued as *The Life and Work of Martin Johnson Heade: A Critical Analysis and Catalogue Raisonné* (New Haven and London, 2000). In the context of the present exhibition it should be noted that John Wilmerding considered taking up the study of Heade in the 1960s but "generously deferred" to Stebbins. See Stebbins 2000, vii.

2.
See William H. Gerdts, "Introduction," in *American Cornucopia: 19th Century Still Lifes and Studies* [exh. cat., Hunt Institute for Botanical Documentation, Carnegie Mellon University] (Pittsburgh, 1976), 8, and Gerdts and Burke 1971, 92.

3.
Stebbins 2000, 108.

4.
Stebbins 2000, 33.

5.
See Sarah Cash, *Ominous Hush: The Thunderstorm Paintings of Martin Johnson Heade* [exh. cat., Amon Carter Museum] (Fort Worth, 1994).

6.
For a discussion of Heade's vases, see Stebbins 2000, 131–133.

7.
John I. H. Baur, "Introduction," in *Commemorative Exhibition: Paintings by Martin J. Heade and Fitz Hugh Lane from the Private Collection of Maxim Karolik and the M. & M. Karolik Collection of American Paintings from the Museum of Fine Arts, Boston* [exh. cat., M. Knoedler] (New York, 1954), as quoted in Stebbins 2000, 161.

8.
On Heade and the language of flowers, see exh. cat. Pittsburgh 1976, 8–9; Gerdts and Burke 1971, 89, 92; and Stebbins 2000, 33–35. For a more general discussion of these books in Britain and America, see Beverly Seaton, *The Language of Flowers: A History* (Charlottesville, Va., 1995), 80–111.

9.
Stebbins 2000, 30–31.

10.
Henry T. Tuckerman, "Flowers," *Godey's Lady's Book* (January 1850), 13 and following, as quoted in Stebbins 2000, 35; and Tuckerman 1876, 543.

11.
Stebbins 2000, 133.

12.
See Stebbins 2000, 128. The apple blossom works are cats. 392, 393, 399, 426, 442, 443, 444, 445, 451, 452, 453, 454, 468, 469, 470, 471, 482, and 517 in Stebbins 2000.

13.
*Apple Blossoms in a Vase* contains the basic patterns for the flowers found in almost all the other works, but an initial drawing or oil study of a branch with the three distinct clusters of blossoms likely existed as well, although none is known today. Stebbins 2000, 128.

14.
Stebbins 1975, 123.

15.
On Heade and surrealism see Barbara Novak, *American Painting of the Nineteenth Century* (New York, 1969), 126–129. Stebbins characterized the connections with surrealism as "superficial," Stebbins 2000, 108.

16.
Stebbins 2000, 166.

## 15

### Sunlight and Shadow: The Newbury Marshes

Martin Johnson Heade | 1819–1904
c. 1871–1875, oil on canvas, 30.5 x 67.3 (12 x 26½)

Martin Johnson Heade's first pictures of marshlands featured the environs of Newbury and Newburyport, Massachusetts, near the mouth of the Merrimack River. Perhaps attracted by the poetry of John Green-leaf Whittier that celebrated the local landscape, or more likely drawn there by his acquaintance with Bishop Thomas March Clark of Newburyport, Heade discovered the area sometime around 1859.[1] By the end of his career he had executed well over one hundred marsh subjects; these account for almost one-fifth of his entire known oeuvre as a painter. Although precedents exist for Heade's marshland paintings, he was the only artist of his time to explore the subject so extensively.

*Sunlight and Shadow* is a particularly masterful example of how Heade balanced many countervailing forces in the compositions of his wetland paintings. The serpentine line of the saltwater creek receding into the open plain on the right is offset by the visual weight of the haystack and apple tree on the left. The rhythm of the creek's zigzag movement is complemented by the undulating wave pattern the treetop and clouds trace across the sky. The pink clouds are mirrored in the shallow pool of water at the lower center, and the form of the tree leaning left is echoed in the sweep of the high, thin clouds placed in the upper right corner. Also, the intricate play of sunlight and shadow in the background behind the haystack is further and more simply articulated in the strong bands of light and dark in the foreground, the mix of light and shadow among the clouds, the direct counterpoint of light and shade on the pair of cows on the right, and in the movement from light to dark across the body of the haystack itself.

Infrared reflectography reveals that Heade painted out a haystack in the middle of his canvas and then moved this prominent element slightly

forward and to the left. By bringing the haystack out of the shadow and into the sunlight he was better able to balance the composition and enrich the play of light and dark. This change demonstrates how Heade rethought his marsh scenes while painting them.

Henry David Thoreau, like Heade, reveled in the experience of being alone in the marshlands: "Would it not be a luxury to stand up to one's chin in some retired swamp for a whole summer's day, scenting the sweet-fern and bilberry blows, and lulled by the minstrelsy of gnats and mosquitoes?"[2] He further observed: "Hope and the future for me are not in lawns and cultivated fields, not in towns and cities, but in the impervious and quaking swamps....Yes, though you may think me perverse, if it were proposed to me to dwell in the neighborhood of the most beautiful garden that human art contrived, or else of a Dismal swamp, I should certainly decide for the swamp."[3]

Heade's marsh paintings conflate Thoreau's notions of a primordial swamp and a cultivated, artful garden. Reflecting the dynamic of an essentially uncultivated landscape that yields a harvest of salt hay naturally, the paintings are simultaneously wild and tamed. Heade offers nuanced descriptions of the tides, meteorological phenomena, and other natural forces that shaped the appearance of the swamp, but he also shows how men hunted, fished, and hayed the marshes and used them as pasture for their cattle. With its lurid pink thunderheads looming ominously over a peaceful landscape, *Sunlight and Shadow: The Newbury Marshes* also unites the aesthetic categories of the sublime and beautiful.[4]

Swamps, though often characterized as forbidding, pestilential wastelands, had been an important part of the early American landscape.[5] The New England settlers had relied on the bounty of grasslands and inlets: "First settlements were generally made in the vicinity of what are today tidal marshes or river lowlands....The colonists' large flocks of animals could not survive even a year without adequate pasturage; to drive them inland away from natural marshes and meadows would have doomed the animals to starvation and upset the agricultural unity of the town group."[6] By the 1870s, as Theodore Stebbins has noted, Heade's marsh pictures were nostalgic evocations of a vanishing way of life: "They speak more to the pastoral ideal in America than to actual life on New England farms in the later years of the nineteenth century....In Heade's Newburyport, marsh hay became a less and less desirable crop over the years, as trains brought cheaper and better hay from distant farms; marsh haying continued long after it was economically feasible...because of its traditional, communal nature, which gave people a sense of connecting with the past."[7]

The currency of the nostalgia for the marsh is verified by Frederick Law Olmsted's design for the Boston Fens begun in 1879.[8] Recognizing that among the city's rapidly growing population many had been raised near the shore, Olmsted envisioned, as he later put it, "a fortunately preserved reservation of a typical small passage of New England sea shore landscape, including a salt creek bordered in part by salt meadows."[9] Olmsted and his colleagues hoped that the marsh motif, along with the many other elements incorporated into the Back Bay Park, would convey "something of the beauty and life-giving qualities of the...pure waters and the untroubled horizons of the first civilization."[10]

fig. 1
Martin Johnson Heade, *Gremlin in the Studio*, c. 1865–1875, oil on canvas, Wadsworth Atheneum, Hartford, The Dorothy Clark Archibald and Thomas L. Archibald Fund

Heade, Thoreau, and Olmsted all constructed edenic images of the marsh for a contemporary audience. Ironically, to achieve the desired natural effects, their various projects required a high degree of self-conscious aesthetic artifice; Heade's finely tuned arrangements, Thoreau's appealing, persuasive rhetoric, and the practical intricacies of Olmstead's carefully engineered plans are all of a kind. In Heade's case that self-consciousness and artifice is evident in details such as the compositional refinements he made to *Sunlight and Shadow: The Newbury Marshes,* as well as in works such as *Gremlin in the Studio* (fig. 1), where he reveals explicitly and with great humor and wit the studio mechanics of his marsh paintings. | CB

1.
Stebbins 2000, 28–29.

2.
Bradford Terry and Francis H. Allen, eds., *The Journal of Henry D. Thoreau* (Boston, 1949), 1:141.

3.
Henry David Thoreau, *Excursions* (Boston, 1863), 190.

4.
On Heade and the sublime, see Andrew Wilton and Tim Barringer, *American Sublime: Landscape Painting in the United States, 1820–1880* [exh. cat., Tate Britain] (London, 2002), 210–215; Bruce Johnson, "Martin Johnson Heade's Salt Marshes and the American Sublime," *Porticus* 3 (1980), 34–39; Earl A. Powell III, "Luminism and the American Sublime," in exh. cat. Washington 1980, 69–96.

5.
See David Cameron Miller, *Dark Eden: The Swamp in Nineteenth-Century American Culture* (Cambridge, Mass., 1989), and Ann Vileisis, *Discovering the Unknown Landscape: A History of America's Wetlands* (Washington, 1997).

6.
*Architecture and Town Planning in Colonial Connecticut* (New Haven, 1951), 14, 60, as quoted in Walter L. Creese, *The Crowning of the American Landscape: Eight Great Spaces and Their Buildings* (Princeton, 1985), 174.

7.
Stebbins 2000, 126. Also see Nancy Frazier, "Mute Gospel: The Salt Marshes of Martin Johnson Heade," *Prospects* 23 (1998), 193–207, and Roberta Smith Favis, *Martin Johnson Heade in Florida* (Gainesville, Fla., 2003), 81–107.

8.
I am indebted to Franklin Kelly for bringing to my attention Walter Creese's study of Olmsted's plans for the Boston Fens in Creese 1985, 167–204. See Kelly's discussion of these issues in exh. cat. Washington 1989, 60. Also see Vileisis 1997, 149, and Favis 2003, 94.

9.
Olmsted to Francis W. Lawrence, 28 January 1890, Box 24, Olmsted Papers, Library of Congress, 3–4, as quoted in Creese 1985, 175.

10.
John C. Olmsted, "The Metropolitan Park System of Boston," *Transactions of the American Society of Landscape Architects* (Harrisburg, 1912), 65–66, as quoted in Creese 1985, 169.

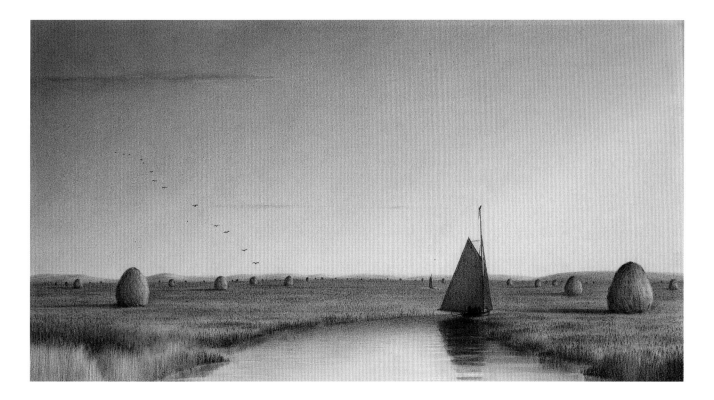

# 16

## Newbury Marshes

Unknown artist, formerly attributed to
Martin Johnson Heade

c. 1890, black and white chalk on paper,
30.5 x 54.6 (12 x 21½)

A series of large chalk drawings of marsh scenes
were first attributed to Martin Johnson Heade
around 1950.[1] What initially made the attribution to
Heade plausible for many art historians were the
marshland subject matter and the rich, often
sophisticated handling of the medium. Yet as more
and more of these works, such as *Newbury Marshes*,
were discovered, questions arose about whether
Heade had indeed executed them. A 1982 analysis
conducted by the Center for Conservation and
Technical Studies at the Fogg Art Museum, Harvard

University, of the materials used in the drawings
dated them to the last third of the nineteenth
century but was inconclusive about Heade's author-
ship.[2] More recently, the preeminent authority on
Heade, Theodore Stebbins, has declared that "an
attribution of these drawings to Heade cannot be
sustained."[3]

Stebbins' reasons for rejecting Heade's author-
ship, which he had previously accepted, are numer-
ous and compelling. The drawings are thought to
show views looking north on the Parker River near
Newburyport and feature a gaff-rigged sloop on the
water and a line of geese at the horizon. No other
works with these same elements are known by
Heade. Heade also did not use black chalk or char-
coal in his known drawings. In addition, these rather
large works are never mentioned in Heade's letters
or in contemporary exhibition reviews and catalogues.
Finally, the use of a one-point perspective system
and the essential symmetry of the chalk drawings are
incompatible with the complex asymmetrical designs
Heade regularly employed.

All these distinctions are evident in *Newbury Marshes*. Heade's known paintings never include geese formations and rarely prominently feature sailboats. While Heade composed his pictures like a chess player—endlessly inventing new ways to group and place his haystacks across the level plain of the marsh—the artist in *Newbury Marshes* is primarily concerned with making sure that the elements in his drawing recede uniformly in space. The lines of the riverbank, augmented by the line of geese and the lines of haystacks, keep the viewer's eye focused on the empty space at the center of the image that culminates at a vanishing point marked off on the horizon. Gradations of light in the reflection of the boat, across the marsh, and in the sky are sensitively handled in the drawing, but the landscape has very little detail. For instance, the serpentine movement of the river that Heade often carefully inscribed in his painting is here simply cut off, with the boat seemingly caught at a dead end. Moreover, none of the subtle characteristics of the marsh plantings or the vegetation on the hills is described. Overall, the drawing is more formulaic and not as richly observed as Heade's oils.

Stebbins offers convincing circumstantial evidence regarding the mystery of who may be responsible for these intriguing examples of late nineteenth-century draftsmanship. One of the works is signed and dated December 1891 by William C. Bowlen, a local Newburyport painter. Others were backed with Newburyport newspapers ranging in date from 1886 to 1891. During this period, two publications were in progress that each featured single illustrations of Marsh subjects: *Pictorial Gems of Newburyport* (1891) and *Newburyport Illustrated: Twenty Views* (c. 1890). These facts suggest the possibility that Bowlen and perhaps other local artists produced the chalk drawings as illustrations for these books but that their work was ultimately not printed. | CB

1.

The history of the drawings is fully discussed in "Appendix A: Questions of Attribution and Authenticity," in Stebbins 2000, 167–169, 195.

2.

Marjorie B. Cohn and Leslie Wyckoff Hill, "A Technical Examination of Fifteen Drawings of the Newburyport Marshes Attributed to Martin Johnson Heade," unpublished typescript (May 1983), as cited in Stebbins 2000, 195. Cohn and Hill determined that in almost every instance the medium used in the drawings was chalk, not charcoal, as had previously been assumed.

3.

Stebbins 2000, 168.

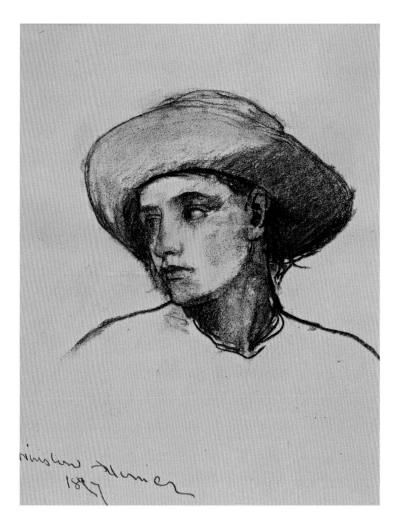

# 17

## Head of a Boy

Winslow Homer | 1836–1910
1877, pencil on paper, 23.8 x 18.7 (9 3/8 x 7 3/8)

Winslow Homer was born in Boston in 1836; in 1842 his family moved across the Charles River to Cambridge, then a semirural community centered around Harvard University.[1] In 1854 or 1855 he began an apprenticeship in a Boston lithography shop and was soon preparing illustrations for sheet music and illustrated newspapers such as *Ballou's Pictorial* and *Harper's Weekly*. In 1859 he relocated to New York to be closer to the heart of American publishing, but he declined an offer of a full-time position from *Harper's* in favor of freelance work. His artistic ambitions lay beyond illustration, and in 1859–1861 he studied at the National Academy of Design. In 1862, however, he was sent by *Harper's* to Virginia to gather material for depictions of the Civil War. The experience transformed him: "He suffered much, was without food 3 days at a time & all in camp either died or were carried away with typhoid fever—plug tobacco & coffee was [sic] the Staples….He came home so changed that his best friends did not know him…."[2]

Homer's wartime experiences were crucial to the formation of his artistic identity.[3] His first exhibited oil paintings, including *Home, Sweet Home* (fig. 1), were based on those very experiences. But after Lee's surrender at Appomattox, Homer necessarily had to look to other subjects and consider how his art might relate to the changed political and social landscape of the nation. He traveled to France in December 1866, ostensibly to see his *Prisoners from the Front*, 1866 (The Metropolitan Museum of Art, New York), on display in the 1867 Universal Exposition, but seems to have been little engaged with the contemporary art scene there. Returning to New York in fall 1867, Homer continued to earn his living by submitting designs for illustrations to *Harper's*, but he also painted and exhibited small oils. During the late

fig. 1
Winslow Homer, *Home, Sweet Home*, c. 1863, oil on canvas, National Gallery of Art, Washington, Patrons' Permanent Fund

fig. 2
Winslow Homer, *Blackboard*, 1877, watercolor on wove paper, laid down, National Gallery of Art, Washington, Gift (Partial and Promised) of Jo Ann and Julian Ganz Jr., in Honor of the 50th Anniversary of the National Gallery of Art

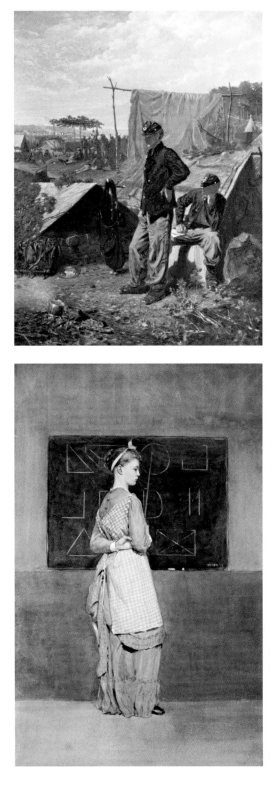

1860s and the early 1870s he traveled widely, sometimes on assignment from *Harper's* and other times apparently on his own initiative. In the summer of 1873 he produced his first works in watercolor, which were well received. Two years later, convinced he could now make his own way, Homer gave up commercial illustration.

During the late 1870s Homer frequently visited his friend Lawson Valentine's farm at Houghton, Massachusetts.[4] *Head of a Boy,* signed and dated 1877, may have been drawn at Houghton Farm, yet no sure evidence supports that Homer was there that year. In October 1877, however, he is known to have traveled to New York's Adirondack Mountains, and it is possible, even likely, that he stopped to see his friend Valentine on the way. The figure in the drawing certainly suggests a rural boy, and several images by Homer clearly set in the country show youths wearing similar hats.[5] This simple portrait, of nothing more than the neck and head of the sitter (his shoulders are sketched in only with broad lines), is nevertheless full of emotion. The boy gazes off to his right, and although we cannot see the object of his attention, his wistful expression suggests a great deal. During these same years Homer often painted scenes juxtaposing boys and girls in farm settings (see, for instance, *The Rustics*, 1874, private collection, and *A Temperance Meeting [Noon Time]*, 1874, Philadelphia Museum of Art).[6] There we find an implied sense of romantic connection, but also of the inability to fulfill the possibilities of the relationship; the figures interact, yet there is no indication that they will manage to extend their affections. Much has been made in scholarship on Homer about his emotional life and whether or not a romantic disappointment was central to the origins of his mature style.[7] A number of works from 1877 focus on what appears to be the same red-haired woman (she is shown, for instance, in the watercolor *Blackboard* [fig. 2]), leading to speculation that she and Homer may have had a relationship, but, in fact, very little is known about his feelings for members of the opposite sex.

In the end, Homer's reluctance to set up narratives with clear resolutions seems to have determined the nature of this work.[8] We are presented with an individual but are not directly engaged by him. As is so often the case with Homer's images, the figure seems to contemplate something outside the picture's space. This boy's attention lies elsewhere, and we are given no clue what may have drawn it. With a work that suggests a portrait (as this one does, at least in format), we are used to the sitter's eyes looking out into our own. Homer's contradicting of that expectation, along with his bold handling of line, give *Head of a Boy* its considerable strength. | FK

1.

Information concerning Homer's biography is drawn from Charles Brock's "Chronology" in Nicolai Cikovsky Jr. and Franklin Kelly, *Winslow Homer* [exh. cat., National Gallery of Art] (Washington and New Haven, 1995), 391–413.

2.

Letter from Homer's mother to his brother Arthur; quoted in exh. cat. Washington 1995, 392.

3.

See Nicolai Cikovsky Jr., "The School of War," in exh. cat. Washington 1995, 17–37.

4.

Valentine, a varnish manufacturer and the employer of Homer's younger brother Arthur, was one of the artist's most important early patrons.

5.

See, for example, *The Sower,* 1868, wood engraving (private collection), and *Watermelon Boys,* 1876 (Cooper-Hewitt Museum of Decorative Arts and Design, Smithsonian Institution, New York); both are reproduced in Wilmerding 1972, figs. 2–27, 76, and 3–43, 121, respectively.

6.

Reproduced in exh. cat. Washington 1995, 113, 114.

7.

See, for instance, exh. cat. Washington 1995, 122–23.

8.

See the author's "Winslow Homer and the Deflection of Narrative," *Antiques* 148 (November 1995), 652–661.

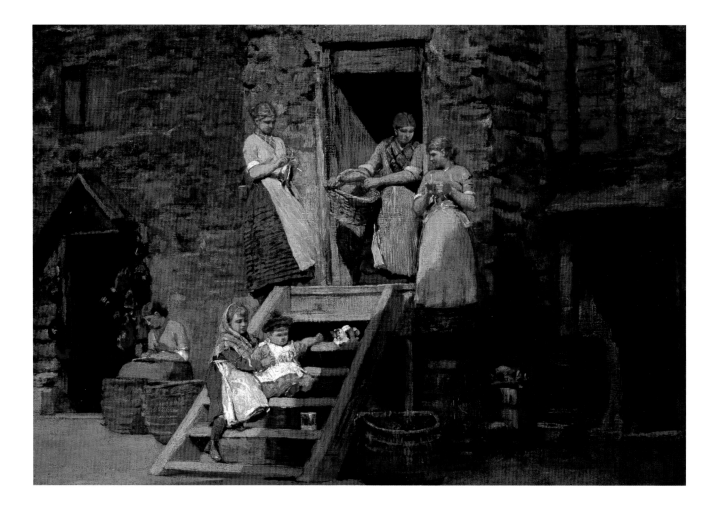

# 18

## Sparrow Hall[1]

Winslow Homer | 1836–1910
c. 1881–1882, oil on canvas, 39.4 x 56.5
(15 1/2 x 22 1/4)

On 15 March 1881 Winslow Homer sailed from New York on the Cunard Liner *Parthia*, bound for Liverpool,[2] and after his arrival there later that month traveled on to London. We do not know precisely when he left London, but by August he was settled in the village of Cullercoats on the North Sea, just below the Scottish border. Located two miles from the larger and better-known city of Tynemouth, Cullercoats' economy had long been based on fishing. Although it was increasingly popular as a daytrip destination from Newcastle, the famous coal port, Cullercoats retained the character of a small village with a tightly knit community. Situated on sandstone cliffs above a small bay, bounded to the south by Tynemouth North Point and to the north by Brown's Point, Cullercoats boasted a secure harbor with a substantial breakwater. The town's structures consisted mainly of stone houses, shops, fishermen's cottages, and the Life Brigade House overlooking the harbor. Homer was said to have settled in "a little house surrounded by a high wall, with one gate, to which he had the key, so that he was safe from intrusion," and also to have rented a studio that offered a fine view over the harbor and out to sea.[3] So far as we know, Homer remained in Cullercoats until he was ready to leave for home. He sailed on 11 November 1882, onboard the *Catalonia* bound from Liverpool to New York.

Virtually every writer who has had anything to say about Homer since 1882 has regarded the trip to England as a critical turning point in his career, one demarcating his early years, with all their promise, from his mature career, when he would bring his art to a new level of intensity and purpose. Why Homer went to Cullercoats and what his reasons were for doing so remains uncertain. It is also not known whether his style changed because of his experiences there, or because he had already determined to reformulate his art and was seeking out a place where he could achieve those changes most effectively and fully.

The works Homer created while in Cullercoats were primarily watercolors and drawings, and they are evidence that he "did not seem to care much about taking for his models the menfolk of the village, but chose rather to give an immortality to the faces and forms of the daughters of the men…who were truly toilers of the deep."[4] After the men sailed in the early evening to fish, the women were left to their responsibilities: keeping house, tending children and other members of the family, repairing nets, gathering bait, and cleaning fish from the previous day's catch. No time of year offered any respite, for the fishermen varied their catch as the seasons changed and were out at virtually every possible moment. In calm and storm, warm weather and bitter cold, these women were expected to provide support essential to the livelihoods of their husbands, brothers, and fathers. Homer's Cullercoats women have often been described as "heroic," and although he may have idealized them somewhat in his art, the stern facts of their lives clearly instilled in them great strength and courage.

The name of the village is said to derive from *Culfre-cots*, the Anglo-Saxon words meaning "dove" and "houses," perhaps because a family named "Dove" had settled in the area as early as 1539.[5] In the late seventeenth century Thomas Dove Jr. built a house that became known as "Dove Cottage" (fig. 1). By the nineteenth century local usage had renamed it "Sparrow Hall," probably because the sign identifying the house had a carved representation of a bird that looked more like a sparrow than a dove.

*Sparrow Hall* is one of the few oil paintings Homer possibly completed during his stay abroad. As has been observed: "The painting depicts the south side of [Dove Cottage] with fishwives and children outside the central and west wing of the building…. The people depicted in the painting are members of

fig. 1
Winslow Homer, *Sparrow Hall,*
*Cullercoats,* photograph,
c. 1870s, Newcastle upon Tyne
City Libraries

fig. 2
Winslow Homer, *Mending the*
*Nets,* 1882, watercolor and
gouache over graphite, National
Gallery of Art, Washington,
Bequest of Julia B. Engel

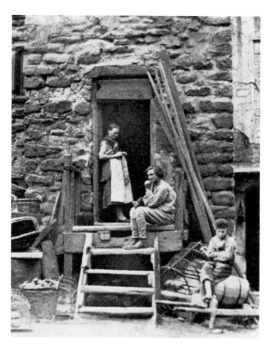

the Bruton and Simpson families…the ancestors of Cud Simpson, who was one of the last residents of Dove Cottage prior to its demolition…."[6] As William H. Gerdts has noted, *Sparrow Hall* is "a rare one for Homer, containing no vestige or even suggestion of the presence of the sea, and the relaxed fisherwomen suggest a more traditional approach to genre than found in most of Homer's English work."[7] Although Homer was indeed most interested in the busy activities of the shore, with the boats coming and going and the women hauling baskets of fish back to town, he did turn his attention to other aspects of Cullercoats life. In the watercolor *Mending the Nets* (fig. 2), for example, we see women engaged in one of the tasks that consumed much of their time. In *Sparrow Hall* two women knitting or darning stand by an entrance to the cottage, apparently enjoying the sunshine. Another woman carrying a wicker basket emerges from the shadows of the interior. On the steps below, a girl protectively steadies a much younger child who dangles a bit of blue yarn in front of a calico cat on the step above (another calico is perched atop a crate at the lower left). At the far left another woman, also by a doorway, sits quietly working with her hands. The various baskets, barrels, crates, and floats scattered about the scene are reminders of these women's livelihoods.

In *Sparrow Hall* Homer endowed the women with a sense of calm dignity and grace, indicating his admiration for them. In a time when fashion favored a slender figure, these women represented a more natural kind of beauty. As Charles Reade wrote in his novel *Christie Johnstone*:

Nature, when she is in earnest, builds beauty on the ideas of ancient sculptors and poets, not of modern poetasters, who with their airy-like sylphs and their smoke-like verses, fight for want of flesh in woman and want of fact in poetry as parallel beauties.

These women had a grand corporeal traet [sic]; they had never known a corset! so they were straight as javelins; they could lift their hands above their heads!–actually! Their supple persons moved as Nature intended; every gesture was ease, grace, and freedom.

What with their own radiance, and the snowy cleanliness of their costume, they came like meteors….[8]

To find such women and make them the subject of his art may have been Homer's "object in crossing the Atlantic."[9] Whatever the case, they were of constant inspiration to him during the year and a half he remained in Cullercoats and led to some of his most lyrically beautiful works. *Sparrow Hall*, wonderfully conceived, richly colored, and superbly painted, stands very high among those works, and indeed among Homer's images from any period. | FK

1.
The painting has been known by several titles over the years, including *On the Steps, Tynemouth,* and *Fisherfolk, Tynemouth.* During Homer's lifetime it was exhibited several times as *Sparrow Hall.*

2.
See Franklin Kelly, "A Process of Change," in exh. cat. Washington 1995, 171–193, from which this entry draws extensively.

3.
William Howe Downes, *The Life and Works of Winslow Homer* (Boston and New York, 1911), 99.

4.
A.B. Adamson, "The Homer That I Knew," in Tony Knipe and John Boon et al., *All the Cullercoats Pictures* [exh. cat., Northern Centre for Contemporary Art] (Sunderland, England, 1988), 17.

5.
See exh. cat. Sunderland 1988, 12. The information about Dove Cottage is based on the research of Knipe and Boon.

6.
Exh. cat. Sunderland 1988, 75.

7.
"Winslow Homer in Cullercoats," *Yale University Art Gallery Art Bulletin* (Spring 1977), 27.

8.
Charles Reade, *Christie Johnstone* (London, 1882), 25–26; see also Kelly in exh. cat. Washington 1995, 176–178.

9.
Adamson in exh. cat. Sunderland 1988, 16.

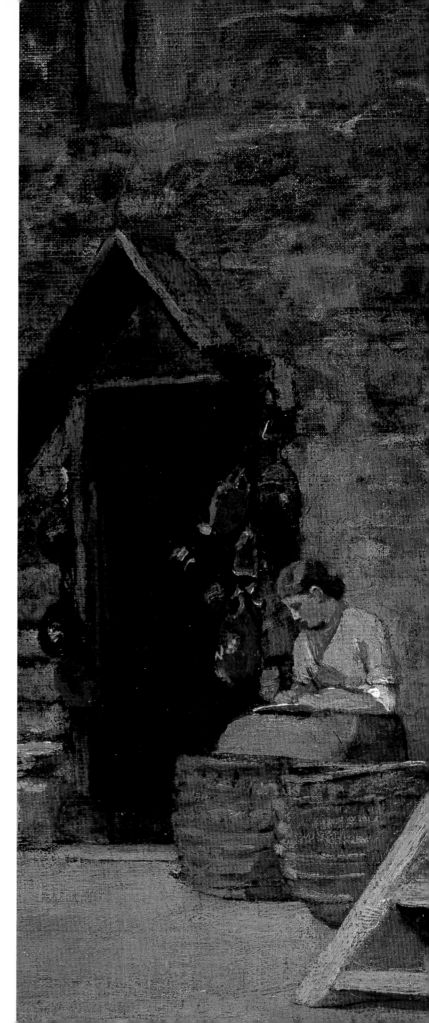

cat. 18 (detail)

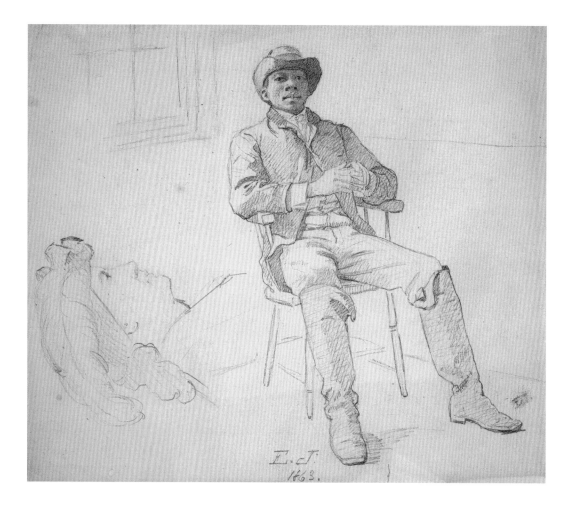

# 19

## Seated Man

Eastman Johnson | 1824–1906
1863, pencil on paper, 21.9 x 25.4 (8⅝ x 10)

Eastman Johnson, often described as one of America's most accomplished genre painters, began his career as a "crayon-limner"—a portraitist.[1] In 1846, while still a very young man, Johnson capitalized on his father's political connections and succeeded in securing studio space in the Capitol building in Washington, D.C. While in the nation's capital, Johnson created a number of crayon portraits of

high-ranking officials and, surprisingly, of such luminaries as Dolley Madison and John Quincy Adams. Shortly after leaving Washington, he completed a portrait drawing of Henry Wadsworth Longfellow. The poet was so pleased with the result that he asked his friends Ralph Waldo Emerson and Nathaniel Hawthorne to sit for the young artist as well.

Bolstered by such early success yet eager for additional training, Johnson set sail for Düsseldorf and its famous art academy in the fall of 1849. According to a contemporary, Johnson enrolled in the academy's mandatory drawing classes, but his skills as a draftsman were so advanced he was soon notified that "in his case the customary two years in drawing would be dispensed with."[2] He was reportedly allowed to "enter the painting classes at once."[3]

Before long Johnson began working in the studio of Emanuel Leutze, leader of the American contingent residing in Düsseldorf. At the time, Leutze was completing his famous painting, *Washington Crossing the Delaware*, 1851 (The Metropolitan Museum of Art, New York). Johnson was charged with making a smaller copy for use in the production of an engraving—an assignment that sharpened his skills both as a draftsman and as a painter.[4]

When Leutze returned to the United States in 1851, Johnson also left Düsseldorf but extended his European stay, settling in The Hague. Captivated by Rembrandt and the Dutch genre painters, Johnson remained an unexpected four years. It was during his residence in the Netherlands that he completed what may have been his first painting with an African-American subject. The work, *Uncle Tom and Evangeline*, 1853 (location unknown), was based on Harriet Beecher Stowe's novel *Uncle Tom's Cabin*, which had first appeared serially two years earlier in the abolitionist newspaper *National Era*. When published in book form in 1852, the novel sold more than 300,000 copies in twelve months. Quickly translated and widely distributed, it also enjoyed great popularity abroad. As a young and aspiring artist, Johnson may

have recognized a subject with considerable public appeal, but his interest in African Americans was genuine. For more than a decade following his return to America in 1855, Johnson continued to produce images that touched on the most hotly debated issue of the day—the abolition of slavery.

In 1857 Johnson visited Mount Vernon, George Washington's home on the Potomac River. Following his visit he completed several paintings of the house and grounds as well as three nearly identical paintings of the kitchen.[5] Each of these interior views included a slave family. As the debate over slavery became more heated, Johnson continued to paint African-American subjects. In 1859, he exhibited *Negro Life at the South*, perhaps his best-known work, at the annual exhibition of the National Academy of Design in New York. Though contemporary and modern interpretations of the painting vary significantly, there is no doubt that the work thrust Johnson to the forefront of those willing to address African-American subjects on the eve of the Civil War.[6] In the spring of 1860, just months before the opening shots were fired, Johnson contributed five works to the National Academy exhibition—three were paintings with slave subjects.[7]

For Johnson, the political issues of the day became personal when war was declared in April 1861 and the artist's brother, Reuben, joined the Union Army. After witnessing the battle of Bull Run near Washington, Reuben described what he had seen in a long letter to his brother. According to John I. H. Baur, Johnson's first modern biographer, the artist traveled to the front lines within months and was at Antietam in September of 1862. He was reportedly in Maryland shortly after the battle of Gettysburg in July 1863. Sometime during this critical year, Johnson completed the drawing of a young African American titled *Seated Man*.

Skillfully drawn and expertly shaded, the figure shares the page with a brief outline of a window casement and a sketch of a woman wearing a feathered hat and a snood (hairnet). Seated in what may be a captain's chair, the young man engages the viewer directly. His boots, jacket, and high-buttoned shirt suggest a livery costume. It is possible that the

fig. 1
Eastman Johnson, *Sunday Morning*, 1863, oil on academy board, Mead Art Museum, Amherst College, Gift of Herbert W. Plimpton, The Hollis W. Plimpton (Class of 1915) Memorial Collection

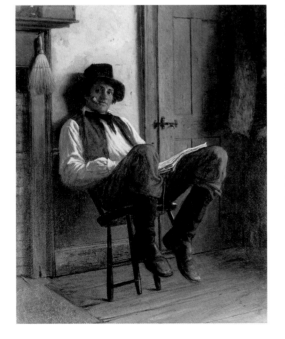

youth (likely a freedman) was employed to assist with military horses, coaches, or wagons.[8]

Although drawn with great care, as if intended to serve as a preparatory sketch for a studio painting, no larger work incorporating this figure has been identified. The sketch may be related, however, to a painting titled *Sunday Morning* (fig. 1), also completed in 1863. The seated figure in this work, though not an African American, assumes a similar pose. The facial features in the drawing are more precise and clearly convey the self-possession of Johnson's subject. | NA

1.
The most comprehensive study of Johnson's life and work, *Eastman Johnson: Painting America*, by Teresa A. Carbone and Patricia Hills, was published in conjunction with a retrospective exhibition of Johnson's work organized by the Brooklyn Museum of Art in 1999. The first modern study of the artist, *An American Genre Painter: Eastman Johnson, 1824–1906* (1940), by John I.H. Baur, was also published by the Brooklyn Museum of Art. We thank Teresa A. Carbone for assistance with this entry.

2.
William Walton, "Eastman Johnson, Painter," *Scribner's Magazine* 40 (September 1906), 266.

3.
Walton, "Eastman Johnson," 266.

4.
Johnson's copy of Leutze's painting is now in the Manoogian Collection, Taylor, Michigan.

5.
The three versions of the kitchen view are now in the collections of the Cummer Museum of Art and Gardens, Jacksonville, Florida; the Mount Vernon Ladies' Association, Mount Vernon, Virginia; and Frank and Cathy Hevrdejs, Houston, Texas.

6.
See in particular John Davis, "Eastman Johnson's *Negro Life at the South* and Urban Slavery in Washington, D.C.," *Art Bulletin* 80 (March 1998), 67–92, and Patricia Hills, "Painting Race: Eastman Johnson's Pictures of Slaves, Ex-Slaves, and Freedmen," in Carbone and Hills 1999, 120–165.

7.
The three works were *Kitchen at Mount Vernon* (private collection), *Mating* (location unknown), and *The Freedom Ring* (Hallmark Fine Art Collection). All are illustrated in Carbone and Hills 1999.

8.
Several drawings by Winslow Homer of African-American men in Union army camps near Washington are in the collection of the National Gallery of Art.

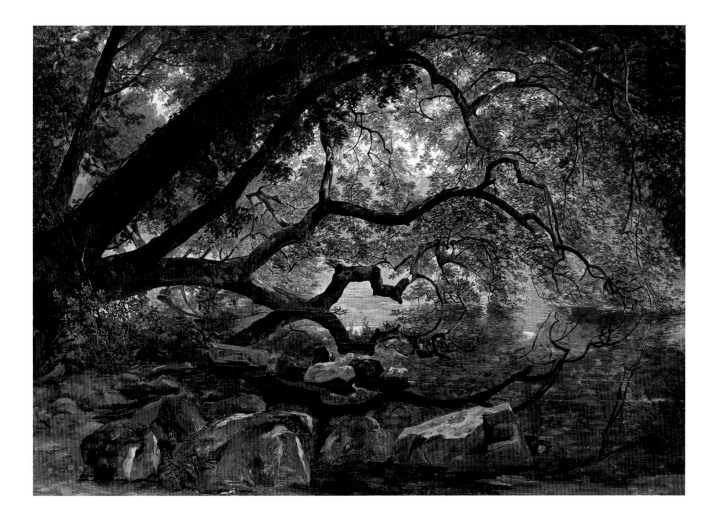

## 20

### An Ilex Tree on Lake Albano, Italy[1]

John Frederick Kensett | 1816–1872
1846, oil on canvas, 44.5 x 63.5 (17 1/2 x 25)

Shortly after his arrival in England in late June 1840 John Kensett exclaimed: "Could I have believed that hardly three weeks should elapse between the period of my treading soil in my native land and that of my forefathers—it seems even now but a dream."[2] Like his traveling companions Asher Durand, John Casilear, and Thomas Rossiter, as well as the many other American artists such as John Singleton Copley, Washington Allston, and Thomas Cole who had made the Atlantic crossing before him, Kensett left the United States in order to see the fabled cultural landscape of Europe and to further his education as a painter. Over the next seven years he traveled widely, settling alternately in London, Paris, and Rome.

From August 1840 to June 1843 Kensett resided in Paris and immersed himself in the city's artistic life. In addition to studying the collections at the Louvre and drawing from antique casts and life at the École Préparation des Beaux-Arts, he met the elder American artist and resident of Paris, John Vanderlyn, as well as Cole himself, who stopped in the city during his second journey to Italy. Struggling to make ends meet and leading something of a bohemian

existence, Kensett at this time often depended on money from his uncle and loans from friends to pay his expenses. He also reluctantly relied on income from engraving jobs, a skill he had mastered in America but from which he was now trying to distance himself. His friend, the painter Benjamin Champney, recalled: "Kensett was at heart a painter, and it was hard for him to stick to his burin when he saw me busy at painting, and before many months he had thrown down his engraving tools, and taken to brushes and paint."[3] As Kensett had hoped, by the end of his European sojourn, though still dependent on engraving to some degree, he viewed himself as a painter who engraved rather than an engraver who painted.

While in Paris the artist had tried unsuccessfully to raise money for a trip to Rome. His plans were further delayed when his grandmother died in England in 1843 and he had to return to London to help settle a legal dispute about the estate. As the proceedings continued for two years, Kensett wrote in February 1844 to Rossiter in Italy: "The mind unsettled and in a state of constant suspense. I hope however ere long to be relieved from this thralldom of uncertainty."[4] Finally in the summer of 1845 Kensett left London, returned briefly to Paris, then traveled through Germany and Switzerland, and at last arrived in Rome that October only to be stricken with rheumatic fever. His friend Thomas Hicks helped nurse him back to health, and Hicks and Kensett found a studio near the well-established community of American artists who lived and socialized in the area around the Spanish Steps. In the spring of 1846 Champney wrote to Kensett to commiserate about his illness: "Accept my sympathy for your misfortune in being ill during so long a period. For to say nothing of the suffering you went through with the fact of your having been so long debarred the privilege of using your palette and brushes at a moment when you felt that much depended upon hard work and study was enough to render your situation anything but agreeable."[5]

Once he had fully recovered, Kensett set to work in earnest. Like most of the American landscapists he was not interested in depicting Rome's urban monuments. On 1 June 1846 he embarked instead on a traditional summer sketching tour of many of the famous sites south and west of the city.[6] Kensett's itinerary included Albano, Ariccia, Gensano, Lake Nemi, Velletri, Olevano, Subiaco, Civitella, and Tivoli. He later noted, "I commenced my studies from nature without delay and up to the 15th of Aug. had the most delightful weather so far as light and cloudless skies went, but the heat was of the most oppressive character."[7] That fall he returned to his studio with "some thirty odd studies in oil, some quite large, all made with care and attention to nature."[8]

Some of Kensett's studies were undoubtedly used to develop the large Italian landscapes that he presented in New York at the National Academy of Design and the American Art-Union and that helped establish his reputation in America. These exhibition works, such as *The Shrine—A Scene in Italy*, 1847 (private collection), were in the venerable style of Claude and featured distant views framed by trees in the foreground, a stately progression from foreground to middle ground to background, with luminous effects of light achieved through glazing. It was a manner that Cole had mastered and that derived its appeal not only from its Claudian precedents but also from the romantic historical associations of Italy itself, symbolized by the many ruins and shrines nestled into views of the native landscape.

Never part of the production of a formal exhibition painting and never exhibited during the artist's lifetime, in *An Ilex Tree on Lake Albano, Italy,* Kensett abandons the standard Claudian formulas that usually dictated depictions of Lake Albano in favor of a more spontaneous, intimate, and personal approach to nature. It is in many ways the complete antithesis of the artist's public landscape style of the late 1840s. As a plein-air oil sketch or finished sketch, the work is instead closely related to traditions of open-air painting in the Roman countryside that had begun around 1780 and culminated in the late 1820s, with the work of Jean-Baptiste-Camille Corot and the Barbizon School, and in the paintings of ancillary figures to Corot such as the academician André Giroux (fig. 1).[9] It is a particularly early example by an American of the kind of outdoor painting that would be widely practiced by other members of the Hudson River School who later visited Italy, such as

Sanford Gifford, Albert Bierstadt, Jasper Cropsey, and Frederic Church. The painting's emphasis on facts of nature rather than historical allusions also foreshadows the vogue for open-air, highly detailed Ruskinian studies of trees and rocks that would become prevalent in the United States in the mid-1850s. Later in the century, oil sketches gained in popularity when they were made more widely available at estate sales and memorial exhibitions such as the one organized for Kensett in 1873, where *An Ilex Tree on Albano, Italy* was shown publicly for the first time.

More than its relation to works that preceded or followed it, the singular design of *An Ilex Tree on Albano, Italy* speaks to something more personal and serendipitous. One can imagine Kensett searching for a cool, shaded space on the shore of Lake Albano to escape the "oppressive" heat, delighted to discover this private sanctuary that was shielded and hidden away from the sun-filled vistas just beyond the veil of the overhanging branches. In such a quiet, peaceful setting, his mind and eye could commune directly with nature. The picture focuses on a small center of

still open, sunlit water on the lake and then radiates out, tree branches and their reflections forming a series of ovals within ovals. With its ocular center and elliptical shapes, the oil study reflects Kensett's views on genius and the sanctity of nature: "It is a beautiful characteristic of genius, that whatsoever receives its touch is gifted with its immortality. It is by mixing up intellectual and spiritual associations with things, and only so that they have any importance to our minds. Things are nothing but what the mind constitutes them. Nothing, but by an infusion into them of the intellectual principle of our nature tis thus this humble habitation becomes a shrine… and thus the most indifferent, and of itself undervalued thing—be it but a fragment of a rock…a decayed branch, or a simple log."[10]

Making a shrine of nature itself was a characteristically American approach to landscape painting and does much to explain why Durand's national identity was not compromised during his seven years in Europe. The decision to go abroad had been extremely problematic for American artists of Kensett's generation and the ways it could blight native

fig. 1
André Giroux, *Forest Interior with a Painter, Civita Castellana*, 1825/1830, oil on paper, National Gallery of Art, Washington, Gift of John Jay Ide in memory of Mr. and Mrs. William Henry Donner

sensibilities exhaustively catalogued by commentators from Bryant to Hawthorne. Kensett, however, seems to have been relatively unaffected by these debates. He returned to America in 1848 with his skills as a painter greatly enhanced. Later writing for Henry Tuckerman's *Book of the Artists* in 1867, he observed simply about his European sojourn, "My real life commenced there."[11] | CB

1.
This work was known previously only by descriptive generic titles such as *Tree and Lake* or *Tree Reaching out over a Lake,* and it was generally thought to be an American subject, perhaps Lake George. Extant installation photos of the Kensett memorial exhibition of 1873, however, show the painting tagged with a catalogue number. In conjunction with the corresponding title and dimension information in the catalogue itself, they have made it possible to determine the work's true title. It now seems certain that it is one of the large oil studies Kensett made during the summer of 1846 when he visited Lake Albano. Copies of the photograph album are owned by the Metropolitan Museum of Art Library and the Archives of American Art. (The image and the numbered tag on the painting can be made out more clearly in the version at the Archives of American Art.) Also see *The Collection of Paintings of the Late Mr. John F. Kensett* [exh. cat., National Academy of Design] (New York, 1873), 19, cat. 226.

2.
Kensett to John R. Kensett, 22 June 1840, as quoted in John Paul Driscoll and John K. Howat, *John Frederick Kensett: An American Master* [exh. cat., Worcester Art Museum] (New York, 1985), 21.

3.
Benjamin Champney, *Sixty Years' Memories of Art and Artists* (Woburn, Mass., 1900), 20, as quoted in exh. cat. New York 1985, 25.

4.
Kensett to Rossiter, 11 February 1844, as quoted in exh. cat. New York 1985, 30.

5.
Champney to Kensett, 30 May 1846, as quoted in exh. cat. New York 1985, 33.

6.
For the history of American artists in Italy see Theodore E. Stebbins Jr. et al., *The Lure of Italy: American Artists and the Italian Experience, 1760–1914* [exh. cat., Museum of Fine Arts, Boston] (New York, 1992).

7.
Kensett to Sarah D. Kellog, 1 October 1846, as quoted in exh. cat. New York 1985, 35.

8.
Kensett to Rossiter, undated, as quoted in exh. cat. New York 1985, 35.

9.
Kensett is known to have made plein-air sketches in America as early as 1848. For discussions of Kensett and outdoor oil sketching, see exh. cat. New York 1985, 82–83, 91, and Eleanor Jones Harvey, *The Painted Sketch: American Impressions from Nature, 1830–1880* [exh. cat., Dallas Museum of Art] (Dallas, 1998), 144–153. For the history of plein-air sketching in Rome also see Sarah Faunce, "Rome and Its Environs: Painters, Travelers, and Sites," in Philip Conisbee et al., *In the Light of Italy: Corot and Early Open-Air Painting* [exh. cat., National Gallery of Art] (Washington, 1996).

10.
Kensett to John R. Kensett, 27 February 1841, as quoted in exh. cat. New York 1985, 25.

11.
Tuckerman 1876, 510.

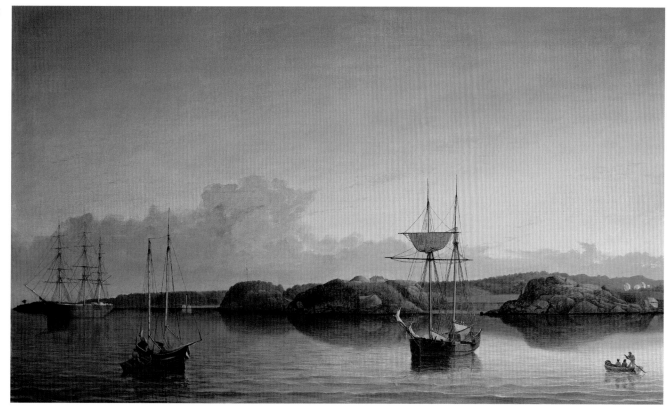

## 21

### Stage Rocks and Western Shore of Gloucester Outer Harbor

Fitz Hugh Lane | 1804–1865
1857, oil on canvas, 62.2 x 99.4 (24 ½ x 39 ⅛)

## 22

### Brace's Rock, Eastern Point, Gloucester

Fitz Hugh Lane | 1804–1865
c. 1864, oil on canvas, 25.4 x 38.1 (10 x 15)

Fitz Hugh Lane was born Nathaniel Rogers Lane in the fishing port of Gloucester, Massachusetts, on 18 December 1804; his family subsequently changed his first and middle names.[1] Paralyzed as a child, probably by infantile polio, Lane was obliged to use crutches. He learned the rudiments of drawing and sketching while in his teens and in 1832 worked briefly with a lithographic firm in Gloucester. Later that year he moved to Boston for formal training and an apprenticeship with William S. Pendleton, owner of the city's most important lithographic firm. Lane remained with Pendleton until 1837, producing illustrations for sheet music and scenic views.

While in Boston, Lane became acquainted with the work of English-born artist Robert Salmon (1775–c. 1845), who was the most accomplished marine painter in the area. Salmon's paintings, with their meticulously detailed ships and crisply rendered effects of light and atmosphere, had a decisive influence on Lane's early style. By 1840 Lane had produced his first oils; two years later he was listed in a

fig. 1
Fitz Hugh Lane, *Gloucester Harbor at Sunset,* late 1850s, oil on canvas, private collection

fig. 2
Fitz Hugh Lane, *Stage Rocks and Western Shore of Gloucester Outer Harbor*, 1857, oil on canvas, Cape Ann Historical Association, Gloucester, Massachusetts

Boston almanac as a "Marine Painter." In 1848 he moved permanently back to Gloucester, and with his sister and brother-in-law constructed an impressive granite house overlooking the harbor. Although Lane regularly exhibited his paintings in New York, Boston, and elsewhere, his reputation was primarily local. As Clarence Cook observed in 1854, "Mr. F. H. Lane, whose name ought to be known from Maine to Georgia as the best marine painter in the country …is as well known as he ought to be."[2]

Lane was inconsistent in dating his paintings, which makes it difficult accurately to establish a stylistic evolution. Nevertheless, it is clear that in the early to mid-1850s his art reached a new level of maturity. In an important series of Boston harbor, presumably dating from the mid-1850s, Lane perfected a style characterized by carefully balanced, calmly ordered compositions and radiant effects of light.[3] His style continued to evolve as the decade wore on, leading to an aesthetic that favored reductive, distilled compositions with fewer elements and a mood of quiet stillness. These qualities are evident

in his best Gloucester works of the period, such as *Gloucester Harbor at Sunset* (fig. 1) and *Stage Rocks and Western Shore of Gloucester Outer Harbor* (cat. 21).

"The area around Gloucester," as John Wilmerding has observed, "is a lovely one, with its smooth curving beaches and striking promontories. At low tide the large dark rocks stand out boldly, frequently complemented by their reflected silhouettes on the water."[4] *Stage Rocks and Western Shore of Gloucester Outer Harbor* and a smaller, related painting (fig. 2) were based on drawings Lane made from the center of the town's harbor, apparently aboard a vessel loaded with lumber.[5] The area depicted had historical meaning, for it was said to have been the place where the great seventeenth-century explorer Samuel de Champlain had landed.[6] Lane described the genesis of the large painting in a letter to his friend Joseph Stevens: "I yesterday made a sketch of Stage Fort and the surounding [sic] scenery, from the water. Piper has given me an order for a picture from this point of view, to be treated as a sunset. I shall try to make something out of it, but it will require some management, as there is no foreground but water and vessels. One o'clock, it is very hot, the glass indicates 84° in my room, with the windows open and a light breeze from the east. This is the warmest day."[7]

Lane "managed" the painting beautifully, animating the foreground expanse of water with various large and small vessels arranged in a zigzag pattern that is mirrored by the contours of the shore.[8] As Wilmerding has written, Lane's

foremost concern here was with the light and the time of day: With masterful control of color, Lane moves from the intense yellows and oranges of the setting sun at the right across through increasingly darker shades of grayish pinks in the central clouds to a touch of purple on the distant horizon at the left. At the top of the canvas a deep blue fades gradually into the paler colors at the horizon, while the water surface is a myriad of small touches of pure pinks, yellows, greens, and blues laid side by side in an almost impressionistic technique.[9]

One can admire Lane's handling of paint in this way in large part because of the superb preservation of the canvas. Unlined and with its surface in virtually

22

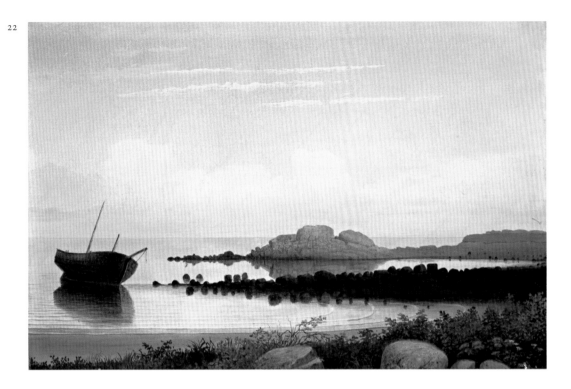

fig. 3
Fitz Hugh Lane, *Brace's Cove, Eastern Point*, 1863, pencil on paper, Cape Ann Historical Association, Gloucester, Massachusetts

fig. 4
Fitz Hugh Lane, *Brace's Rock*, 1863, pencil on paper, Cape Ann Historical Association, Gloucester, Massachusetts

pristine condition, *Stage Rocks and Western Shore of Gloucester Outer Harbor* may be fairly ranked one of Lane's greatest performances.

The coast around Cape Ann is punctuated by numerous ledges and rocky outcroppings that are serious obstacles for mariners. Lane painted many of these sites, including Norman's Woe, which was famous as the setting in Henry Wadsworth Longfellow's poem, "The Wreck of the Hesperus." Lane's last dated works were a series of small oils of Brace's Rock, at the end of a ledge forming one side of Brace's Cove. The name is believed to have come from the middle English and old French word for arm; now obsolete, in nautical terms it meant an arm of the sea, or cove.[10] The cove was frequently mistaken for the entrance to Gloucester's harbor, which actually lies a mile further on, and shipwrecks there were common. In August 1863 Lane made two drawings of the point, one looking toward the east (fig. 3) and the other from the opposite side looking to the west (fig. 4). Lane's executor, Joseph Stevens, recorded on the former drawing the names of five people who had received paintings based on it. Four such

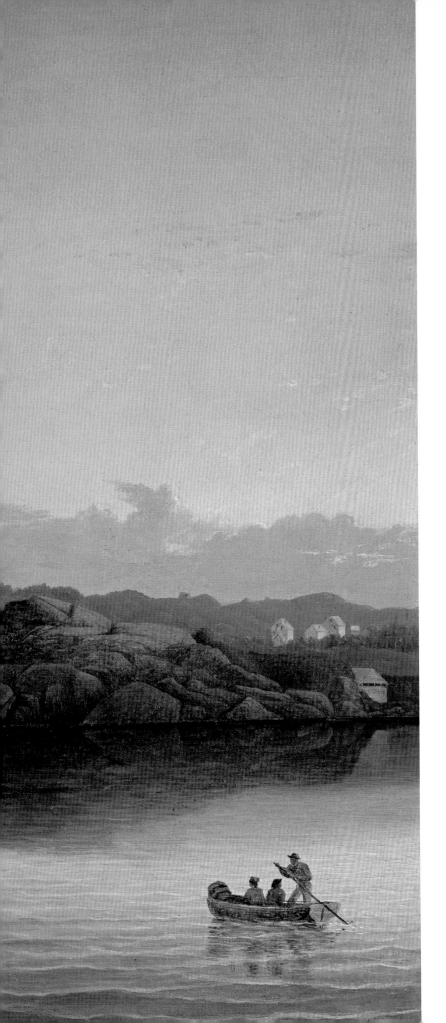

oils are known today, although one (1864, private collection) is a small sketch and may not have been among those Stevens listed. The three others are all approximately 10 by 15 inches in size; two (fig. 5 and private collection) are dated 1864, presumably the year *Brace's Rock* was painted.

Although the order in which they were painted is not known, the three finished oils of Brace's Rock are variations on a theme. Each shows the still scene bathed in the light of late afternoon, which illuminates the bright colors of the rocks, plants, and water. Yet there are subtle differences between them, too. The most significant of these are the design, condition, and position of the grounded vessels at the left side of the composition. In two of the oils the boats face out to sea, one leaning to the right, the other to the left; only in *Brace's Rock* is the boat shown heeled over to the right with its bow facing shore. As Wilmerding has noted, this arrangement creates a visual rhythm that directs the viewer's eye back to the central motif of the rock, giving the canvas a sense of self-contained order.[11] It is as if this lonely place exists completely and perfectly on its own.

The feeling of emptiness and quiet, the lengthening shadows of afternoon, and the presence of the abandoned boats in Lane's paintings of Brace's Rock give these works a poignancy unsurpassed in his oeuvre.[12] By the time they were painted, Lane was already in failing health, and the effects of polio had aged him beyond his years. The nation was at war, with some of the bloodiest battles of our history being fought at places like Chancellorsville and Cold Harbor, both in Virginia. Did these paintings reflect the events of the time in which they were created, and was their sense of loneliness and finality the artist's response to those events and an indication that he was all too aware of his own mortality? Perhaps only hindsight suggests such a reading. Like Longfellow contemplating a fire made of driftwood from wrecked ships, those who saw Lane's paintings perhaps would have been reminded, "Of what we once had thought and said, / Of what had been, and what might have been, / And who was changed and who was dead."[13] Or, like John Ruskin, they may

cat. 21 (detail)

fig. 5
Fitz Hugh Lane, *Brace's Rock*,
1864, oil on canvas, Harold Bell

have found a ruined boat a "noble" subject leading to associations of the transience of human achievements, because "man's work has therein been subdued by Nature's."[14] We know that Lane had a vivid dream about a wrecked ship because he left us a written account of the experience as well as a painting of what he dreamed—he admitted he could only "give to the beholder some faint idea of the ideal."[15] Surely the memory of that dream, with its "gorgeous and brilliant coloring," must have played some part in the creation of the Brace's Rock pictures, for they too have the haunting quality of a beautiful vision. | FK

1.
The standard source on Lane is Wilmerding 1971.

2.
Cook (1828–1900) visited Lane at his home in Gloucester that year. Although he had not yet risen to the prominence as a critic he enjoyed in the 1860s and 1870s, Cook was already a highly perceptive writer about American art and artists as the author of a column in the *Independent*, a New York City weekly newspaper. Cook devoted his column for 7 September 1854 to a discussion of Lane and his paintings. See William H. Gerdts, "'The Sea Is His Home': Clarence Cook Visits Fitz Hugh Lane," *American Art Journal* 17 (Summer 1985), 44–49.

3.
For example, *Boston Harbor, Sunset*, c. 1850–1855 (Collection of Jo Ann and Julian Ganz Jr.). For a discussion of these works, see Earl A. Powell III, "The Boston Harbor Pictures," in exh. cat. Washington 1988, 47–59.

4.
Wilmerding 1971, 37.

5.
Wilmerding 1971, 71. The drawings are reproduced in *Paintings and Drawings by Fitz Hugh Lane Preserved in the Collections of the Cape Ann Historical Association* (Gloucester, Mass., 1974), nos. 17, 18.

6.
Wilmerding 1971, 72. Lane knew the history of the area and had apparently been commissioned to create a history painting of Champlain's landing.

7.
Fragmentary letter in the collection of the Cape Ann Historical Association; quoted in Wilmerding 1971, 71. John J. Piper knew Lane and owned several of his works.

8.
Wilmerding 1971, 71.

9.
Wilmerding 1971, 72.

10.
Joseph E. Garland, *Eastern Point: A Nautical, Rustical, and Social Chronicle of Gloucester's Outer Shield and Inner Sanctum, 1601–1950* (Peterborough, N.H., 1971), 10.

11.
Wilmerding 1971, 88.

12.
This discussion draws on the author's "The Paintings of Fitz Hugh Lane," *Antiques* 134 (July 1988), 116–127.

13.
"The Fire of Driftwood" (1849, 1850), in *Norton Anthology of Poetry* (New York, 1970), 711–12.

14.
"On Boats," *The Crayon* 3 (November 1856), 335.

15.
From an 1862 letter; quoted in Wilmerding 1971, 80. The painting is in the collection of the Terra Museum of American Art, Chicago.

# 23

## Mount Desert Island, Maine

Jervis McEntee | 1828 – 1891

1864, oil on canvas, 26.7 x 40 (10 1/2 x 15 3/4)

Jervis McEntee first studied landscape painting with Frederic Church in New York from 1850 to 1851.[1] In 1857 McEntee rented rooms at the Tenth Street Studio Building, where he worked alongside prominent landscape painters of the Hudson River School such as Church, Sanford R. Gifford, and Worthington Whittredge. Elected a full academician by the National Academy of Design in 1861, he exhibited his work there regularly, and it was also included in major shows such as the Paris Universal Exposition in 1867 and the Centennial Exposition in Philadelphia in 1876. In 1868 McEntee toured Europe with Gifford and, while in Rome, collaborated with Church and George Alexander Healy on the *The Arch of Titus*, 1871 (The Newark Museum), a six-foot-high canvas that features the three artists posed near the base of the monument. A modest, self-effacing, and somewhat melancholy man, McEntee's moods often found expression in his landscapes, which, though admired by fellow artists and critics, were generally more subdued, intimate, and pessimistic, and hence less popular, than those of his Hudson River School colleagues.

The only primary evidence relating directly to McEntee and Gifford's initial 1864 trip to Maine is an expense account and other annotations found in Gifford's sketchbooks.[2] The two artists apparently met in Boston and, accompanied by McEntee's wife and Gifford's sister, they continued on to Maine, spending three weeks on Mount Desert Island, from 14 July to 5 August. There McEntee and Gifford sketched at Bar Harbor, Eagle Lake, the Southwest and the Northeast Harbors at the entrance to Somes Sound, and Green (Cadillac) Mountain. They also visited Katahdin, Bangor, and Portland before moving on to North Freyburg, where they apparently parted company.

McEntee and Gifford were particularly close and often went on sketching expeditions together. Although there are no letters pertaining specifically to their 1864 excursion to Maine, their enduring interest in the state's mountain scenery is verified by correspondence from later trips. In August 1878, for instance, Gifford proposed "to make the entire circuit of the flanks of Ktaadn ending at Lake Ktaadn. We shall see many lakes and grand mountain and valley views—the whole is a novel trip."[3] Afterward Gifford reminisced to McEntee: "I cannot tell you how much I enjoyed your companionship in the Maine woods and I am happy in believing that you enjoyed the wild beauty of the lovely lakes and mountains we visited."[4]

The artists' decision to travel to Maine in 1864 has been explained in the case of McEntee as a response to the Maine landscapes of his former teacher Church, and in the case of Gifford as an attempt to recuperate from his service at the front and the death of his brother Edward in the Civil War in 1863.[5] Given the many precedents for Maine subjects in the works of prominent artists like Thomas Cole and Church, both men would have realized that the state offered a rich range of subjects for landscape painters. Also, the grievous effects of the Civil War were not limited to those in combat, and it seems reasonable that both artists would have welcomed a respite from horrors and deprivations such as those visited upon New Yorkers during the Draft riots the previous summer. In addition, McEntee and Gifford, as did all the Hudson River School artists, regularly made sketching expeditions in search of material for paintings. The journey would have appealed to them particularly because of its comforting associations with familiar antebellum habits and routines.

McEntee and Gifford's time in Maine resulted in two important and similar works: *Mount Desert Island, Maine* and *The Artist Sketching at Mount Desert, Maine* (fig. 1). McEntee's work is inscribed 17 July 1864 and Gifford's 22 July 1864. Both feature panoramic views from the summit of Cadillac Mountain on the eastern side of Mount Desert Island. As described by W. B. Lapham in his 1886

fig. 1
Sanford R. Gifford, *The Artist Sketching in Mount Desert, Maine,* 1864–1865, oil on canvas, Jo Ann and Julian Ganz Jr.

guidebook, the vistas were "grand—almost overwhelming. Here one gets a bird's eye view of more than three-fourths of the entire island, including its harbors, bays, coves, sounds, lakes, ponds, mountains, forest, farms and villages; also of several towns on the mainland, numerous islands along the coast line, and a broad expanse of ocean…the two grandest objects in nature, high mountains and a boundless ocean, here occupy the same horizon, and no earthly view can be more absorbing."[6] In addition to having been painted around the same time and featuring similar formats and views, both works show seated figures with hats, long-sleeved shirts, and pants, lounging on a rocky precipice with their legs stretched out to the left.

The differences between the two paintings are, however, perhaps more telling than their similarities. The horizon line in *Mount Desert Island* is hemmed in by outcroppings of rock on the left and right, with the view of the ocean reduced to a small triangular area. The tones are subdued and uniform, and the stones are illuminated by sunlight in the foreground that is comparable to the coloration of the sky. The sunlit, sloping form of the foreground, overlapping and juxtaposed to the dark, sloping mountain form of the middle ground, draws the eye downward and

focuses attention on the contours of the terrain. The only sign of life in the picture is the lounging figure.[7] In contrast, the horizon in Gifford's painting extends without interruption all the way across the canvas to the left. Gifford's palette is warm and bright, the pale blues of the sky and the rich, glowing earth tones of the rocks and trees enlivened by the sparkling white touches on the umbrella, sketch pad, and small boats. The figure of the artist seated on the precipice in the right foreground invites us to share the expansive, breathtaking view that lies before him. Otter Cove and the surrounding coastline are filled with boats and bustling with activity.

In sum, *The Artist Sketching at Mount Desert, Maine,* is an optimistic, convivial, celebratory painting, filled with naturalistic effects of light and atmosphere. It shows an artist and adventurer actively taming nature, with his umbrella planted at the summit of Mount Cadillac like a flag of conquest. *Mount Desert Island, Maine* is a more suggestive, psychologically expressive scene. Its lone, inactive figure seems stranded and stares out to sea as though wistfully longing for rescue and escape. Such imagery recalls the romantic poetry of William Cullen Bryant, whose poems often inspired McEntee and reflect the painter's stated ambitions: "In landscape, certainly,

you can tell a certain kind of story. The days and seasons in their gay or solemn beauty, in their swift departure, influence you, impress you, awaken emotions, convey teachings....I look upon a landscape as I look upon a human being—its thoughts, its feelings, its moods, are what interest me; and to these I try to give expression."[8]

It can be debated whether the essentially anonymous figure with its back turned to the viewer in these two works is Gifford or McEntee, but whatever the identification, the device was clearly inspired by the experience of one artist seeing the other alone at work in the landscape. Hence, it memorializes Gifford and McEntee's time together.

Such a scene must have been particularly striking in the relative isolation afforded the artists by working at the summit of Mount Cadillac in 1864. That year the four-member party stayed in a rustic one-room cabin built by the United States Coast Survey, well provisioned with food, bedding, kitchen utensils, tobacco, and five quarts of whiskey.[9] Inevitably, however, the spot became more and more accessible to tourists; by the 1880s, in the wake of the building of a railway to the summit, the once remote location was drawing thousands of visitors each summer. | CB

1.
For biography see Kevin Avery, "Jervis McEntee," in John A. Garraty and Mark C. Carnes, eds., *American National Biography* (New York, 1999), 15:33–35.

2.
See Ila Weiss, *Poetic Landscape: The Art and Experience of Sanford R. Gifford* (Newark, N.J., 1987), 100–101.

3.
Gifford to McEntee, 31 August 1878, Jervis McEntee Papers, Archives of American Art, reel D30, frame 405.

4.
Gifford to McEntee, 13 October 1878, Archives of American Art, reel D30, frames 408–409.

5.
See exh. cat. Rockland 1999, 101.

6.
W. B. Lapham, *Bar Harbor and Mount Desert Island* (New York, 1886), 36, quoted in exh. cat. Rockland 1999, 105.

7.
J. Gray Sweeney, "McEntee & Company," *McEntee & Company* (New York, 1998), 7, and exh. cat. Rockland 1999, 105, see a plume of smoke from a steamer on the horizon. This, however, appears instead to be a very slight abrasion of the painting surface.

8.
G. W. Sheldon, *American Painters* (New York, 1879), 52.

9.
See Weiss 1987, 100.

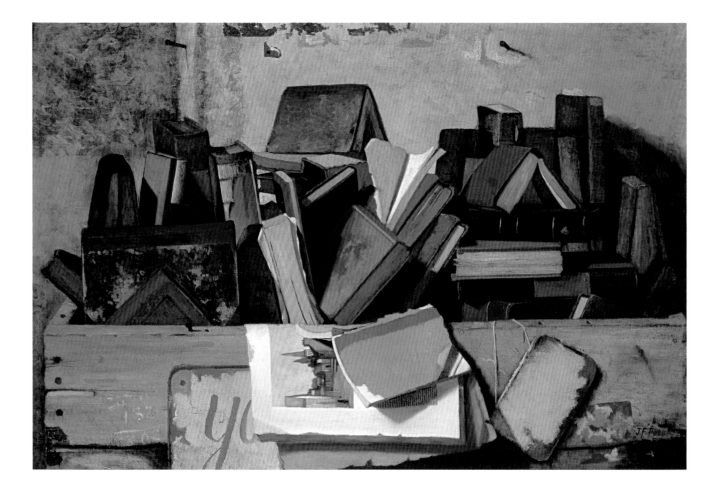

## 24

### Take Your Choice

John Frederick Peto | 1854–1907
1885, oil on canvas, 51.4 x 76.8 (20¼ x 30¼)

John Frederick Peto, today recognized as one of America's most important still-life painters, was a Philadelphia-born artist who began his career as a picture framer and gilder. Studying and exhibiting at the Pennsylvania Academy of the Fine Arts between 1879 and 1888, he met and befriended the talented William Michael Harnett (1848–1892). While Harnett went on to achieve a substantial

reputation for his precisely painted still lifes, particularly his intriguing trompe l'oeil images, Peto left his Philadelphia studio for the seaside town of Island Heights, New Jersey, to play cornet for Methodist camp meetings and live quietly with his wife and daughter. Although he continued to paint, Peto did not exhibit or sell his works but bartered or gave them away. He received little recognition beyond the local community until his rediscovery by the art critic Alfred Frankenstein in 1949.

Works by Harnett (and by Peto even before they were recognized as his) held a special appeal for American modernist sensibilities in the 1930s and 1940s because of their affinities, however unintentional, with surrealist and abstract paintings of the era. Among the earliest collectors of Harnett and Peto images was Alfred Barr, the distinguished art historian

and first director of the Museum of Modern Art, who eventually came to own three works by Peto, including *Box of Books*, 1884, a composition similar to *Take Your Choice*. The latter painting figured prominently in the reattribution story that formed the content of Frankenstein's landmark volume *After the Hunt*. In this book, which unraveled the connection between Harnett and his close colleague Peto, the author proposed that paintings that were once assumed to be "soft-style" Harnetts were actually the work of his forgotten contemporary.[1] As part of his discussion of this confusion and the possibility of forgery at some point, Frankenstein called attention to the purposeful obscuring of a portion of the inscription before the word "artist" on the reverse of *Take Your Choice*, and to contradictory signatures that were revealed through cleaning the painting's surface.[2] Today, even without such technical evidence, it would be difficult to mistake this archetypal image of worn and torn objects for the work of anyone but Peto. This discernment is due not only to Frankenstein's early detective work, but also to John Wilmerding's insightful exploration of the artist in his 1983 catalogue and exhibition, *Important Information Inside: The Art of John F. Peto and the Idea of Still-Life Painting in Nineteenth-Century America*.

From the late 1870s to the 1900s, Peto painted several varieties of still lifes, including the traditional tabletop arrangements, his distinctive letter racks, objects and instruments hung on a door, and shelves and boxes of books. Of these, his compositions of books are the most architectural or geometric in feeling and perhaps the most dramatic in lighting. *Take Your Choice* is one of the earliest of these bookshelf subjects: most date from around 1900. While there is, at first glance, a sort of chaos in the precarious jumble of volumes in this work, this initial perception gives way to a sense of quietude permeating the balanced elements that are capped and centered by the green book, tipped on its side (as the apex of the arrangement). Likewise, the meditative, even melancholic quality of the image is pierced by the brilliant colors that dominate the center of the composition. The startling warm and cool contrast between the orange and blue book covers draws the eye to the middle of the pile and demonstrates Peto's extraordinary sensitivity as a colorist.

The mystery and solemnity of Peto's library compositions result not only from their rich palettes and somber, suggestive lighting, but also from the implicit histories of the objects that are presented. Volumes are shown with pages bent and covers rubbed down to their inner layer, or literally hanging by a thread. These well-used books are the stuff of life, produced by and echoing human struggle.[3] They also suggest the triumph of creativity. As Wilmerding noted: "A shelf of worn volumes bespoke the pleasures of constant reading—the old masters made familiar. Within these broken bindings and frayed pages reposed the muse of literature. Peto's books stand as embodiments of culture as diverse as the shapes and colors of the volumes themselves. For him books were more than inert things lying around tables or shelves; they were unexpected but accessible incarnations of art."[4] | DC

1.
Although Alfred Barr congratulated Frankenstein on his publication, he took exception to its lack of emphasis on Peto, saying, "My only objection to a book which I am sure is a masterly job is your captioning. A number of first-rate Petos are attributed to Harnett with no indication that they are actually by Peto. I realize that we disagree about the relative importance of these two men, but since in my mind your book is chiefly important for its reconstitution of Peto, I must object." Barr to Frankenstein, 23 September 1953 (Frankenstein Papers, Box 9), as quoted in Elizabeth Johns, "Harnett Enters Art History," *William M. Harnett* [exh. cat., Amon Carter Museum and The Metropolitan Museum of Art] (Fort Worth and New York, 1992).

2.
Alfred Frankenstein, *After the Hunt* (Berkeley and Los Angeles, 1969), 22–23.

3.
Peto's life challenges included coping with Bright's disease, the debilitating kidney disease that eventually took his life.

4.
Exh. cat. Washington 1983, 106.

# 25

## Christmas Card — Snow Storm, Horse and Sleigh

Andrew Wyeth | born 1917

c. 1949, watercolor on paper, 8.4 x 13.5
(3 5/16 x 5 5/16)

# 26

## Christmas Card — Pine Tree with Footprints

Andrew Wyeth | born 1917

c. 1956, ink on paper, 8.6 x 13.5 (3 3/8 x 5 5/16)

The youngest of five children, Andrew Wyeth was born into one of America's most prominent artistic families. Newell Convers Wyeth's (1882–1945) presence as father and creative mentor permeated family life. N.C., as he was known, came to the Brandywine Valley to study with Howard Pyle (1853–1911) and gained recognition for his illustration of Scribner Classics, such as *Treasure Island* and *The Last of the Mohicans.* Eventually he settled there with his wife Carolyn, raising their family in Chadds Ford, Pennsylvania, a small community on the Delaware border. From Andrew's early teens, his father saw a future in his artistic abilities and took him under his wing, teaching Andrew in his studio. At the age of twenty, Andrew sold out his first one-man show in New York City.[1] He was on his way toward a promising career.

More than any other holiday, Christmas at the Wyeths' was an event. As Andrew recalled, "My father made Christmas joyous . . . ."[2] N.C. would dress up as Santa Claus, covered in Christmas lights. He'd stomp on the roof and sweep down the ladder, causing a ruckus.[3] N.C. was driven to cultivate his

children's experiences and imaginations in order to create for them a "reservoir of reflection"—a foundation for an enriched and creative life.[4] Christmas at the Wyeths' was the clearest embodiment of this philosophy.

Andrew and Betsy Wyeth were married in 1940 and over the next two decades began to establish their own traditions. During this time Andrew drew and painted Christmas scenes, sending them to friends as holiday greetings. Fascinated with the flexibility of watercolor and inspired by the winter landscapes of the Brandywine Valley, Andrew set out to capture these scenes and the essence of the Christmas spirit.[5] He explained, "It's throwing everything to the wind and working just as fast as I can. That makes me put down, crystal-clear, my emotions without any hesitation. This ties up with Christmas, with that same spontane[ity] and excitement."[6]

Wyeth's ease with the medium is evident in *Snow Storm, Horse and Sleigh.* A sweeping wash creates the horizon. With just a few brushstrokes, the blades of the sled delicately cut into the snow. The harshness of winter is conveyed in the blowing mane of the horse and the stiffness of the man's grip upon the reins. In an article for *Life,* Wyeth recalled a similar scene, "Even now on Christmas Eve I can almost hear runners on the snow . . . . Early morning around Christmas time has a strange light to it that no other time has. My imagination, my feeling for certain colors, the tan colors, the color of reindeer, the strange mood of a landscape some of my temperas have— are very much tied up with a personal feeling for Christmas—for the winter landscape around them."[7] "Andy and Betsy," as inscribed on the back of *Snow Storm, Horse and Sleigh,* sent this Christmas card to their friend Hyde Cox.[8]

Infused with childhood memories, there is often a sense of whimsy, whether real or imagined, in Wyeth's Christmas scenes. In his pen-and-ink drawing *Pine Tree with Footprints,* the squiggles in the snow are ambiguous; they may be paw prints from a small critter, or, as the title suggests, footprints, from someone who decided against bringing the tree home for Christmas. This work shares the same imaginative and seemingly effortless use

of pen and ink with another holiday drawing, *Christmas Card* (fig. 1). Balanced on the tips of his feet, the elf struggles with an enormous sack of presents as he makes his way through the snowdrifts. Given to Cox as Christmas cards from the Wyeths, *Snow Storm, Horse and Sleigh* and *Pine Tree with Footprints* were bequeathed to Wilmerding in 1999. | AS

fig. 1
Andrew Wyeth, *Christmas Card,* c. 1950, pen and black ink on wove paper, National Gallery of Art, Washington, Rosenwald Collection

1.
Andrew Wyeth's first one-man show of watercolors, painted at the family's summer home in Port Clyde, Maine, was shown at the Macbeth Gallery in 1937.

2.
Richard Meryman, "The Wyeths' Kind of Christmas Magic," *Life* 71 (17 December 1971), 125.

3.
"American Realist," *Time* 58 (16 July 1951), 72.

4.
Meryman, "The Wyeths," 123–125.

5.
Wyeth remarked, "I find it the most flexible of all media and prefer using it in its purest form—no mixed media, no acrylics, just straight from the tube." Diane Casella Hines, "Living Legends of American Watercolor: Profiles of Fourteen Artists," *American Artist* 47 (February 1983), 69.

6.
Meryman, "The Wyeths," 126.

7.
Meryman, "The Wyeths," 126.

8.
In an interview with Mary Landa, curator of the Wyeth Collection, Betsy Wyeth recalled that in 1941 a "young man" purchased two watercolors from the Macbeth Gallery. These were Hyde Cox's first works by Andrew Wyeth. Later the Wyeths met Cox through their good friend Philip Hofer, curator of printing and graphic arts at the Fogg Art Museum, Harvard University. Cox eventually took on the role of president of the Cape Ann Historical Association, and he became a close friend of John Wilmerding as Wilmerding pursued his dissertation research on Fitz Hugh Lane.

27

# 27

## Christmas Card — Boots and Hanging Jacket

Andrew Wyeth | born 1917
c. 1950, watercolor on paper, 13.3 x 8.6 (5 1/4 x 3 3/8)

# 28

## A Crow Flew By Study

Andrew Wyeth | born 1917
1950, watercolor on paper, 42.1 x 29.5
(16 9/16 x 11 5/8)

In a present to John Wilmerding in March 2001, Andrew Wyeth included a note: "I like to think this study for *A Crow Flew By* belongs with the Christmas card Hyde gave you in his will. My grateful thanks for the support you have given my work through all these years. Andy."[1] The Christmas card referred to was *Boots and Hanging Jacket*.

Cox bequeathed *Boots and Hanging Jacket* to Wilmerding in 1999. As with the other Christmas cards, Wyeth painted the watercolor in the mid-1950s. In this simple scene, we see a faded denim jacket. Suspended on a wrought-iron hook, the coat hangs above a pair of worn leather boots. We can almost imagine its owner having been outside gathering holly, which now spills from the pocket, kicking off his boots, and hurrying inside to a warmer climate. The small scene seems instantly to capture that moment. Except for a fine outline near the boot, the watercolor seems effortless.

We come across the blue denim jacket again in *A Crow Flew By Study*, one of ten sketches made for the final work (fig. 1). It represents a theme Wyeth pursues throughout his career. Growing up in the

Brandywine Valley, Wyeth was free to explore and roam the countryside. Over the hill from his family's property was a small African-American community, centered around an octagonal church that was originally a Quaker schoolhouse; the area was once a stop on the Underground Railroad. Through his explorations, Wyeth made friends with the neighborhood children, many of whom became subjects in his later work.[2]

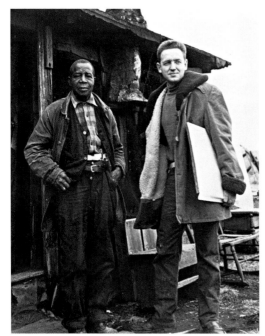

Members of the Loper family formed one such group of friends. Though Wyeth had not seen Ben Loper since childhood, one day, driving by, he spotted Ben standing outside his home and stopped for a brief visit. A couple of days later he returned (fig. 2). Entering Ben's home, Wyeth was captivated by a scene he would later try to capture—Loper sitting alone in the dark room, leaning forward with a beam of sunlight hitting his face in a bright yellow triangle across one eye.[3] Wyeth returned several times over the next month, "I'd go over to paint H. F. Dupont in the morning. I'd have to be let into Winterthur (the du Pont mansion) by guards, and be 'received.' Then, in the afternoon, I'd walk over to Ben Loper's house in the community and would be so much more relaxed, so much more natural."[4] One day a boy described as "not all there" was also paying Loper a visit. While Wyeth was busy sketching, the boy repeatedly opened the door and looked out, perhaps twenty times in the short space of an hour. Exasperated, Wyeth finally asked the child what he was looking for. The reply became the title of the painting—"A Crow Flew By." To Wyeth this simple phrase summarized the nature of the bare wall with the hanging coats. These were "symbols of a man's whole life lined up."[5]

Through the sketches, Wyeth carefully selected the elements included in the final painting. As he said, "it's not what you put in but what you leave out that counts."[6] Tempera, the medium he chose for the final painting, requires additional preparation. Egg tempera is a fast-drying medium that allows for little correction. With smudges, thumbprints, and visible pinpricks in the corners, the watercolor sketch is clearly a working document. Wyeth referred to his sketches, arranged on a board next to his easel, while working on the final painting. Though this view of the jacket was not realized in the painting, elements of the denim coat and textured hat are seen in the final work.

That this watercolor survives is somewhat unusual. Commonly, Wyeth destroys preliminary sketches, in part because he rarely revisits a subject once he is finished with it.[7] Many of the objects in the final work were painted from memory, but

28

Wyeth borrowed the denim jacket from Loper, taking it to his studio for further study.[8] To suggest texture, Wyeth used a dry brush to add lines to the coat, blending the blue and black pigments to create folds and shadows in the fabric. Only a few color sketches were made for *A Crow Flew By,* but the blue denim jacket seemed to captivate Wyeth; perhaps this explains why the study remained in the artist's collection for more than fifty years. | AS

1.
Note from Andrew Wyeth to John Wilmerding, dated 27 March 2001, Wilmerding Collection.

2.
Mary Lynn Kotz, "Wyeth's Black Models," *ArtNews* 100 (May 2001), 172.

3.
Elaine de Kooning, "Andrew Wyeth Paints a Picture," *ArtNews* 49, no. 1 (March 1950), 39–40.

4.
Henry Francis du Pont (1880–1969), heir to the Dupont fortune, was an avid collector and horticulturist. Focusing on American decorative arts, he amassed one of the largest collections of silver, ceramics, and furniture in the United States. In 1951 du Pont turned his family estate into a public museum, creating Winterthur Museum, Garden, and Library; Kotz, "Wyeth's," 173.

5.
De Kooning, "Andrew Wyeth," 41.

6.
De Kooning, "Andrew Wyeth," 40.

7.
Philip Hofer, *Andrew Wyeth: Dry Brush and Pencil Drawings* [exh. cat., Fogg Art Museum] (Cambridge, Mass., 1963), curator's foreword.

8.
De Kooning, "Andrew Wyeth," 54.

MAINE

Blue
Hill •

• Castine

## The Lure of the Pine Tree:
## Drawings of Mount Desert and
## the Coast of Maine

From the early nineteenth century, travelers in search
of varied and dramatic scenery have felt the attrac-
tion of Maine's rocky, irregular coast, and a reflection
of that interest is the large number of Maine subjects
in the present exhibition. The most compelling
destination for many of these visitors is exhaustively
discussed in John Wilmerding's *The Artist's Mount
Desert,* which details the responses of America's best-
known landscape painters to the extraordinary sights
of Mount Desert Island.[1] Wilmerding notes that the
place is truly a study in contrasts, offering splendid
views both focal and panoramic—rugged shorelines
and inviting harbors, mountains and meadows, and
geological evidence of both fire (volcanoes) and ice
(glaciers). As one writer states in 1872, "nowhere else

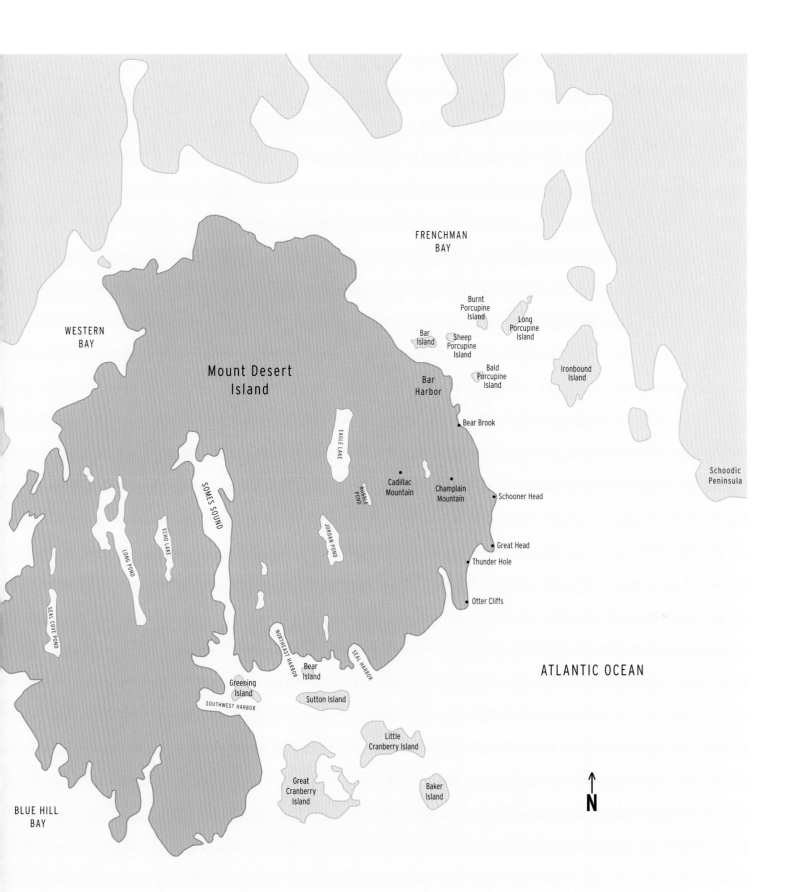

FRENCHMAN
BAY

WESTERN
BAY

Mount Desert
Island

Bar Island

Burnt Porcupine Island

Sheep Porcupine Island

Long Porcupine Island

Bald Porcupine Island

Ironbound Island

Bar Harbor

EAGLE LAKE

Bear Brook

SOMES SOUND

BUBBLE POND

Cadillac Mountain

Champlain Mountain

Schoodic Peninsula

Schooner Head

ECHO LAKE

JORDAN POND

Great Head

LONG POND

Thunder Hole

SEAL COVE POND

Otter Cliffs

NORTHEAST HARBOR

Bear Island

SEAL HARBOR

ATLANTIC OCEAN

Greening Island

SOUTHWEST HARBOR

Sutton Island

Little Cranberry Island

Great Cranberry Island

Baker Island

BLUE HILL BAY

N

in this country is there so much variety of scenery in so small a space."[2]

Mount Desert received its name from the French explorer, Samuel de Champlain, in 1604.[3] "Isle de Mont-Deserts" seemed aptly to describe the island, with its thirteen barren and rocky peaks that rose forbiddingly across the glittering waters. A party of Jesuit missionaries had established a colony among the Indians there around 1612, but they were quickly driven away by the English. In subsequent years, fishermen, farmers, boat builders, and lumbermen settled the land, attracting little attention until tourism, in various forms, appeared in the nineteenth century.

Beginning with Thomas Doughty, Alvan Fisher, and, most importantly, Thomas Cole, who came to sketch in 1844, many artists have succumbed to the allure of this island. Shaped like an irregular circle and located about two-thirds the way along the Maine coast, it encompasses approximately 108 square miles and extends about 20 miles into the Gulf of Maine. Despite its remoteness, or perhaps because of it, well-known figures such as Frederic Church and Fitz Hugh Lane visited several times in the 1850s to record and interpret its wild and rugged beauty. In 1872 one writer observed: "In the course of time, Church's pictures of the scenery at Mount Desert were seen in the exhibitions of the National Academy. At one time and another most of the noted artists have followed on sketching tours, and it is chiefly by this means, in the first instance, that Mount Desert has become so popular as a watering place." He added, "now most of the visitors to Mount Desert, even the prosaic folk, go prepared to enjoy the picturesque, the beautiful, the sublime."[4]

Visiting artists would have approached the island by schooner in the early years or by steamer after 1850, sailing around it and up the eastern side to Bar Harbor. They found accommodations nearby at Schooner Head, a site with an extraordinary view, at the Lynam Homestead, a family-run boarding house that was soon favored by artists. As described in 1872 by George Ward Nichols: "The house itself is not especially picturesque, and the surrounding country is bleak and bare, while an old well-sweep and withered tree in the yard give the place a look of loneliness and neglect. But it is the artistic associations of the old house which will make it celebrated, for within its walls have been gathered many of the names most celebrated in American art—Cole, Church, Gifford, Hart, Parsons, Warren, Bierstadt, Brown, Colman, and others."[5]

Even as tourism to Mount Desert increased, the attraction of the island continued to be its natural splendors, rather than the creature comforts and entertainments offered by more fashionable and less remote resorts.[6] After the end of the Civil War, a boom in travel ensued and new, larger hotels sprung up on Mount Desert. Steamboat trips (first twice a week and then daily) replaced the earlier schooner travel: one could conveniently take a train from Boston, arrive at Portland near midnight, board the steamer, and reach the commercial wharf at Southwest Harbor (then the "principal place of resort" despite the aroma of the lobster-canning plant) at mid-morning. Passengers could disembark, or by the 1870s could continue the journey eastward past the entrance to Somes Sound, around the coast and up to Bar Harbor. Those averse to steamboat travel could take the fifty-mile stage ride from Bangor on the mainland over the bridge to Mount Desert.

On the heels of the first artists came others, both professionals and ranks of amateurs. There are numerous accounts from the 1870s of sketching excursions, ladies attired in the shorter, no-nonsense skirts and sturdy boots that would facilitate scurrying among the rocks and climbing in and out of the small boats hired to reach the most intriguing destinations.[7] Hiking to all the notable scenic attractions, the many peaks, cliffs, caves, lakes, and celebrated and colorfully named rock formations became de rigueur. When Mount Desert was featured in the well-known volume *Picturesque America*, the writer noted of one location that "the rocks are mainly of pink feldspar, but within the caves the sea has painted them in various tints of rare beauty, such as would delight the eye and tax the skill and patience of a painter to reproduce. The shores here, indeed, supply almost exhaustless material for the sketch-book of the artist."[8]

Later in the century, artists continued to visit the island but focused less on the geological or scientific accuracy of their depictions and more on the evanescent qualities of light and atmosphere of these places. As tastes evolved from conveying the grandest aspects of nature to offering a more subjective, emotional response, artists felt less need to record the notable sites of Mount Desert. They still came to visit and enjoy the superb surroundings (American modernists Marsden Hartley and John Marin painted there in the twentieth century), but produced fewer exacting visual records. While the novelty of the island for artists waned somewhat by the end of the century, its popularity with tourists continued to grow.

Samuel Eliot Morrison noted four successive waves of "summer visitor culture" on Mount Desert: "First came artists and scientists who camped or boarded around; then simple families of clergy-men, college professors and the like, largely from Bangor or Boston, who took hotel rooms and wanted nothing of the Island but what they found, taking their pleasure in boating, fishing, walking, driving in buckboards and picnicking. Then came people of wealth and taste from all the Eastern cities, who built big 'cottages'...followed by multimillionaires... fleeing from life's complications," who established institutions and amenities for their comfort and amusement away from the masses of visitors.[9] In the twentieth century these affluent families began to sense that the scenery that made Mount Desert so unique was becoming threatened by the increasing numbers of all those who came to admire it. In response, they moved to purchase and preserve in trust some of the most beautiful tracts. In 1919 this land was given to the federal government and became the core of Lafayette National Park, the first national park established east of the Mississippi. Ten years later, the park's name was changed to Acadia. Today it encompasses more than 35,000 acres and receives some three million visitors a year, most, no doubt, toting cameras (and some perhaps sketchbooks) to preserve their impressions and carry them back home.[10] | DC

1.
Wilmerding 1994.

2.
"Miscellany," *Appleton's Journal of Literature, Science and Art* (5 October 1872), 389.

3.
The name is pronounced "dessert," as in the after-dinner sweet, rather than as the word for an arid land.

4.
George Wood Nichols, "Mount Desert," *Harper's New Monthly Magazine* (August 1872), 324–325.

5.
Nichols, "Mount Desert," 331–332. The artists mentioned may be identified as Thomas Cole (1801–1848), Frederic Church (1826–1900), Sanford Gifford (1823–1880), William or James M. Hart (1823–1894 and 1828–1901), Andrew Warren (?–1873), and Samuel Colman (1823–1920). It is not possible to be certain which of the many artists with the surname Brown is the one referred to.

6.
In addition to its obvious aesthetic properties, Mount Desert offered numerous bays and inlets that promoted excellent fishing and boating.

7.
Nichols, "Mount Desert," 328, 331–332, and Albert Webster, "Mount Desert Island," *Appleton's Journal of Literature, Science and Art* (26 September 1874), 402.

8.
O. B. Bunce, "On the Coast of Maine," in *Picturesque America*, William Cullen Bryant, ed. (New York, 1874), 1:6.

9.
Samuel Eliot Morison, *The Story of Mount Desert Island, Maine* (Boston, 1960), 49.

10.
See *www.nps.gov/acad/history.htm*.

## 29

## View from East End of Bear Island

Alvan Fisher | 1792–1863

1848, pencil on paper, 24.8 x 35.2 (9 3/4 x 13 7/8)

In reply to William Dunlap's request for information for his ambitious two-volume *History of the Rise and Progress of the Arts of Design in the United States* (1834), Alvan Fisher observed matter-of-factly: "my life has been without striking incidents; it has been what I apprehend to have been the life of most of the American artists, a life of toil, seeking the realization of a dream—of hope and disappointment—of cloud and sunshine, so that it is difficult, perhaps, to say whether I was wise or foolish in choosing a profession."[1] Fisher's ambivalence toward his career was emblematic of the struggles faced by American

artists early in the nineteenth century. Caught between the demands of a culture that was wary of the arts while frankly admiring practical pursuits and material wealth, he was obligated constantly to improvise ways to, as his descendant Philip Fisher wrote in 1898, "make it pay."[2]

Born in Needham, raised in Dedham, and trained in Boston, Massachusetts, Fisher traveled widely in the east, from South Carolina to Maine.[3] In 1825 he toured Europe for sixteen months, where he saw the work of J.M.W. Turner in England and spent ten months in Paris copying works at the Louvre and taking life classes at a private academy. Although never "able to make a living without the aid of portrait painting,"[4] Fisher was one of the first American artists to find some success with landscape and genre scenes. His subjects were varied and, in addition to portraits of celebrated figures such as the German phrenologist Johann Gaspar Spurzheim, included views of Harvard College, the revolutionary war hero Lafayette's French estate La Grange, Niagara Falls,

winter and barnyard scenes, as well as animal portraits of Henry Clay's bull, Ozimbo, and the famous American race horse, American Eclipse. Indicative of Fisher's constant search for new materials was a notebook entitled, "Subjects for Paintings as they occur to the mind to be matured afterwards," in which he lists five scenes taken from James Fenimore Cooper's story *The Prairie* (1827).

One of the first American artists to explore Maine, Fisher's initial visit took place in the summer of 1835, when he traveled to Mount Desert Island probably accompanied by his contemporary and friend, the painter Thomas Doughty.[5] Fisher later returned to the state on numerous occasions. In the summer of 1848 he arrived in Camden by 1 August and spent at least a week on Bear Island, from 6 to 13 August, the day he made the sketch of *View from East End of Bear Island*.

The exact orientation of the scene depicted is difficult to ascertain. Fisher may have been looking south toward Sutton Island or north to the shoreline of Mount Desert Island. The drawing is constructed in the manner of Claude, with the tall pine trees on the left framing the view. There is a progression backward in space, from the foreground rocks to the middle ground, which is defined by the spit of land jutting out from the left, to the distant view of the barely visible island shrouded in fog in the background.

Such sketches were an important part of Fisher's artistic practice. He declared, "trust not to memory," and implored artists, "Always go into the forests for trees for landscapes and never put into a picture anything that is not drawn from nature."[6] In the studio, the Maine drawings were used to produce finished paintings such as *New England Coast* (fig. 1). They relied on traditional academic procedures espoused by Fisher who declared: "Painting may be divided into three distinct studies or principal considerations, viz: conception, development and drawing, after these operations proceed to colouring and then finishing in details."[7] A comparison of *View from East End of Bear Island* with *New England Coast* reveals how dependent Fisher was on landscape formulas. Despite the fact that they show different scenes, they both employ almost identical compositions that mirror each other in their use of Claudian precepts.

By the mid-1850s such standard academic practices were being challenged by a more rigorous adherence to naturalistic effects favored by artists such as Asher B. Durand and Frederic Church, and by the practice of outdoor oil sketching. In an 1856 letter to *The Crayon*, Fisher reflected on these changes and reminisced about his early days in Maine:

Your young correspondent will find, when he has had my experience in artistic life, that there is nothing so conducive to practical success in art as a comfortable life, a good table, and if the experience of years justifies my saying it, something better than "hard cider" to sustain the spirits flagging….I must now tear myself away from the pleasant circle of artists' whose eminent success in studies from nature, in oil colors, make me regret that I so long confined myself to the lead pencil and water-colors. I am too old, however, to try any new tricks, and must be content with the way in which poor Doughty and I used to pick up nice bits about Nahant and the Cranberry Isles.[8] | CB

fig. 1
Alvan Fisher, *New England Coast*, 1848, oil on canvas, private collection, Milton, Massachusetts

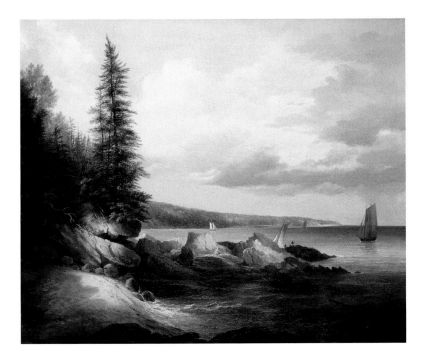

1.
William Dunlap, *History of the Rise and Progress of the Arts of Design in the United States*, 2 vols. (New York, 1834), 2:265.

2.
Philip A. Fisher, quoted in Robert C. Vose, "Alvan Fisher (1791–1863): American Pioneer in Genre and Landscape," Robert C. Vose typescripts and clippings, Archives of American Art, reel 4314, frame 92.

3.
For Fisher's biography see Fred Barry Adelson, "Alvan Fisher (1792–1863): Pioneer in American Landscape Painting" (Ph.D. diss., Columbia Univ., 1982). Also see Robert C. Vose Jr., "Alvan Fisher, 1792–1863: American Painter in Landscape and Genre," *Connecticut Historical Society Bulletin* 27, 4 (October 1962), 97–130. (This is a condensed version of the Vose typescript at the Archives of American Art.)

4.
Fisher to Charles W. Wright, 8 March 1831, Miscellaneous Papers—Alvan Fisher, The New York Public Library, as quoted in *Seeking the Realization of a Dream* [exh. cat., Heritage Plantation of Sandwich] (Cape Cod, 2001), xxii.

5.
In July and September 1835 Fisher and some partners, including his brothers John and Francis, purchased hundreds of acres in the town of Ellsworth on the mainland north of the island, thus setting the stage for further visits over the next decade and a half. The area around the Cranberry Islands was a favorite destination and Fisher was particularly fond of Bear Island, recommending it to friends and making it the subject of the majority of his Maine paintings. By the time of his 1848 trip there, however, the Ellsworth properties had been sold and the artist's ties to Maine were beginning to dissolve. Although he would sell more than thirty Maine subjects from 1847 to 1857, primarily in the auctions he organized in 1847, 1852, and 1857, by 1850 Fisher had apparently made his last visit to the state and was beginning to turn his attention toward the White Mountains in New Hampshire. For Fisher's time in Maine see Adelson 1982, 2:553–573.

6.
Quoted in Vose, Archives of American Art, reel 4314, frame 105.

7.
Quoted in Vose, Archives of American Art, reel 4314, frame 105.

8.
*The Crayon* 3 (November 1856), 348–349.

cat. 29 (detail)

# 30

## Penobscot Bay, Maine

Edward Seager | 1809–1886

1848, pencil on paper, 26.4 x 41.9 (10³/₈ x 16¹/₂)

Edward Seager was born in Maidstone, Kent, England, the third son and sixth child of Henry Seager and Sarah Lansdell.[1] The family lived in Tremadoc, Wales, from 1811 to 1816, and in Liverpool, England, from 1819 to 1827. By the early 1830s they had migrated to Canada, where Henry Seager died of cholera in 1832, and by 1838 Edward had settled in Boston. There he taught at the English High School, establishing the study of drawing as part of the curriculum in 1844. In 1850, at the urging of Daniel Webster, he became the first professor of drawing and drafting at the Naval Academy in Annapolis,

Maryland, a post he held until 1871. Seager died in Washington, D.C.

The nature of Seager's early artistic education is not known, but the fact that he was a drawing instructor indicates some degree of formal training. His father may have taught him the rudiments of drawing, or perhaps he had access to contemporary drawing manuals published in America and England. Whatever the nature of his training, his extant studies demonstrate an awareness of many academic conventions and skills. His landscapes with clearly defined fore-, middle-, and backgrounds incorporate standard Claudian elements. There are also many detailed nature studies of leaves, branches, and trees. Drawings from casts and from life reflect knowledge of anatomy and the figure. Other works are clearly formal exercises on how to render light on three-dimensional geometric forms. Finally, a mastery of mechanical drawing and perspective is evident in Seager's images of bridges, trestles, sawmills, and railways.

Seager's career as a teacher attests to the value of drawing as a practical skill in mid-nineteenth-century America. The ability accurately to record the country's topography was essential to the task of nation-building and crucial to the mission of government agencies such as the U.S. Coast and Geodetic Survey. Instruction in perspective exercises and mechanical drawing were critical for the growth of industry in the United States. As the need for skilled draftsmen became more apparent, drawing curriculums such as the one Seager established in Boston became a feature of many public school education programs.[2]

Seager made his living chiefly by teaching, apparently never pursuing painting full-time. Yet he was a peripatetic traveler who sensitively sketched many quintessential American landscapes, including many of the sites favored by the Hudson River School artists. Among his destinations were Mount Washington in New Hampshire; Lake George in the Adirondack Mountains; Newburgh on the Hudson River; the Berkshires in North Adams, Massachusetts; Penobscot Bay, Maine; Harpers Ferry, West Virginia; and Niagara Falls. Seager also traveled extensively outside the United States to Panama, Cuba, the Virgin Islands, and Canada, as well as throughout Europe, to Italy, France, Germany, England, and Switzerland.

Seager's talents as a landscape artist are exemplified by *Penobscot Bay, Maine*. The sweeping movement of the inscription at the bottom left leads to a central lane that meanders downhill past several pleasant, well-managed homesteads, through a brief interval of shade, and finally down to the waters of the bay itself. Seager's mastery of the medium of pencil augments the majestic rhythms of the topography, with darker and lighter tones creating an intricate play of light and with broader marks in the foreground slowly giving way to increasingly more delicate hatching in the middle and backgrounds, until the pencil strokes become indistinguishably melded together in the very fine, smooth gradations of the hills along the horizon. | CB

1.
For Seager's biography see Sandra K. Feldman, *The Drawings of Edward Seager (1809–1886)* [exh. cat., Hirschl & Adler Galleries] (New York, 1983).

2.
See, for instance, Nicolai Cikovsky's discussion of drawing curriculums in public schools in exh. cat. Washington 1995, 154–155.

# 31

## Castine from Wasson's Hill, Brooksville, Maine

Fitz Hugh Lane | 1804 – 1865
1850, pencil on paper, 23.8 x 69.5 (9 3/8 x 27 3/8)

# 32

## Entrance of Somes Sound, Mount Desert, Maine

Fitz Hugh Lane | 1804 – 1865
1855, pencil on paper, 27 x 40.6 (10 5/8 x 16)

Lane first went to Maine in 1848 on a trip to Castine with his friend Joseph Stevens, who was visiting his family. Although there is little documentation concerning their stay, at least two paintings resulted, *Twilight on the Kennebec,* 1849 (private collection), and *View on the Penobscot* (location unknown). Both works were exhibited at the American Art-Union in New York in 1849, but neither seems to have excited

much critical interest. Lane had chosen subjects that very nearly marked the eastern and western boundaries of the same area of Maine that would receive so much of his artistic attention over the next fifteen years. Between the two rivers were such sites as Owl's Head, Camden, Castine, and Penobscot Bay, all of which would form the subjects of memorable works. If one expands the area slightly farther eastward to take in Mount Desert and its vicinity, the entire range of Lane's travels in Maine is embraced.

Lane may have returned to Maine in 1849; he was certainly there in 1850, and his activities in that year are well documented.[1] Traveling by train and boat, Lane and Stevens reached Castine in August, and they were soon out in the surrounding countryside to find subjects for Lane to sketch. Lane's bout with polio during childhood had confined him to crutches, and Stevens recalled that it was difficult for the artist to carry the paraphernalia that would have allowed him to sketch in oil. Accordingly, most of his studies are in pencil, often on several sheets joined in horizontal format, as is the case with *Castine from Wasson's Hill, Brooksville, Maine.*[2] A notation at the lower right indicates that Lane and Stevens were accompanied by the elder Joseph Stevens, a Castine doctor. In this panoramic view, Lane recorded the vista from the east across Smith's Cove and the Bagaduce River. He carefully drew in the tiny forms of the town's houses, churches, and other

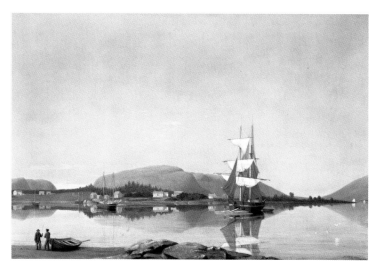

fig. 1
Fitz Hugh Lane, *Castine, Maine*, 1856, oil on canvas, Museum of Fine Arts, Boston, Bequest of Maxim Karolik

fig. 2
Fitz Hugh Lane, *Entrance of Somes Sound from Southwest Harbor*, 1852, oil on canvas, private collection

fig. 3
Fitz Hugh Lane, *Southwest Harbor, Mount Desert*, 1852, pencil on paper, Cape Ann Historical Association, Gloucester, Massachusetts

buildings in the upper center of the sheet. No oil painting based on this work is known, but Lane did complete two views of Castine from Fort George, just above the town (fig. 1 and *Castine from Fort George*, 1856, Thyssen-Bornemisza Collection), and another from the harbor (*Castine*, 1850s, Timken Art Gallery, San Diego, California).

Later in August, Lane and Stevens chartered a boat named the *General Gates* and embarked on a voyage to Mount Desert. Stevens recorded the stirring experience of seeing the island as they grew nearer:

It is a grand sight approaching Mount Desert from the westward, to behold the mountains gradually open upon the view. At first there seems to be only one upon the island. Then one after another they unfold themselves until at last some ten or twelve stand up there in grim outline. Sailing abreast the range, the beholder finds them assuming an infinite diversity of shapes, and it sometimes requires no great stretch of imagination to fancy them huge mammoth and mastodon wading out from the main.[3]

Arriving at Southwest Harbor, Stevens admired the vista to the north. "Here, from what seems to be a cave on the mountain side, is Somes Sound, reaching through a great gorge seven miles into the heart of the island."[4] The sight also engaged Lane, who rendered it in one of his first important Mount Desert pictures, *Bar Island and Mount Desert Mountains from Somes Settlement*, 1850 (Collection of Erving and Joyce Wolf).

Lane was back in Castine in the summer of 1852, once again in the company of his friend Stevens. In August, just as they had done two years earlier, they chartered a boat—in this case the sloop *Superior* —and set sail for Mount Desert. A number of drawings survive from this trip, of which a few were used in composing paintings once Lane had returned to Gloucester in the fall. Among the most celebrated of these is *Entrance of Somes Sound from Southwest Harbor* (fig. 2), which was based on a drawing most likely made from onboard the *Superior* (fig. 3). Lane's transformation of the topographical record of the drawing into the painting, a masterpiece of pictorial structure and balance, is evidence of the remarkable stylistic evolution in the 1850s that would lead to the great achievements of his maturity (see cats. 21, 22).

32

Lane and Stevens sailed Maine's waters again in the summer of 1855, visiting Camden, Rockland, and, once again, Mount Desert. Lane sketched many of the same sites that had previously captured his attention, including Owl's Head, the Camden Mountains, and Somes Sound.[5] The latter inspired two sketches, *Entrance of Somes Sound, Mount Desert, Maine* (cat. 32), and *Looking Westerly from the Eastern Side of Somes Sound near the Entrance* (Cape Ann Historical Association), both completed in September 1855. These drawings are notable in Lane's oeuvre for their "textural detail, tonal contrast, and variety of pencil stroke."[6] In *Entrance of Somes Sound* Lane returned to a vantage point similar to the one he had used for his oil of 1852, but the view is now from a higher elevation located farther to the east. He may have been thinking of composing a painting of the sound from this perspective, but none is known to exist. More likely, as John Wilmerding has aptly observed, "perhaps he just wanted to fix the image forever in his mind."[7] | FK

1.
See Wilmerding 1971, 51–56, and Wilmerding 1994, 45–67.

2.
Wilmerding 1971, 51.

3.
Stevens' observations were published as an article in the *Gloucester Daily Telegraph* (11 September 1850) and are reprinted in Wilmerding 1971, 53–54.

4.
Quoted in Wilmerding 1971, 53.

5.
See the author's "Lane and Church in Maine," in Wilmerding 1971, 147–148, and Wilmerding 1994, 61.

6.
Wilmerding 1994, 61.

7.
Wilmerding 1994, 61.

## 33

### Rocks at Mount Desert

John Henry Hill | 1839–1922
1856, pencil on paper, 19.7 x 24.5 (7 ³/₄ x 9 ⁵/₈)

Around 1855 John William Hill, John Henry Hill's father and teacher, was introduced to the writings of the influential English critic John Ruskin, more specifically his famous opus *Modern Painters*. Reading Ruskin changed John William's, and in turn his son's, approach to art. Henceforth both men worked in an exacting style based on the philosophy of truth to nature as expounded by Ruskin and practiced by English pre-Raphaelite artists such as William

Holman Hunt, John Everett Millais, and Dante Gabriel Rossetti.[1] In 1863 the Hills became founding members of the Association for the Advancement of Truth in Art, an organization devoted to spreading the tenets of the pre-Raphaelites in America.[2] When visiting London in 1864, John Henry contributed a series of letters to the association's periodical, *The New Path*, in which he commented at length on the works of J.M.W. Turner, for Ruskin the greatest exemplar of modern painting. John Henry also corresponded directly with Ruskin who, having seen examples of his work in London, praised the artist's "very fine eye for color"[3] and later, in 1881, commented that he had a "very great art gift."[4]

The year Hill drew *Rocks at Mount Desert*, Ruskin published the fourth volume of *Modern Painters*, in which he explicitly discussed the importance of drawing stones: "For stone, when it is examined, will

be found a mountain in miniature. The fineness of Nature's work is so great that in a single block…she can compress as many changes of form and structure, on a small scale, as she needs for her mountains on a large one."[5] Hill's drawing illustrates Ruskin's point; in choosing to render in minute detail the striations, crags, and crevasses of boulders along the island shore, he captures the essential geological characteristics of Mount Desert. The approach is analogous to that used by Ruskin in his renowned contemporaneous watercolor study, *Fragment of the Alps* (fig. 1).[6]

Under the influence of Ruskin a distinction began to be made in American exhibitions by the mid-1850s between the broad sketch and the detailed "Study from Nature." In March 1855 a writer for *The Crayon* noted that "the true method of study is to take small portions of scenes, and thereto explore perfectly, and with the most insatiable curiosity, every object presented, and to define them with the carefulness of a topographer….To make a single study of a portion of landscape in this way, is more worth than a summer's sketching. Young artists should never sketch, but always study."[7] Hill's drawing combines features of both the study and the sketch. The central rock formation is rendered in sharp focus, with great attention to detail, while the outlying elements of the drawing are handled in a much broader, more cursory fashion. This tendency to leave the borders of his images unfinished is also found in Hill's 1867 portfolio of twenty-five etchings pointedly entitled *Sketches from Nature,* which the artist, alluding to the distinction between study and sketch, described apologetically as an endeavor he undertook "between more persistent and serious work."[8] In 1879 Ruskin himself touched upon Hill's weakness for the sketch, admonishing him to "Finish every drawing from corner to corner."[9]

But if Hill was sometimes guilty of indulging in "sketches," his allegiance to Ruskin and the pre-Raphaelites was never seriously to be doubted. In 1868 he had joined the U.S. Geological Survey led by Clarence King and produced a startlingly meticulous watercolor of Shoshone Falls in Idaho, inscribed "Study from Nature," in which he gave equal attention to background and foreground and covered the sheet thoroughly with visual details. When his father died in September 1879, he returned home to West Nyack, New York, and published *An Artist's Memorial*, a portfolio of etchings after his father's paintings, thus helping to ensure that the work of one of the first exponents of Ruskin's ideas in America was not forgotten. | CB

1.
The Hills' involvement with the American pre-Raphaelite movement is documented by Linda S. Ferber and William H. Gerdts in exh. cat. Brooklyn 1985, 166–192. William Trost Richards (cats. 39–42) was also associated with the movement.

2.
Thomas Farrer (cat. 10) and William Trost Richards also were members.

3.
Ruskin to Hill, undated, as quoted in exh. cat. Brooklyn 1985, 178.

4.
Quoted in exh. cat. Brooklyn 1985, 166.

5.
John Ruskin, *Modern Painters* (London, 1856), 4:368, as quoted in exh. cat. Brooklyn 1985, 285.

6.
Ruskin's watercolor was exhibited in the United States in 1857 at the National Academy of Design, New York, *American Exhibition of British Art*, as no. 155, *Study of a Block of Gneiss, Valley of Chamouni, Switzerland.*

7.
"The Academy Exhibition— No. 1," *The Crayon* 1 (28 March 1855), 203, quoted in exh. cat. Brooklyn 1985, 41.

8.
Quoted in exh. cat. Brooklyn 1985, 171.

9.
Ruskin to Hill, 26 March 1879, as quoted in exh. cat. Brooklyn 1985, 178.

fig. 1
John Ruskin, *Fragment of the Alps*, c. 1854–1856, watercolor and gouache over graphite on cream wove paper, Fogg Art Museum, Harvard University Art Museums, Gift of Samuel Sachs

## 34

### Frenchman Bay, Mount Desert

Aaron Draper Shattuck | 1832 – 1928
1858, pencil and colored chalks on paper,
26.7 x 42.6 (10 1/2 x 16 3/4)

Aaron Draper Shattuck explored the coastline of
Maine during the summer of 1858 when he accompa-
nied the *U.S. Vigilant* on an inspection tour of the
state's many lighthouses. He recalled the schooner's
departure on 31 May in a letter to his sister, Marian
Colman: "We left Portland on Monday about noon
and ran down Casco Bay.... Seemed as though we
were sailing through some fairyland, so beautiful
were the islands bathed in rosy light, melting away
in the distance."[1] As the summer passed, Shattuck
became ever more enchanted: "I lay upon the deck
all day in the dreamy sunshine and was for a time
happy. At night the stars shone out with more than
usual splendor and the sky at evening was lovely.

We have passed more than a thousand islands thus
far. As it is not safe to sail at night upon this rocky
coast, we have generally made harbor and had a
good night's rest. I leave some of these beautiful
islands with reluctance."[2] The young artist's idyll
eventually culminated with two weeks on Mount
Desert Island, where he made a series of drawings
including *Frenchman Bay, Mount Desert*.

In 1858 Shattuck was on the brink of a success-
ful career.[3] During the summer of 1855 he had
sketched and painted with Asher B. Durand in the
White Mountains. Later that year Shattuck exhibit-
ed for the first time at the National Academy of
Design, and his "studies of rocks, grasses and field
flowers" were praised in the Ruskinian journal *The
Crayon* as "truthful as well as earnestly painted."[4]
In 1856 he was elected an associate member of the
academy and began renting rooms in the Tenth
Street Studio Building, where he worked alongside
Albert Bierstadt, Frederic Church, and John Kensett.
As Shattuck's reputation grew in the 1860s and
1870s, his paintings were exhibited widely and issued
as engravings, and they entered prominent private
collections.

Shattuck came of age as an artist at a period when Ruskin and the pre-Raphaelites' call for unerring attention to the minute visual facts and details of nature in painting was being heeded in America. As William Gerdts has observed, artists became more concerned with the degree of exactitude with which they could render stones and plants than with overall compositional effects: "Although in the 1850s Pre-Raphaelitism was associated rather exclusively with landscape painting, it was becoming more specifically identified with the detailed study of natural foreground, as especially emphasized in landscape or with independent foreground studies. These were the basic constituents of the many 'Studies from Nature' that began to proliferate in exhibitions of the later 1850s and the 1860s."[5] In a review of the 1856 National Academy of Design show, a work by Shattuck garnered the ultimate pre-Raphaelite compliment in being compared with the kind of objective precision usually associated with science: "a geologist would know how to prize his *Study of Rocks*."[6]

Such comments apply equally to the rock formation found in *Frenchman Bay, Mount Desert*. Here the jagged, angular shapes of individual stones and boulders, as well as the dramatic chasm that opens between the outcropping, highlighted by white chalk in the foreground, and the steep, shadowy rock face behind it, drawn in dark pencil, expertly map the cataclysmic forces that brought the formation into being. Shattuck, who often gathered detailed information on the weather and cloud formations, further displayed his scientism by noting at the bottom of the drawing the type of rock shown, limestone.

Shattuck exhibited his views of Mount Desert into the 1870s, but he was destined to outlive the popularity of the "truth to nature" movement in American art.[7] In 1888, beset by illness and no longer critically acclaimed, he stopped painting to, among other things, make violins. Ironically, profits from sales of a special stretcher key for paintings that the artist had patented in 1885 became one of his main sources of income. | CB

1.
Shattuck to Marian Colman, 13 June 1858, Emigh Collection, as quoted in John Myers, "Aaron Draper Shattuck, 1832–1928, Painter of Landscapes and Student of Nature's Charms" (Ph. D. diss., Univ. of Delaware, 1981), 87.

2.
Shattuck to Marion Colman, 3 June 1858, Emigh Collection, as quoted in Myers 1981, 91.

3.
For Shattuck's biography, see Myers 1981 and Charles B. Ferguson, *Aaron Draper Shattuck, N.A., 1832–1918: A Retrospective Exhibition* [exh. cat., New Britain Museum of American Art] (New Britain, Conn., 1970).

4.
*The Crayon* 1 (28 March 1855), 202–203, or 28 February 1855, 140.

5.
William H. Gerdts, "Through a Glass Brightly: The American Pre-Raphaelites and Their Still Lifes and Nature Studies," in exh. cat. Brooklyn 1985, 56.

6.
*New York Daily Tribune* (12 April 1856), 4.

7.
Shattuck exhibited Mount Desert scenes at the Boston Athenaeum in 1862, the National Academy of Design in 1864, the Northwestern Fair in Chicago in 1865, and the Chicago Industrial Exposition in 1875. See "Paintings of Mount Desert, Exhibited from 1836–1894," in exh. cat. Rockland 1999, 170.

## 35

### Eagle Cliff, Somes Sound, Mount Desert

William Stanley Haseltine | 1835–1900
c. 1859, pen and ink and gray wash on paper,
38.7 x 56.8 (15 1/4 x 22 3/8)

## 36

### Otter Cliffs, Mount Desert (Looking toward Sandy Beach and Great Head)

William Stanley Haseltine | 1835–1900
c. 1859, pencil and white chalk on blue paper,
34.9 x 55.3 (13 3/4 x 21 3/4)

## 37

### Thunder Hole, Mount Desert Island

William Stanley Haseltine | 1835–1900
c. 1859, pencil and gray wash on paper,
38.1 x 55.3 (15 x 21 3/4)

## 38

### Wooded Coast, Mount Desert Island, Maine

William Stanley Haseltine | 1835–1900
c. 1859, pencil and gray wash on paper,
34.5 x 48.9 (13 9/16 x 19 1/4)

William Stanley Haseltine's paintings of New England's rocky coast drew praise for their geologic accuracy and stunning beauty as early as 1867, when Henry Tuckerman applauded the "individuality" of the artist's "rock-portraits" in his influential *Book of the Artists*.[1] Declaring that few artists had been so conscientious in their delineation of rocks, Tuckerman extolled Haseltine's coastal views, noting that in his paintings science and art were equally well served.

Born in Philadelphia and educated at the University of Pennsylvania and Harvard College, Haseltine studied briefly with German emigrant artist Paul Weber in Philadelphia before sailing for Düsseldorf in the summer of 1855.[2] For many years, aspiring art students from numerous countries had journeyed to Düsseldorf to study at the city's famous art academy or privately with German masters. According to Helen Haseltine Plowden, the artist's daughter, Haseltine studied with Andreas Achenbach. Although no documents have come to light confirming a formal teacher-student relationship with Achenbach, Haseltine was surely acquainted with the celebrated painter through Malkasten, the convivial artists' club that served as a meeting place for the city's art community.

In Düsseldorf Haseltine quickly joined the large American contingent already gathered in the city. In the summer of 1856, just a few months after his arrival, he accompanied fellow Americans Worthington Whittredge, Albert Bierstadt, and other expatriates on a sketching trip that began along the banks of the Rhine and continued into Switzerland and northern Italy.

35

36

37

For an artist who would later paint the distinctive rock formations of coastal New England, Haseltine's final sketching trip along the southern coast of Italy in the spring and summer of 1858 was near-ideal preparation. Included among the plein-air drawings that he brought back to Philadelphia a short time later were numerous sketches of Capri's limestone cliffs and the vertiginous rock walls near Sorrento and Amalfi.

Once home, Haseltine quickly began to exhibit the fruits of his European tour. In April 1859 he contributed four works to the thirty-fourth annual exhibition at the Pennsylvania Academy of the Fine Arts. All were European landscapes, including a painting titled *View from the Island of Capri, near Naples.*3 Just a few months later, Haseltine traveled north to Mount Desert—the only island on the eastern coast of America where rock and water meet with the same drama long celebrated at Capri.

Four pencil drawings in the Wilmerding collection likely date from this 1859 trip: *Otter Cliffs, Mount Desert (Looking toward Sandy Beach and Great Head); Thunder Hole, Mount Desert Island; Wooded Coast, Mount Desert Island, Maine;* and *Eagle Cliff, Somes Sound, Mount Desert*—all sites on the southeastern coast of the island.

Otter Cliffs, named for the playful sea creatures once abundant in the vicinity, is one of the island's most distinctive rock formations. Haseltine's drawing, a study of light, shade, and rock, is also an exercise in contrast, for the massive foreground boulders are balanced by the slight line of the distant horizon and the delicate masts of the anchored schooner.

The play of light and shade on the faceted surfaces of weathered rocks is even more dramatic in Haseltine's "portrait" of Thunder Hole. As an early observer noted, the "crash of the breakers" against the rock walls that form "Thunder Hole" (fig. 1) produces a sound easily mistaken for a "clap of thunder."4 Haseltine's skillful use of gray washes precisely defines walls naturally structured to create a thunderous echo.

As Rebecca Bedell has recently pointed out in her study of geology and American landscape painting, Haseltine was creating his meticulously detailed

fig. 1
Harry Fenn, *Thunder Cave,* c. 1874, engraving, from William Cullen Bryant, *Picturesque America* (New York, 1874; centennial edition 1974).

studies of the New England coast just as Louis Agassiz, Harvard's charismatic professor of natural sciences, delivered his popular series of public lectures on the geologic history of the earth.5 It is possible, though not certain, that Haseltine studied with Agassiz while a student at Harvard from 1852 to 1854. What is certain, however, is that Haseltine saw a clear link between artist and scientist. In response to a question from a colleague, he reportedly remarked: "Every real artist is also a scientist, and scientists . . . were also artists in the truest sense of the word; an artist is not satisfied until his work is a true expression of what he feels to be real; detail is of equal importance to the artist as to the scientist; both eschew vagueness and both eliminate that which is irrelevant and meretricious; they keep before their mind's eye the whole, while studying the part."6 The "whole" that Agassiz addressed in his lectures and publications was the geologic history of earth—the fire and ice responsible for the rocky coast Haseltine recorded with such strict attention to detail.

Broader in perspective, Haseltine's two other drawings from his early trip to Mount Desert (*Wooded Coast, Mount Desert Island, Maine,* and *Eagle*

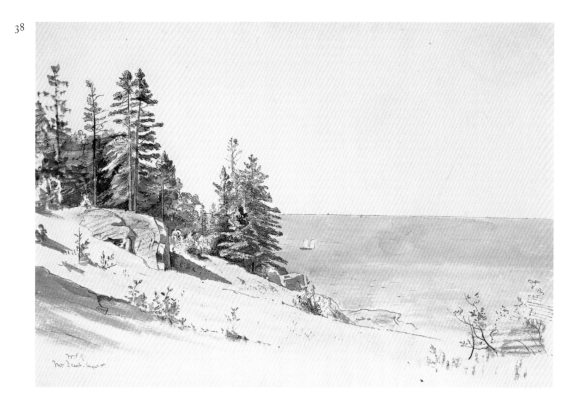

38

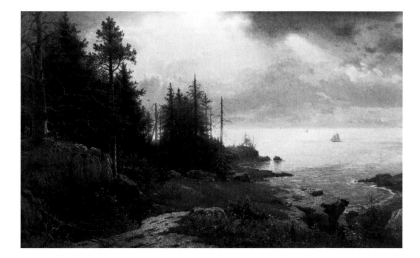

fig. 2
William Stanley Haseltine, *View of Mount Desert*, 1861, oil on canvas, Courtesy D. Wigmore Fine Art, Inc., New York

*Cliff, Somes Sound, Mount Desert*) also include distinctive rock formations, but these are part of views more pastoral in character—views with still water and calm breezes. Sailing vessels appear in the distance of each image—harbingers (in 1859) of the island's commercial and recreational future.

Frenchman Bay, the subject of one of these drawings, is the large body of water east of Mount Desert separating the island from the mainland near Schoodic Peninsula. The name reflects the early history of the area, which included a visit by French explorer Samuel de Champlain in 1604 and a subsequent attempt at settlement by French Jesuit missionaries. In 1688 the governor of Canada gave the island to a Frenchman, Antoine de la Mothe Cadillac, who settled briefly on a site overlooking Frenchman Bay. Conflicting claims of French and British sovereignty continued for more than a century. The issue was not settled until 1759 when the French military was defeated at Quebec. Though the British (and later the Americans) claimed the island, geographic names recalling earlier French dominance (including Frenchman Bay) remained.

fig. 3
Harry Fenn, *Eagle Cliff, Somes Sound*, c. 1874, engraving, from William Cullen Bryant, *Picturesque America* (New York, 1874; centennial edition 1974)

As John Wilmerding noted in *The Artist's Mount Desert*, Haseltine's coastal view looking out on Frenchman Bay is related to a major oil by the artist, *View of Mount Desert* (fig. 2), completed two years later, in 1861. The plein-air pencil sketch captured the essential elements of the landscape and thus provided the skeletal structure for the later painting.

The last of the drawings from Haseltine's 1859 trip, *Eagle Cliff, Somes Sound, Mount Desert*, also features a site with historical resonance. Somes Sound, the largest inlet on the island, was the location of the first permanent settlement. Following the defeat of the French military at Quebec, Sir Francis Bernard, British governor of the Massachusetts Bay colony, urged Abraham Somes, a Gloucester barrel maker, to settle on the island. Spurred by the governor's promise of free land, Somes and his partner, James Richardson, sailed up what would become Somes Sound in 1761. They chose a spot at the head of the sound, which they christened Somesville.

Eagle Cliff, the subject of Haseltine's drawing, was also the subject of an illustration (fig. 3) that accompanied one of the earliest published articles extolling the scenery of Mount Desert. Written by O. C. Bunce and titled "On the Coast of Maine," the article appeared in William Cullen Bryant's *Picturesque America* in 1874. In his text, Bunce noted that while Harry Fenn was sketching the site, "a splendid bald-eagle" sailed "in wide circles around the head of the cliff, thus giving, to the imagination of the artist, ample justification for the title."[7] Seen from below, the cliff in Fenn's illustration looms large above the tiny sailboat at the shoreline's edge. Haseltine's rendering of the same cliff is less "picturesque"—a more literal representation that offers a sweeping view of the sound in place of Fenn's extreme verticality.

In 1867 Haseltine returned to Europe and settled in Rome, where he remained for the better part of thirty years. He would journey again to Mount Desert, but not before his long residence abroad brought changes in both focus and technique (see cats. 48, 49). | NA

1.
Tuckerman 1966, 556–557.

2.
For biographical information see Helen Haseltine Plowden, *William Stanley Haseltine* (London, 1947), and Marc Simpson, Andrea Henderson, and Sally Mills, *Expressions of Place: The Art of William Stanley Haseltine* [exh. cat., Fine Arts Museums of San Francisco] (San Francisco, 1992). According to Plowden 1947, 28, Weber "grounded him thoroughly in the technique of drawing." We thank Andrea Henderson Fahnestock, City Museum of New York, for assistance with biographical information.

3.
Exh. cat. San Francisco 1992, 159.

4
Bryant 1874, 1:13.

5.
Rebecca Bedell, *The Anatomy of Nature: Geology and American Landscape Painting, 1825–1875* (Princeton, 2001). See in particular chap. 5, 109–121.

6.
Plowden 1947, 168.

7.
Bryant 1874, 15.

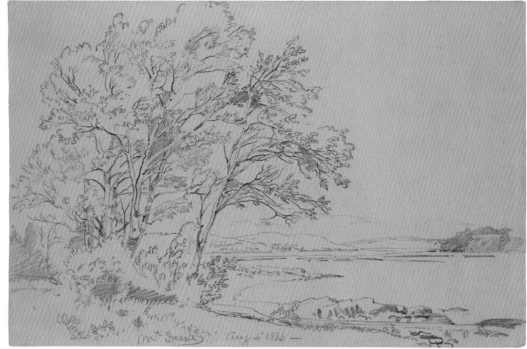

## 39

Mount Desert

William Trost Richards | 1833 – 1905
1866, pencil on gray paper, 15.2 x 23.5 (6 x 9 1/4)

## 40

Rocks at Mount Desert

William Trost Richards | 1833 – 1905
c. 1866, pencil on paper, 15.4 x 23.8 (6 1/16 x 9 3/8)

## 41

Sailboat at the Dock
(probably Mt. Desert)

William Trost Richards | 1833 – 1905
c. 1866, pencil on paper, 15.4 x 23.8 (6 1/16 x 9 3/8)

## 42

Sunrise over Schoodic

William Trost Richards | 1833 – 1905
early 1870s, gouache on paper, 17.5 x 34.6
(6 7/8 x 13 5/8)

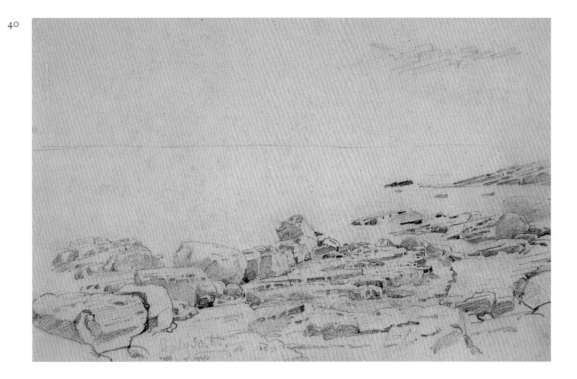

William Trost Richards spent several weeks with his family at Mount Desert Island during the summer of 1866—a critical juncture in his career. For several years prior to his visit, he had been closely associated with the American pre-Raphaelite movement. As the Civil War concluded, however, and Richards matured as an artist, his aesthetic views began to change. Less focused on exquisitely precise images of the natural world, he began to compose rather than copy his subjects. Three drawings in the Wilmerding collection, completed during this transition period, reflect the Ruskinian naturalism of Richards' early years and at the same time foretell the more fluid compositions that characterize his later work.

In the fall of 1866, shortly after his vacation in Maine, Richards set sail for Europe, his second trip to the great museums he had first visited in 1855. As Linda Ferber has noted, Richards' departure for Europe in 1866 effectively marked the end of the first stage of his career. A later watercolor in the Wilmerding collection, also of Mount Desert, clearly reflects the change in Richards' work following his return from Europe.

Richards was born in Philadelphia, the fourth son of a Welsh immigrant who is thought to have been a tailor. He attended public schools in Philadelphia until 1847, when his formal education was cut short by the death of his father and the pressing need to help support his family. By 1850 he was employed as a designer of ornamental ironwork— a position that suggests he may have demonstrated early skills as a draftsman. Like his contemporary, William Stanley Haseltine, Richards studied with Paul Weber, a German artist who arrived in Philadelphia in 1849 and remained for more than a decade. It may have been Weber who initially encouraged Richards to undertake sketching trips in the Pennsylvania countryside, for such subjects are found among his earliest works.

In 1855, on the occasion of the Exposition Universelle in Paris, Richards traveled to Europe for the first time. Astonished by what he saw, he expressed his delight in a letter to his brother, "You cannot imagine what a new world has been opened to me."[1] But he also added, "I have found nothing as yet in the way of Landscape Art to equal the pictures painted by Church of New York."[2]

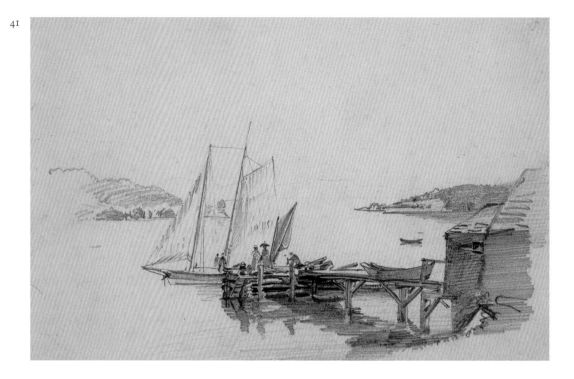

After sketching trips to Switzerland and Italy, Richards traveled to Düsseldorf. In a letter to his fiancée, he declared, "I am convinced that the Germans are greater Masters in the mechanical of Art than any other people—and it is the mechanical of Art that I now most need."[3] In June 1856, after several months in Düsseldorf, Richards returned to Philadelphia.

Having honed his skills abroad, the artist began to produce the paintings and drawings that would bring him his first substantial success. With Frederic Church as his pictorial model and John Ruskin as his theoretical guide, Richards set off on a course that eventually resulted in images so detailed and precise that he would later be invited to join the Association for the Advancement of the Cause of Truth in Art—the American pre-Raphaelites. Founded in 1863 by Thomas Charles Farrer (see cat. 10), an English disciple of Ruskin who had settled in New York in 1860, the short-lived association included the critic Clarence Cook and the geologist Clarence King as well as several artists and architects. The association's publication, *The New Path*,

appeared sporadically between 1863 and 1865. Through this journal, the views of Ruskin and the English pre-Raphaelites were championed well after the 1861 demise of *The Crayon*, the American journal that had initially reported on the English movement and printed extensive excerpts from Ruskin's publications. As Roger Stein has pointed out, Ruskin's blending of art, nature, and religion found a receptive audience in America in the early 1860s, with no more devoted acolyte than William Trost Richards.[4]

By 1863, when Richards joined the newly formed group, he had already produced a series of meticulously rendered paintings and drawings that reflected his early work as a commercial draftsman, his study with Paul Weber, his training in Düsseldorf, and his allegiance to Ruskin's doctrine that an artist should function as a telescope—as an instrument reporting on the factual beauty of the natural world without betraying his own presence.

Richards had so successfully adopted the Ruskinian mode that just weeks before he arrived at Mount Desert in the summer of 1866, the *Boston Evening Transcript* reported that Ruskin himself had

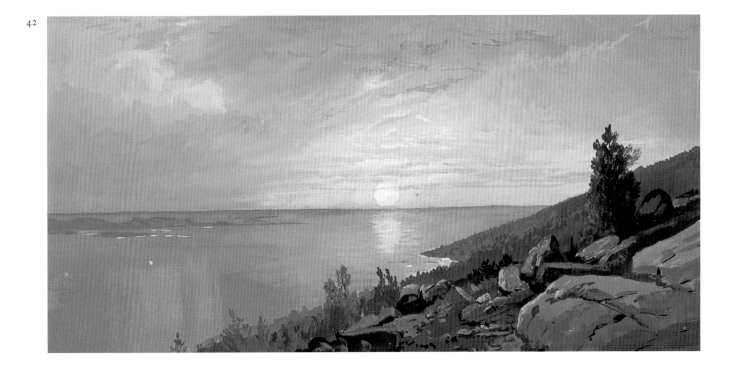

42

praised a work by Richards: "If this is a specimen of American art, the schools of Europe will be able to produce but few equally meritorious."⁵

Ironically, the comment appeared just as Richards was turning away from his strict adherence to the self-effacing "telescoping" Ruskin promoted. Responding, perhaps, to criticism that had been leveled at the pre-Raphaelite approach, Richards gradually moved toward interpretive rather than imitative landscapes.

The most Ruskinian of Richards' three Mount Desert drawings is his study of the island's rocky shore. Long interested in geology, Richards wrote to a friend at Harvard College in 1854, "I almost envy your geological Surveys with Prof. Agassiz." A few years later Ruskin's famous *Study of a Block of Gneiss* (now titled *Fragment of the Alps*, see cat. 33) was exhibited in Philadelphia, where Richards could have examined it at length in the *American Exhibition of British Art*. His own study of shoreline rocks is a carefully worked study of tiered and tumbled rocks defined by light and shadow. Juxtaposing rounded boulders and striated tiers, he captured the essential character of the island's coastal shore.

Far more domestic is the dock scene that may record the coming and going of one of the schooners that ferried visitors from one part of the island to another. Two women, one with a parasol, stand at the end of the dock. Other figures seem engaged in preparing the boat for departure. Clearly representative of a particular (though unidentified) site, the drawing is also an exercise in vertical and horizontal structure. Richards selected a view that allowed for the contrast of sturdy, heavily shadowed pilings and soft, pliable sails.

The third drawing, a shoreline landscape inscribed "August 4, 1866," bears the stamp of Ruskin's mandate to record every leaf, but the composition offers a much broader view. The foliage of the trees is rendered with some detail, but in the distance spare lines define receding hills and the water's edge.

The final work, *Sunrise over Schoodic*, a gouache, likely dates from a later trip, after Richards' return from Europe in 1867. As Linda Ferber has written, Richards responded to pictures he had seen several years earlier by reexamining his own approach to

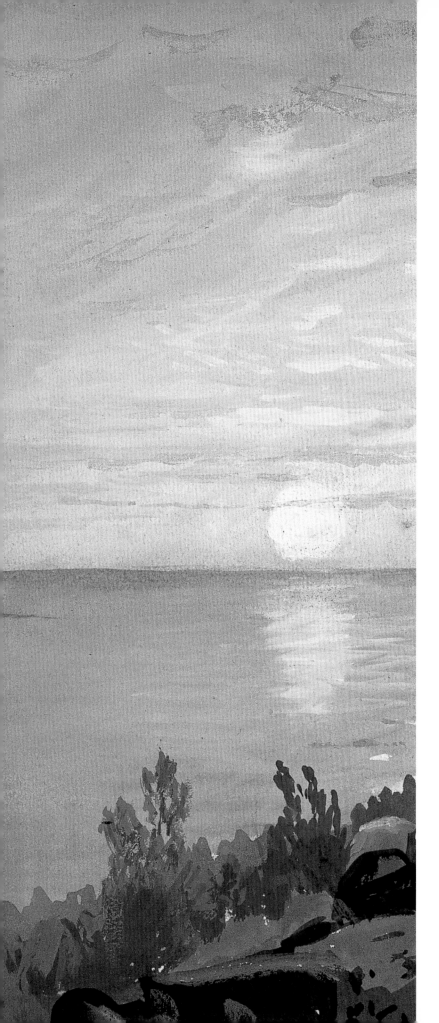

painting—seeking a balance between subject and method, nature and art. Writing to a friend, he declared: "All the great men seem to me to have possessed in common, an intense love for the Appearance of Nature, and an equally intense love for the means and resources of Art.... Among lesser men of...influence, some have been affected very strongly only by the Appearances of Nature, and others have had their principal delight in the means of tender or powerful effects they have found in the difficult material of Art. Both true sources of power, but producing only the best results when equally joined in the highest degree . . . ."[6]

*Sunrise over Schoodic* (the mainland peninsula to the east of Mount Desert Island) represents a dramatic change in Richards' painting style. Gone is the meticulous, leaf-by-leaf representation of nature. Loose and often broad strokes of paint define the landscape. Even the foreground boulders are composed of patches of paint rather than individual strokes marking fissures and cracks. In this later work, Richards is far more concerned with capturing the essence of the landscape than recording the facts of its geologic structure. | NA

1.
Linda S. Ferber, *William Trost Richards: American Landscape & Marine Painter, 1833–1905* [exh. cat., The Brooklyn Museum] (Brooklyn, 1973), 18. We thank Linda S. Ferber for assistance with this entry.

2.
Exh. cat. Brooklyn 1973, 20.

3.
Exh. cat. Brooklyn 1973, 21.

4.
Linda S. Ferber, *William Trost Richards (1833–1905): American Landscape and Marine Painter* (Ph.D. diss., New York, 1980), 131.

5.
"Two Remarkable Pictures," *Boston Evening Transcript* (23 May 1866), 2.

6.
Ferber 1980, 167.

cat. 42 (detail)

The Nubble    Coast of Maine —

## 43

### The Nubble, Coast of Maine

Ralph Albert Blakelock | 1847 – 1919

c. 1865 – 1868, pen and pencil on paper,

12.5 x 20.3 (4 15/16 x 8)

Ralph Albert Blakelock's battles with poverty, mental illness, and deceitful patrons are well known and have garnered considerable recent attention.[1] Blakelock's crisp ink sketches of Maine, however, likely predate the onset of the difficulties that plagued the artist in his later years. The fluid and active lines that characterize Blakelock's drawings of Maine are perhaps more representative of the work he completed during the period of his informal "apprenticeship" with his uncle, James Arthur Johnson, an amateur artist and musician.[2] It was Johnson who served as friend and mentor to young Blakelock as he gradually abandoned plans to become a physician (as his father wished) and turned instead to art.

In the fall of 1864, at age seventeen, Blakelock entered the Free Academy of the City of New York (later City College of New York). The required curriculum included instruction in drawing with a view toward practical application. Blakelock purportedly excelled at drawing, though he found his instructor, Hermann Koerner, uninspiring. James Johnson provided access to a more stimulating environment when he introduced Blakelock to several residents of the Tenth Street Studio Building, New York's premier address for artists. For the better part of nine months many of the city's most prominent artists worked in their Tenth Street studios, where they frequently received visitors. During the summer months, however, the artists often closed their studios and set out on extended sketching trips to gather material for their winter's work.

In the summer of 1865 Blakelock joined the exodus and traveled to Arlington, Vermont, where James Johnson had acquired a summer home. Blakelock and his uncle reportedly spent much of the summer sketching in the surrounding countryside. It was during this summer that the artist met his future wife, Cora Rebecca Bailey, who later recalled,

"we roamed the country together all that summer; he sketching and painting while I sat by his side."[3]

During subsequent summers in Vermont, Blakelock and his uncle undertook extended sketching trips in the White Mountains of New Hampshire and along the coast of Maine. It seems likely that *The Nubble, Coast of Maine* was completed during one of these trips.

The Nubble, a small island off the southern coast of Maine near York Harbor (fig. 1), is now the site of one of the most famous lighthouses in America.[4] The island, approximately 250 yards long and, at its southern end, 60 feet high, was first described by Bartholomew Gosnold, who met with a group of Indians on the rocky prominence in 1602. Twelve years later, Captain John Smith took note of the island on his second voyage to America. A member of his crew is generally credited with the appellation "Knubble," which has since become "Nubble."[5] The lighthouse, which still warns ships away from treacherous rocks, was completed in 1879. Blakelock's drawing clearly predates the construction of the lighthouse.

According to Susielies M. Blakelock, wife of the artist's grandson, *The Nubble, Coast of Maine* was once part of a large sketchbook that also contained drawings from the artist's early trips west in 1869 and 1872.[6] In its original state, the sketchbook included pages with six to eight drawings each. Following Blakelock's death, the pages were cut apart and the drawings distributed among the artist's wife and children. *The Nubble* was included in the group that

passed from Cora Rebecca Bailey Blakelock, the artist's widow, to her son, Allen Osborne Blakelock, and subsequently through the family until sold by Vose Galleries in 1981. Several additional drawings of Maine, among them two of nearby York Harbor, were also included in the group.[7]

Blakelock's drawing of "The Nubble" is elegant in its simplicity. The artist appears to have first sketched the site in pencil and later strengthened his lines with ink. Remnants of a pencil notation ("The Nubble Maine") remain visible below the later ink inscription: "The Nubble Coast of Maine." A faint pencil line beneath the more visible ink line at the horizon suggests a slight change in viewpoint during the later reworking. With true economy of line, Blakelock captured the rugged profile of the coastal island and thus the threat it posed to passing ships. | NA

1.
See in particular Dorinda Evans, "Art and Deception: Ralph Blakelock and His Guardian," *The American Art Journal* 19 (1987), 39–50; Abraham A. Davidson, *Ralph Albert Blakelock* (University Park, Pa., 1996); and Glyn Vincent, *The Unknown Night: The Genius and Madness of R. A. Blakelock, An American Painter* (New York, 2003).

2.
James Arthur Johnson had married Emily Blakelock, the younger sister of the artist's father. A detailed account of Johnson's influence on Blakelock appears in Vincent 2003, chaps. 6–8.

3.
Vincent 2003, 77.

4.
For "The Nubble" see Clifford Shattuck, *The Nubble, Cape Neddick Lightstation, York, Maine* (Freeport, Maine, 1979). We thank Virginia Spiller of the Old York Historical Society, York, Maine, for her assistance in locating a photograph of "The Nubble."

5.
According to the Oxford English Dictionary, the meaning of the word "knubble" relates to "knuckle" and "knob." The variant "nubble" is defined as a "small knob or lump" and "nubbly" as "having numerous small protuberances; knobby, lumpy."

6.
Susielies M. Blakelock's comments appear in *Ralph Albert Blakelock, 1847–1919, Drawings* [exh. cat., Vose Galleries] (Boston, 1981), 2.

7.
Four drawings of Maine, including *The Nubble*, are reproduced in exh. cat. Boston 1981, 3.

fig. 1
*The Nubble, Cape Neddick Lightstation, York, Maine,* photograph, Courtesy Old York Historical Society, York, Maine

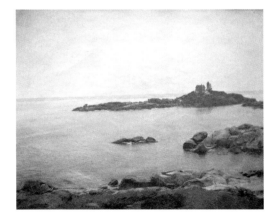

## 44

### Rocks near the Landing at Bald Porcupine Island, Bar Harbor

Felix Octavius Carr Darley | 1822–1888
1872, pencil and wash on paper, 25.2 x 35.4
(9 15/16 x 13 15/16)

While his name may not be familiar today, Felix Octavius Carr Darley was the premier illustrator of nineteenth-century America. He is thought to have made some four thousand drawings, the majority of which were used as the basis for engraved magazine and book illustrations as well as banknote designs. His most famous images were of the characters and scenes from the novels of Washington Irving; he became almost as closely identified with these stories as the author himself.

Although essentially self-taught, Darley exhibited his drawings at the Pennsylvania Academy of the Fine Arts, in his hometown of Philadelphia, as early as 1844. Early in his career he demonstrated complete mastery of anatomy, perspective, and line, creating figures and vignettes that could be dramatic or humorous but were always believable. Between 1848 and 1859 Darley lived in New York and kept company with some of the most celebrated artists of the day, including Frederic Church, Jasper Francis Cropsey, and William Casilear, fellow members of the Century Club.[1] Although Darley was primarily an illustrator of literary and genre subjects, he was keenly observant of all things visual and would certainly have had intimate knowledge of his colleagues' landscape paintings. Travel also broadened his descriptive powers. After visiting England and the Continent with his wife in 1866–1867, Darley published his recollections, both text and illustrations, in *Sketches Abroad with Pen and Pencil* (Boston, New York, and London, 1868).

*Rocks near the Landing at Bald Porcupine Island* is one of three known drawings of Mount Desert Island, Maine, made by the artist in 1872. Two of these, this example and another titled *The Ovens— Mt. Desert*, were exhibited at the National Academy of Design in 1874.[2] It is not surprising that Darley chose to visit Mount Desert, for it was already a popular destination for artists by the 1850s. The "Porcupines," small islands just off of Bar Harbor, on the northeast coast of Mount Desert, acquired their name because, as noted by one of the artist's contemporaries, "seen at a distance, or under the misty veil which so often hangs about them, their abrupt form on the sea front, tapering to a point inland, their backs bristling with the sharp-pointed tops of pine and cedar trees, they are sufficiently like the porcupine to bear that name....Bald Porcupine... as seen from the neighboring land, has a gaunt, bare and forbidding aspect, but when you have gained a foothold upon its ragged shore, a thousand pictures present themselves to your delighted eyes."[3]

By 1872, the year Darley visited the location, Bald Porcupine had recently been purchased by the famous Western adventurer, General John C. Fremont.[4] Darley's drawing of the site, executed during his mature career, displays his strengths in composition and observation of detail, and especially his sensitivity to values and contrast. Applied with an exceedingly sure hand, Darley's pencil delineates the jagged, darkly creviced, rock-strewn shore and the tall but weather-beaten pines clinging to the rough outcroppings. The atmospheric, softly suggested land seen in the background is likely Mount Cadillac, the tallest peak on Mount Desert. *Bald Porcupine Island* is not a simple preparatory sketch but a drawing worked to a high degree of finish, intended for exhibition and sale.[5] | DC

1.
*Illustrated by Darley* [exh. cat., Delaware Art Museum] (Wilmington, Del., 1978), 13.

2.
*The Ovens—Mt. Desert* (Schiek Collection) and the third of these subjects by Darley, *Mt. Desert Island* (The Free Library of Philadelphia), are illustrated in exh. cat. Wilmington 1978, 136, nos. 135 and 136, respectively. Two drawings, with titles similar to those Darley showed at the National Academy of Design, were also shown at the Century Club in 1874; see Nancy Finlay, *Inventing the American Past: The Art of F.O.C. Darley* (New York, 1999), 37 n. 31.

3.
George Ward Nichols, "Mount Desert," *Harper's New Monthly Magazine* (August 1872), 328.

4.
"Miscellany—Mount Desert," *Appleton's Journal of Literature, Science, and Art* (5 October 1872), 389.

5.
Darley's drawings were highly valued. Nancy Finlay notes that an account book for the years 1853 to 1875 "records an increasing number of independent commissions for drawings and paintings that sold for increasingly higher prices as time went on." Finlay 1999, 30.

## 45

### Coastline near Otter Cliffs, Mount Desert Island

Alfred Thompson Bricher | 1837–1908

c. 1870s, watercolor on paper, 8.9 x 21.9

(3 1/2 x 8 5/8)

Alfred Bricher first visited Maine at the very outset of his professional career, making sketches on Mount Desert Island alongside Charles Temple Dix and William Stanley Haseltine in the summer of 1859, the same year he established a studio in Boston.[1] After moving to New York in 1868, Bricher's works were regularly included in the annual exhibitions of the National Academy of Design and the American Society of Painters in Water Colors, up until his death. Beginning in 1866, Louis Prang also published Bricher's paintings as chromolithographs in Boston, and in the late 1870s, Bricher illustrated articles for *Harper's New Monthly Magazine*. In addition to Maine, Bricher traveled widely throughout the Hudson River Valley and New England, and he also ventured as far west as Iowa, Wisconsin, and Minnesota on the upper Mississippi River and as far north as Nova Scotia and Grand Manan Island. His knowledge of the eastern seaboard was so extensive

that in 1895 the critic Arthur Hoeber commented there was "Scarcely a corner but is familiar to him."[2]

Although *The Art Journal* recognized Bricher by 1875 as having "already assumed a leading position as an artist, not only as a marine painter, but also in the delineation of landscapes,"[3] during the 1870s he was regularly accused of lacking originality and even of copying William Trost Richards' style. On 8 February 1874, a critic for the *New York Times* wrote: "We cannot but admire Mr. Bricher's skill and power of expression…yet all of Mr. Bricher's pictures remind us so strongly of the work of another well-known artist that we must fain believe that Mr. Bricher's inspiration is taken at second hand."[4] In April 1874 *Scribner's Monthly* noted, "Mr. Bricher generally reminds us of Mr. Richards."[5] A year later the criticism still persisted in a review of the annual show at the National Academy of Design: "No one can doubt Mr. Bricher's technical skill, but his pictures would bear a much higher value did they not so strongly resemble the work of other artists. In the north room is a large work…which is an echo of Mr. W. T. Richards."[6]

In looking at Bricher's work of the 1870s, such criticism seems overstated and the comparison misplaced. Given the shared subject matter, inevitably a relationship exists between many of Richards' and Bricher's marine studies, but Bricher's works, especially his drawings, show a special obsession with shoreline views not evident in Richards' oeuvre. While

Bricher introduced the variation of female figures at the shore around 1880, his interest in these types of marine compositions remained essentially undiminished for the rest of his life. Bricher's work in this area, in other words, was more than just a passing phase in his art; it was something he specialized in and continuously refined. Not surprisingly, as the years went by, negative comparisons with Richards became less relevant and finally faded away. As Jeffrey Brown has suggested, the seemingly endless variations on shore themes, in fact, appear more closely related to Martin Johnson Heade, whose method of reworking a theme until every possible permutation had been explored may have influenced Bricher.[7]

*Coastline near Otter Cliffs, Mount Desert Island,* is a quiet and unassuming, yet impressive work. The line of its gently sloping hills divides the composition diagonally, with the wedge of sky and water on the left matched and balanced by that of the shore and mountain on the right. The recession in space from foreground to background describes a spectrum that moves from microcosmic to macrocosmic forms —from tidal pools to bay, ocean, and sky, and from sand to rocks, boulders, and mountains. Recalling the subtle moods and monumental forms of Heade's series of marsh scenes with haystacks, Bricher's treatment of the theme of the low tide culminates at the end of the century in paintings such as *Low Tide, Hetherington's Cove* and *Low Tide, Maine,* works that Brown described as "definitive statements of all the low tides he knew—massive, irregular boulders protruding like skeletons from their fleshy shrouds of seaweed, limpid tidal pools reflecting the evanescence of changing skies, and pebbles and rippling wavelets breaking up large shimmering planes of beach and tide-calmed sea."[8] Bricher's scenes of low tide may reflect something of his own temperament —calm, dependable, placid—he seems rarely to have deviated from his yearly schedule of travel, studio work, and exhibition commitments.

Given the persistence of the subject of the low tide in Bricher's work from the 1870s to the late 1890s, as well as uncertainties about the number of times the artist may have visited Maine, it is difficult definitively to date *Coastline near Otter Cliffs, Mount Desert Island.*[9] The sketch, however, may very well be among those referred to in *Appletons' Journal* in 1875: "Mr. Bricher spent part of the past summer at Mount Desert, and has a large collection of watercolor sketches of the bold and romantic scenery of that rugged island. He paid particular attention to the study of the rock formation of the island, all of which will be of value to him in the composition of pictures."[10] | CB

1.
For Bricher's biography see Jeffrey R. Brown, *Alfred Thompson Bricher* [exh. cat., Indianapolis Museum of Art] (Indianapolis, 1973).

2.
Arthur Hoeber, "My Pet Subject," *The Monthly Illustrator* (June 1895), 352.

3.
"American Painters—Alfred T. Bricher," *The Art Journal* 1, 11 (November 1875), 340.

4.
"The Water-Color Exhibition Second Notice," *New York Times* (8 February 1874), 3.

5.
"American Water Colors," *Scribner's Monthly* 7, 6 (April 1874), 760.

6.
"The Fine Arts," *New York Times* (7 February 1875), 9.

7.
Exh. cat. Indianapolis 1973, 20.

8.
Exh. cat. Indianapolis 1973, 31–32.

9.
Bricher exhibited Mount Desert subjects in 1864, 1871, 1875, and 1894, as documented by Pamela Belanger in exh. cat. Rockland 1999, 168.

10.
"The Arts," *Appletons' Journal of Literature, Science and Art* 14, 343 (16 October 1875), 505.

# 46

## Otter Cliffs

George Henry Smillie | 1840–1921
1893, pencil and watercolor on paper,
25.1 x 35.6 (9⁷/₈ x 14)

# 47

## Seal Harbor, Mount Desert

George Henry Smillie | 1840–1921
c. 1893, watercolor on paper, 35.9 x 54
(14¹/₈ x 21¹/₄)

In 1868 a critic for the *New York Evening Mail* dubbed George Henry Smillie and his older brother James David Smillie "The Dioscuri of the New York Art firmament"—an apt allusion to the twin heroes of classical mythology, Pollux and Castor, who were transformed into the Gemini constellation by Zeus.[1] Sons of James Smillie, the celebrated engraver of important Hudson River School paintings such as Thomas Cole's *Voyage of Life* series and Albert Bierstadt's *The Rocky Mountains*, the two brothers' lives were inextricably bound together by kinship and shared interests. They traveled together, worked side by side in adjacent studios, helped each other with their paintings, were given joint commissions, and even married in the same year. The depth of their attachment was evident following James' death in 1909, when George deemed it fitting to complete and cosign several of his brother's unfinished canvases.

Unlike James, an accomplished etcher and engraver who largely abandoned painting for printmaking in the 1880s, George was always primarily a

47

painter in oils and watercolors. He first exhibited at the National Academy of Design in 1862, becoming an associate member in 1864. In 1868 he was elected a member of the American Society of Painters in Water Colors. During the 1860s he traveled with his brother in search of subjects to the Catskills and Berkshire Mountains, to rural western Pennsylvania, and to the White Mountains and Adirondacks. A trip to the Far West in the summer of 1871 took Smillie to San Francisco, Yosemite, and the Rocky Mountains. In March 1873 he suffered a breakdown of some kind. Smillie eventually regained his health and in 1879 reemerged as an important figure with the exhibition of his *Goat Pasture* at the National Academy of Design. Unlike his brother, during the late 1870s and early 1880s Smillie responded effectively to the declining fortunes of the Hudson River School by changing his style so that his landscapes conveyed moods and feelings more than specific places.

In search of patronage in early August 1893, Smillie traveled to Bar Harbor, a well-established summer resort in Maine frequented by bankers, diplomats, and other members of high society. On

6 August 1893 the *New York Times* published a listing of notable visitors such as George Vanderbilt and John Jacob Astor, as well as lesser-known figures such as Smillie himself, and chronicled some of the leisure activities available to vacationers during the season:

The Kebo Valley Club…will keep the members busy. There is music at 11 o'clock every morning and dinners Wednesdays and Saturdays at 7:30, followed by dancing at 9 o'clock. Saturday is the most fashionable night. A tennis tournament to last a week begins on the 7th….A flower parade, theatricals, races, and athletic sports are planned. Afternoon teas will be given every Thursday at 5 o'clock, which are presided over by different ladies. There are to be children's dances one afternoon a week and whatever else may be evolved that can amuse.[2]

In contrast, the concerns voiced in a letter of 5 August from Smillie to his wife, the artist Nellie Jacobs, asking her to join him and encouraging her to try to sell her own flower paintings, reflected the new economic reality ushered in by the recent stock market crash of 27 June:

These seem to be hard times with everyone, dear wife, and we must hope for a turn in the tide....It takes a little time to work up a place and I think I am strengthening myself here and becoming more acquainted. You know these rich people are not easy to get at, but if once reached it means a good deal....Things have been improving in interest and you can help by being in the studio mornings when you can work quietly while I am out to see anyone who may want to come to see the pictures. I have had a number of callers since my last "Wednesday"....There are quantities of flowers can be bought here for a small price....I know you can improve the occasion and really make it pay....An old gentleman who came in with Mr. Norcross said when your wife comes soon I am going to bring my wife to the studio for I admire these flower pictures very much....[3]

Smillie and his wife must have been encouraged to some degree by the response to their work because they returned to Bar Harbor for the next two summers even as the economic downturn continued.

Smillie had articulated his approach to new landscape subjects earlier when talking about the appeal of Marblehead, Massachusetts, in terms that can be applied to his Maine excursions as well:

The reason I like Marblehead is that it gives me ideas to work from. There is character about those rough fields and those ledges and boulders. I wander over them all summer, not painting much, but quietly soaking up the scenery and getting myself tuned to that particular note that sounds in those airy gray and green landscapes. Then, when I come home, although I have no record of particular places, I have an impression of the whole, and the impression crystallizes into pictures. I deliberately avoided seeking out picturesque subjects, choosing instead the more abstract, simple, scenery, something that gives me a chance.[4]

The two watercolors, *Otter Cliffs* and *Seal Harbor, Mount Desert*, are examples of the "more abstract, simple, scenery" that Smillie preferred. Both have similar compositions featuring steep, rocky inclines cutting down and diagonally from corner to corner across the picture plane; these are balanced by open expanses of water and sky defined by sharp horizon lines. Whereas *Seal Harbor, Mount Desert* is a full-fledged watercolor characterized by impressionistic effects of color and light, *Otter Cliffs* is a detailed pencil study of rocks with very little attention paid to

the atmospheric envelope of sea and sky. The comparison illuminates how the innovations of Smillie's later post-1880 style, with its emphasis on brilliant colors and broken brushwork, was dependent on the close studies and skilled draftsmanship that characterized his earlier works in the Hudson River School manner. This distinction served as the basis for Smillie's frequent assertions that he was not an impressionist. For Smillie, the striking simplicity of his late designs was employed to convey feelings and moods, not objectively to render optical effects. Near the end of his career, he marveled at the fact that while the definition of landscape painting, as illustrated by *Otter Cliffs* and *Seal Harbor, Mount Desert*, could be reduced to a horizon crossed by a diagonal, it was nevertheless a formula capable of expressing an endless variety of emotions: "Yet what diversity of expression may be got out of [these two lines] and how much of tragedy or sentiment may be told by them!...The longer man lives the simpler grows the composition."[5] | CB

1.
*New York Evening Mail* (4 February 1868), as quoted in Brucia Witthoft, "George Smillie, N.A.: The Life of an Artist," *American Art Review* 5, no. 1 (Summer 1992), 130.

2.
"Bar Harbor Is Waking Up," *New York Times* (6 August 1893), 13.

3.
Smillie to Nellie Smillie, 5 August 1894, quoted in Witthoft, "George Smillie," 139–140.

4.
Untitled clipping, *Brooklyn Eagle* (6 December 1885), as quoted in Witthoft, "George Smillie," 138.

5.
Unidentified clipping, signed Geo. H. Smillie, as quoted in Witthoft, "George Smillie," 141.

48

# 48

## Northeast Harbor, Maine

William Stanley Haseltine | 1835 – 1900
1895, watercolor and Chinese white on paper,
38.4 x 56.2 (15 1/8 x 22 1/8)

# 49

## Northeast Harbor, Maine

William Stanley Haseltine | 1835 – 1900
1895, gouache on paper, 38.1 x 56.8 (15 x 22 3/8)

In the spring of 1893 Haseltine returned to America
and just a few weeks later traveled to Mount Desert
Island. By then the island had become one of the
most fashionable summer resorts on the East Coast.
Palatial "cottages" built by Vanderbilts, Rockefellers,
Morgans, and Astors had begun to dot the landscape.
Following the summer season Haseltine returned to
Rome. Two years later, in 1895, he traveled again to
Mount Desert where he spent much of the summer
among friends at Northeast Harbor. Two exquisite
watercolors in the Wilmerding collection—both of
Northeast Harbor—date from this summer visit.

These highly finished watercolors, each approxi-
mately 15 by 22 inches, attest to the changes that had
occurred within both Haseltine's work and American
landscape painting (see cats. 35–38). The artist's
earlier focus on dramatic rock formations rendered
with Ruskinian attention to geologic detail gave way
to more fluid views, delicate in color and often sprin-
kled with softly filtered light. Haseltine's daughter
later wrote of the change in her father's work,
acknowledging his debt to French impressionism
by calling him a "Pre-Monet Impressionist."[1]

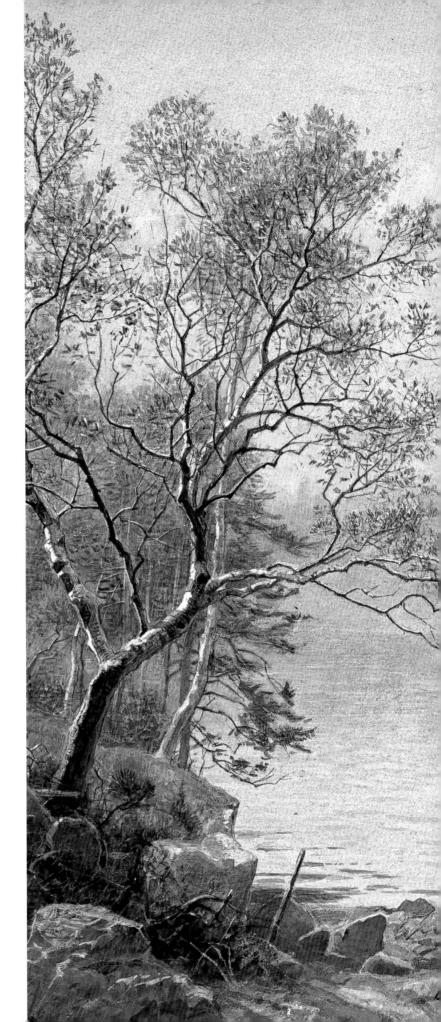

cat. 49 (detail)

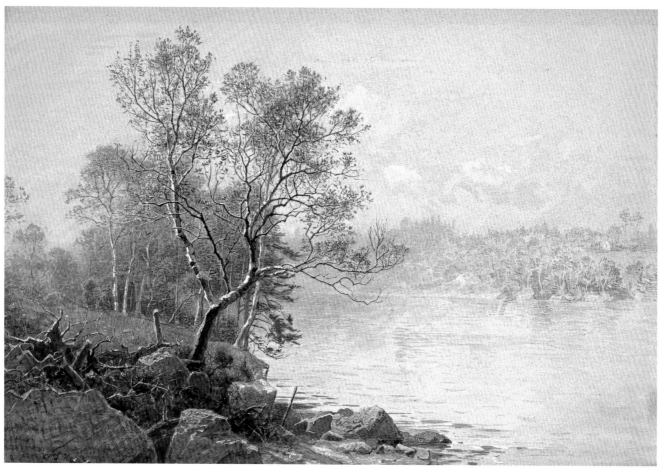

49

As John Wilmerding has noted, Haseltine's late watercolors of Mount Desert frequently look inward, toward protected harbors, rather than outward to sea.[2] In both these plein-air views the artist (and the viewer) metaphorically "stand" at shoreline's edge looking toward the inner harbor. In place of the waves that thundered against coastal rocks in earlier works (cat. 37), Haseltine's later paintings feature reflective water lapping quietly at the roots of graceful birch and aspen trees. The textured rocks for which Haseltine had long been celebrated are still present. Now, however, they serve art more directly than science. | NA

1.
Plowden 1947, 83.

2.
Wilmerding 1994, 120.

## 50

### Entrance of Somes Sound,
### Mount Desert

John Marin | 1870 – 1953
1922, watercolor on paper, 12.5 x 20 (4 $^{15}/_{16}$ x 7 $^{7}/_{8}$)

## 51

### View across Somes Sound,
### Mount Desert

John Marin | 1870 – 1953
1922, watercolor on paper, 12.5 x 20 (4 $^{15}/_{16}$ x 7 $^{7}/_{8}$)

Among the circle of artists that surrounded Alfred
Stieglitz at the 291 gallery beginning in 1905, John
Marin was the first to achieve a fully developed,
personal, modern style. In anticipation of the Armory
Show in 1913, Stieglitz assiduously promoted Marin's
radically fragmented watercolors of New York in
order to call attention to the burgeoning American
avant-garde he was cultivating at 291. Following
the Armory exhibition, Marin's reputation took root,
and by mid-century his long and productive rela-
tionship with Stieglitz had made him perhaps the
best-known artist in the United States.

When Stieglitz met Marin in Paris in June
1909, he encouraged him to embrace a more experi-
mental style. He eventually offered the young artist
the practical support he needed to return to New
York in 1910 and pursue a more radical aesthetic in
America. As a photographer Stieglitz consistently
championed works on paper at 291 and paid little
attention to hierarchies that elevated painting and
sculpture over other media. He especially appreciated
Marin's natural mastery of watercolor. Indeed, the
drawings and watercolors by Henri Matisse and Paul
Cézanne that Stieglitz made available to Marin at

his gallery may have been more critical to Marin's evolution as a watercolorist than the works of the French avant-garde he had seen previously in Paris.

In August 1922 Marin visited the painter Arthur B. Carles in Southwest Harbor on Mount Desert. During his stay, he went along the island's coast in a small motorboat with his sketchbooks and executed a series of approximately forty-seven watercolors, including *Entrance of Somes Sound* and *View across Somes Sound*. He used two different types of paper—one a very light stock similar to tracing paper and the other a heavier, more traditional watercolor stock. The works were primarily done in two formats—about two-thirds are approximately 7 by 7 inches and the balance a more horizontal 5 by 8 inches. The watercolors were executed quickly and spontaneously as "minute sketches," a term that applies equally to the time needed to complete them and to their relatively small size.

*Entrance of Somes Sound* and *View across Somes Sound*, both in the horizontal 5 by 8 inch-format, offer a compendium of Marin's rich vocabulary of watercolor gestures. Dynamic lines, dashes, and dots, and vibrant swaths of color float on the white ground of the paper. These effects echo those found in works Marin had seen at 291, such as the saturated bands of striated color and the spare designs of Matisse's Collioure watercolors, shown in 1908; the forceful, prismatic structures of Cézanne's watercolors exhibited in 1911; and the expressionistic calligraphy of Wassily Kandinsky's seminal *Garden of Love*, which Stieglitz purchased for 291 from the Armory Show in 1913.[1] As part of an ensemble, the watercolors also demonstrate how Marin's works flow into one another in an endless current of spontaneous creative activity. This sense of fluidity, continuity, and seriality, while more explicit in a well-defined group of works like the "minute sketches," is characteristic of his entire oeuvre.

Marin had formulated the idea of sketching Mount Desert from a boat during his first trip to the island in September 1919. Blithely unaware of the many artists who had preceded him there, he wrote to Stieglitz: "Since my last writing I have taken a rare trip no one had told me of. Mount Desert. I expected one mountain. There are mountains every-where piling up out of the sea, mountains tumbling over and into one another with curious shapes and most wonderful islands, severe, rocky, forbidding, beautiful. 'Isles of the Sea,' weird phantoms of

fig. 1
Arnold Böcklin, *Island of the Dead,* 1880, oil on wood, The Metropolitan Museum of Art, New York, Reisinger Fund, 1926

monsters, unreal yet strangely real. One would approach them in a boat all alone, a little boat, built somewheres [sic], that was equally at home in smooth or troubled waters."[2]

The image Marin evoked in his letter, of a lone boat approaching a "forbidding" island haunted by "weird phantoms…unreal yet strangely real," likely alludes to a painting Stieglitz once owned, a reproduction of a popular masterpiece of symbolist painting, Arnold Böcklin's *Island of the Dead* (fig. 1), which had hung in Stieglitz's New York apartment.[3] The morbidity of Böcklin's painting of a figure on a boat bearing a coffin stands in absolute, stark contrast to the liveliness and spontaneity of Marin's watercolors of Mount Desert. The comparison is nevertheless a reminder of how important symbolist notions were to the development of modernism in general and to the Stieglitz circle in particular. Both artists' works are evocations; Böcklin's of the stillness, ineffability, and disembodiment of death, Marin's of the dynamism, palpability, and all-engulfing tumult of life. | CB

1.
For works shown at 291 see Sarah Greenough et al., *Modern Art and America: Alfred Stieglitz and His New York Galleries* [exh. cat., National Gallery of Art] (Washington, 2000).

2.
Herbert J. Seligmann, ed., *Letters of John Marin* (New York, 1931), n.p.

3.
Edward Steichen described Stieglitz's apartment in *A Life in Photography* (Garden City, N.Y., 1963), n.p.

Provenance, Exhibition History, and References |
Bibliography of John Wilmerding's Published Works | Index
| Photographic Credits

# Provenance, Exhibition History, and References

## 1

### Mississippi Boatman

George Caleb Bingham, 1850, oil on canvas, 61 x 44.5 (24 x 17½)

Signed and dated, lower left: G.C. Bingham/1850

Provenance: Art Union of Philadelphia, 1851 (listed for sale, $60); found in Rhode Island in the 1940s by B.R. Leviss, Fall River, Mass.; [Vose Galleries, Boston, 1965]; acquired 1965.

Exhibitions: *Catalogue of Prizes to Be Distributed on Dec. 31, 1852*, Philadelphia Art Union, 1851?, no. 51; *George Caleb Bingham 1811–1879*, National Collection of Fine Arts, Smithsonian Institution, Washington; Cleveland Museum of Art; The Art Galleries, University of California at Los Angeles, 1967–1968, no. 17.

References: *Philadelphia Art Union Reporter* 1 (January 1851–January 1852), no. 51; Philadelphia Art Union, *Catalogue of Prizes to Be Distributed on Dec. 31, 1852*; John Francis McDermott, *George Caleb Bingham River Portraitist* (Norman, Okla., 1959), 416, no. 58; Wilmerding, "George Caleb Bingham," 556–557, 556, ill.; E. Maurice Bloch, *George Caleb Bingham: The Evolution of an Artist and A Catalogue Raisonné* (Berkeley and Los Angeles, 1967), 106–107, 169, 335/ 76 (A194), 238 (postscript); E. Maurice Bloch, *The Drawings of*

*George Caleb Bingham: With a Catalogue Raisonné* (Columbia, Mo., 1975), 119, ill. pl. IX; E. Maurice Bloch, *The Paintings of George Caleb Bingham* (Columbia, Mo., 1986), 190, 82, ill.; Wilmerding 1999, 120–121, pl. 10, color ill.

## 2

### Portrait of Thomas Cole

Frederic Edwin Church, c. 1845, pencil on paper, 17.5 x 15.2 (6⅞ x 6)

Signed, lower left: F. Church; inscribed, bottom center: Thomas Cole

Provenance: Thomas Cole, Catskill, N.Y., until 1848; his son, Theodore Cole; his daughter, Mary Emily Cole Van Loan, until 1967; [Hirschl & Adler Galleries, New York]; acquired 1973.

Reference: Franklin Kelly, *Frederic Edwin Church and the National Landscape* (Washington, 1988), 1, xii, ill.

## 3

### Fog off Mount Desert

Frederic Edwin Church, 1850, oil on academy board, 29.2 x 39.4 (11½ x 15½)

Inscribed and dated, lower center: MT. DESERT/1850

Provenance: The American Art-Union, New York; sold by the Art-Union at auction to Samuel W. Bridgham, New York, December 1852; private collection, Michigan; [Alexander Gallery, New York, c. 1983]; [Hirschl & Adler Galleries, New York], acquired 1985.

Exhibition: American Art-Union (annual exhibition), 1851, no. 135.

References: Mahonri S. Young, "Other Regionalisms in American Painting," *Apollo* (November 1984), 333, ill.;

Kelly 1988, 36, 37, fig. 32, 145 n. 73; Franklin Kelly, "Lane and Church in Maine," in exh. cat. Washington 1988, 136–137, ill. fig. 7; Wilmerding 1994, 81–82, 187, color ill.

## 4

### Newport Mountain, Mount Desert

Frederic Edwin Church, 1851, oil on canvas, 54 x 79.4 (21¼ x 31¼)

Signed and dated, lower left: F. Church '51

Provenance: Sotheby's, New York, sold at auction 2 June 1983, no. 42; [Hirschl & Adler Galleries, New York]; acquired 1983.

References: Kelly, "Lane and Church," in exh. cat. Washington 1988, 137–138, ill. fig. 9; Wilmerding 1994, 83–85, 187, color ill.; Pamela J. Belanger, *Inventing Acadia: Artists and Tourists at Mount Desert* [exh. cat., The Farnsworth Art Museum] (Rockland, Maine, 1999), 56–58, color ill.

## 5

### Still Life with Crab Apples and Grapes

Joseph Decker, 1888, oil on canvas, 21 x 35.6 (8¼ x 14)

Signed and dated, lower right: J. Decker. 88

Provenance: Dr. James Piccolo, New Haven, Conn., until 1972; Yale University Art Gallery until 1987; acquired 1987.

Exhibitions: *Variations on a Theme: Still Life Painting in America*, Hirschl & Adler Galleries, New York, 1988–1989, checklist no. 10; *Counterpoint: Two Centuries of American Masters*, Hirschl & Adler Galleries, New York, 1990, no. 16.

References: Richard York Gallery, *An American Gallery, III* (New York, 1987), no. 9, color ill.; William H. Gerdts, *Joseph Decker (1853–1924): Still Lifes, Landscapes and Images of Youth* [exh. cat., Coe Kerr Gallery] (New York, 1988), n.p., as *Grapes and Crab Apples*.

## 6

### Still Life of Flowers

Adelheid Dietrich, 1868, oil on wood, 36.5 x 26 (14⅜ x 10¼)

Signed and dated, lower left: gem./v. Adelheid Dietrich 68

Provenance: [Goupil's, New York]; Maj. General Lucius H. Allen, San Francisco; his daughter and son-in-law, Harriet and Jonathan G. Kittle, San Francisco; their daughter, Lucia Hamilton Kittle Sherman, San Francisco; her stepson, Frederick Barreda Sherman, Mill Valley, Calif., 1946; his wife, Cornelia Ripley Sherman, Mill Valley, Calif.; her estate, until 2000; [Sotheby's, New York, 30 November 2000, lot 116]; [Hirschl & Adler Galleries, New York, sold 11 May 2002]; acquired 2002.

## 7

### Drifting

Thomas Eakins, 1875, watercolor on paper, 28.3 x 41.9 (11⅛ x 16½)

Signed and dated, lower right: Eakins 75

Provenance: The artist; sale, Pennsylvania Academy of the Fine Arts, 1880, to benefit the family of Christian Schussele (purchaser not recorded); private collection, Philadelphia; Robert Carlen Gallery, Philadelphia, 1967; Mr. and Mrs. Elmer E. Pratt, Radnor, Pa.; Thomas S. Pratt; [Hirschl & Adler Galleries, New York, 2002]; acquired 2002.

Exhibitions: *8th Annual Exhibition*, American Society of Painters in Watercolor, New York, 1875, no. 208 (as *No Wind—Race Boats Drifting*); *Water-Color Drawings Loaned to the Pennsylvania Academy of Fine Arts*, Pennsylvania Academy of the Fine Arts, Philadelphia, 1877–1878, no. 18 (as *No Wind, Race-Boats Drifting*); *Louisville Industrial Exposition*, Louisville, Ky., 1879, no. 310 (as *Waiting for a Breeze*); *Thomas Eakins*, Whitney Museum of American Art, New York, 1970, no. 19.

References: Thomas Eakins Record Book 1, 11; Thomas Eakins Record Book 2, 20; Lloyd Goodrich, *Thomas Eakins: His Life and Work* (New York, 1933), 167; Margaret McHenry, *Thomas Eakins Who Painted* (Oreland, Pa., 1946), 162; Donelson F. Hoopes, *Eakins Watercolors* (New York, 1971), 34–37, pl. 7, color (det., cover); Gordon Hendricks, *The Life and Work of Thomas Eakins* (New York, 1974), 83, 84; Theodor Siegl, *The Thomas Eakins Collection* (Philadelphia, 1978), 57–59; Lloyd Goodrich, *Thomas Eakins*, 2 vols. (Washington, 1982), 1:89, 91, 108, 165, fig. 33; Kathleen A. Foster, "Makers of the American Watercolor Movement, 1860–1890," Ph.D. diss., Yale Univ., 1982, 216–217; William Innes Homer, *Thomas Eakins: His Life and Art* (New York, 1992), 68, 69, fig. 59, color ill.; Kathleen A. Foster, *Thomas Eakins Rediscovered: Charles Bregler's Thomas Eakins Collection at the Pennsylvania Academy of the Fine Arts* (New Haven and London, 1997), 429, 430; Darrell Sewell et al., *Thomas Eakins* [exh. cat., Philadelphia Museum of Art] (Philadelphia, 2001–2002), xxix, 391 n. 36.

## 8

### Portrait of Dr. William Thomson

Thomas Eakins, 1906, oil on canvas, 172.7 x 122.6 (68 x 48¹/₄)

Unsigned

Provenance: Estate of the artist; Mrs. Thomas Eakins, Philadelphia; her niece, Mrs. John Randolph [Rebecca Macdowell] Garrett Sr., Roanoke, Va.; estate of Rebecca Macdowell Garrett, until 1983; Christie's, New York, "American Paintings, Drawings and Sculpture of the 18th, 19th and 20th Centuries," 3 June 1983, lot 105; [Hirschl & Adler Galleries, New York, 1983]; acquired 1998.

Exhibitions: *Nine Paintings by Thomas Eakins*, Roanoke Fine Arts Center, Roanoke, Va., 1960; *Thomas Eakins, Susan Macdowell Eakins, Elizabeth Macdowell Kenton*, Slack Hall, North Cross School Living Gallery, Roanoke, Va., 1977; *The Art of Collecting*, Hirschl & Adler Galleries, New York, 1984.

References: Alan Burroughs, "Thomas Eakins, The Man," *The Arts* 4 (December 1923), 316, ill.; Alan Burroughs, "Catalogue of Work by Thomas Eakins," *The Arts* 5 (June 1924), 332; Lloyd Goodrich, "An Exhibition of Eakins' Work: Catalogue of the Works of Thomas Eakins," in *The Pennsylvania Museum Bulletin* 25 (March 1930), 31, no. 288; Goodrich 1933, 203, no. 443; Hendricks 1974, 260, 261, 352, fig. 287; *Thomas Eakins, Susan Macdowell Eakins, Elizabeth Macdowell Kenton* [exh. cat., Slack Hall, North Cross School Living Gallery] (Roanoke, Va., 1977), 31, no. 26, 48, fig. 35; Goodrich 1982, 2:53; *The Art of Collecting* [exh. cat., Hirschl & Adler Galleries] (New York, 1984), 49, no. 36; Foster 1997, 220–224, 422–424.

## 9

### The Chaperone

Thomas Eakins, c. 1908, oil on canvas, 46.3 x 36.2 (18¹/₄ x 14¹/₄)

Unsigned

Provenance: Mrs. Thomas Eakins, Philadelphia; estate of Mrs. Thomas Eakins; Babcock Galleries, New York; Garelick Gallery, Detroit; Marshall M. Miller, Huntington Woods, Mich.; Peter Brady, Washington, D.C., by 1977;¹ sale Christie's, New York, 24 April 1981, no. 92; [Hirschl & Adler Galleries, New York, 1981]; acquired 1982.

Exhibition: *Art for the Nation: Gifts in Honor of the 50th Anniversary of the National Gallery of Art*, National Gallery of Art, Washington, 1991, no cat. no.

References: Goodrich 1933, no. 450, 203; Homer 1992, 242, fig. 231.

Note: 1. According to Phyllis D. Rosenzweig, *The Thomas Eakins Collection of the Hirshhorn Museum and Sculpture Garden* (Washington, 1977), 297. This entry is based on one by the same author in Franklin Kelly et al., *American Paintings of the Nineteenth Century*, Part 1, National Gallery of Art Systematic Catalogue (Washington, 1996), 185–189.

## 10

### Mount Tom

Thomas Charles Farrer, 1865, oil on canvas, 40.6 x 61.6 cm (16 x 24¹/₄)

Signed, lower right: TCF (initials in monogram)

Provenance: William C. Gilman, by 1867; sale Christie's, New York, 24 November 1979, no. 37; [Berry-Hill Galleries, New York, 1979]; Judith and Wilbur Ross Jr., New York, 1979; [Hirschl & Adler Galleries, New York, until May 2002];¹ acquired 2002.

Exhibitions: Northampton, Mass., October 1865; Brooklyn Art Association, New York, March 1867; *A Mirror of Creation: 150 Years of American Nature Painting*, The Vatican Museums, Vatican City, 1980, no. 21, ill.; *Arcadian Vales: Views of the Connecticut River Valley*, George Walter Vincent Smith Art Museum, Springfield, Mass., 1981, 68–69, 44, ill.; *The New Path: Ruskin and the American Pre-Raphaelites*, The Brooklyn Museum, Brooklyn, New York, and Museum of Fine Arts, Boston, 1985, 164–165, cat. 11; 164, ill.; 10, color pl. 2.

References: *Hampshire Gazette* (26 September 1865); *Northampton Free Press* (13 October 1865); "Art Matters" *New York Times* (3 April 1867), 8; "The Art Exhibition," *Brooklyn Daily Union* (18 March 1867), 1; John I. H. Baur, "God, Man and Nature," *Museum Magazine* 1 (September 1980), 80, ill.; Joseph S. Czestochowski, *The American Landscape Tradition: A Study and Gallery of Paintings* (New York, 1982), 99, color ill.; Linda S. Ferber, "Ripe for Revival: Forgotten American Artists," *ArtNews* 79 (December 1980), 70, ill.; Roger B. Stein, "A Flower's Saving Grace: The American Pre-Raphaelites," *ArtNews* 84 (April 1985), 86, color ill.; Linda S. Ferber and William H. Gerdts, *The New Path: Ruskin and the American Pre-Raphaelites* [exh. cat., The Brooklyn Museum] (New York, 1985), 10, color ill., 164–165.

Note: 1. A label on the reverse of the canvas reads, "MT TOM/painted by Thomas C. Farrer/bought by Henry W. Messinger." Judging from the label's apparent age, it probably refers to an owner who would have had the painting some time after Gilman but well before the auction in 1979. Messinger has not been identified.

## 11

### Still Life with Wine Glass

Martin Johnson Heade, 1860, oil on board, 28.3 x 17.8 (11¹/₈ x 7)

Signed and dated, lower left: M J Heade / -60

Provenance: [William Macbeth Galleries, New York]; [Christie's, New York, 11 December 1981, sale 5108, lot 37]; [Hirschl & Adler Galleries, New York, 1981–1984]; Richard S. duPont; [Hirschl & Adler Galleries, New York, 1990–1996]; acquired 1996.

Exhibitions: *Lines of Different Character—American Art from 1727 to 1947*, Hirschl & Adler Galleries, New York, 1982–1983, no. 20; *Variations on a Theme: Still-Life Painting in America*, Hirschl & Adler Galleries, New York, 1988–1989, cat. 31; *Intimate Observation: American Still-Life Painting*, Hirschl & Adler Galleries, New York, 1994.

References: *Lines of Different Character—American Art from 1727 to 1947* [exh. cat., Hirschl & Adler Galleries] (New York, 1982–1983), 34, color ill.; *Variations on a Theme: Still-Life Painting in America* [exh. cat., Hirschl & Adler Galleries] (New York, 1988–1989), cat. 31; Theodore E. Stebbins Jr., *The Life and Work of Martin Johnson Heade: A Critical Analysis and Catalogue Raisonné* (New Haven and London, 2000), 30, 31, 131, 282, ill.

## 12

### Roses and Heliotrope in a Vase on a Marble Tabletop

Martin Johnson Heade, 1862, oil on board, 35.2 x 27 (13 7/8 x 10 5/8)

Signed and dated, lower right: 1862/M. J. Heade

Provenance: Midwestern art market; [Hirschl & Adler Galleries, New York, 1996]; acquired 2001.

Exhibition: *Martin Johnson Heade*, Museum of Fine Arts, Boston, National Gallery of Art, Washington, and Los Angeles County Museum of Art, 1999–2000, cat. 26.

References: Theodore E. Stebbins Jr., *Martin Johnson Heade* [exh. cat., Museum of Fine Arts, Boston] (New Haven and London, 1999), 57, 61, 177–179, 191, 198, cat. 26, color ill.; Stebbins 2000, 33, 34, 131–133, 283, color ill., no. 326.

## 13

### Apple Blossoms in a Vase

Martin Johnson Heade, 1867, oil on board, 35.6 x 30.5 (14 x 12)

Signed and dated, lower right: M. J. Heade 67

Provenance: Originally owned by Cyrus W. Field; by descent to Mrs. Alice Judson Jones, Washington, D.C., his great-granddaughter; [Hirschl & Adler Galleries, New York, 1971]; acquired 1972.

Exhibition: *Martin Johnson Heade*, College Park, Md., 1969, no. 24.

References: William H. Gerdts and Russell Burke, *American Still-Life Painting* (New York, Washington, and London, 1971), 96; Theodore E. Stebbins Jr., *The Life and Works of Martin Johnson*

*Heade* (New Haven and London, 1975), 121, 123, fig. 68, cat. 105; exh. cat. Boston 1999, 58; Stebbins 2000, 128, 129, 133, 298, color ill.

## 14

### Still Life with Roses, Lilies, and Forget-Me-Nots in a Glass Vase

Martin Johnson Heade, 1869, oil on canvas, 26 x 21 (10 1/4 x 8 1/4)

Signed and dated, lower left: MJ Heade -69

Provenance: [Walker Galleries, London, 1950s]; [Bonhams, London, 18 June 1981, lot 100 (cover ill.)]; [Hirschl & Adler Galleries, New York, 1981]; private collection, Mich., 1981–1986; [Hirschl & Adler Galleries, New York, 1986]; private collection, Conn.; acquired 2000.

Exhibitions: *American Still Lifes from the Hirschl & Adler Collections*, Hirschl & Adler Galleries, New York, 1985; *Intimate Observation: American Still-Life Painting*, Hirschl & Adler Galleries, New York, 1994.

Reference: Stebbins 2000, 299, no. 394, ill.

## 15

### Sunlight and Shadow: The Newbury Marshes

Martin Johnson Heade, c. 1871–1875, oil on canvas, 30.5 x 67.3 (12 x 26 1/2)

Signed, lower right: MJ Heade

Provenance: Stuart P. Feld, New York, 1967; acquired 1967.

References: Stebbins 1975, cat. 238, ill.; Barbara Novak, *Nature and Culture: American Landscape and Painting, 1825–1875* (New York, 1980), 97; Stebbins 2000, 255, ill.

## 16

### Newbury Marshes

Unknown artist, formerly attributed to Martin Johnson Heade, c. 1890, black and white chalk on paper, 30.5 x 54.6 (12 x 21 1/2)

Unsigned

Provenance: [Vose Galleries, Boston, 1969]; acquired 1969.

Reference: Stebbins 1975, cat. 238, ill.

## 17

### Head of a Boy

Winslow Homer, 1877, pencil on paper, 23.8 x 18.7 (9 3/8 x 7 3/8)

Signed and dated, lower left: Winslow Homer/1877

Provenance: Charles Steele Brown, New York; his son, Archibald Manning Brown, New York; Mrs. Archibald Manning Brown, New York; [Hirschl & Adler Galleries, New York, 1976]; acquired 1976.

## 18

### Sparrow Hall

Winslow Homer, c. 1881–1882, oil on canvas, 39.4 x 56.5 (15 1/2 x 22 1/4)

Unsigned

Provenance: The artist; his brother, Charles S. Homer, 1910; his sister-in-law, Mrs. Charles Savage Homer, from 1917 until 1937; her nephews, Arthur P. Homer and Charles L. Homer; [Wildenstein & Co., New York, 1943]; private collection; [Hirschl & Adler Galleries, New York, 1976]; acquired 1976.

Exhibitions:[1] Century Association, New York, 7 April 1883, no. 1; Doll and Richards, Boston, 10 (?) December 1883–January 1884; *Catalogue of Works of Art on Exhibition at the Gallery of the Buffalo Fine Arts Academy*, Buffalo Fine

Arts Academy, 3 June–8 July 1884, no. 335; *Eleventh Annual Exhibition*, Carnegie Institute, Pittsburgh, Pa., 1907, no. 221; *Exhibition and Private Sale of Oil Paintings by the Late Winslow Homer*, Doll & Richards, Boston, Mass., 9–21 February 1912, no. 6 (listed as *Fisher Folk, Tynemouth;* after this date, unless otherwise noted, the painting is catalogued by this title); *Panama-Pacific International Exposition*, San Francisco, 1915, no. 2517; *Paintings and Water Colors by Winslow Homer*, Doll & Richards, Boston, Mass., 25 January–6 February 1923; *Winslow Homer Water Colors and Early Oils from the Estate of Mrs. Charles S. Homer and Other Sources*, Macbeth Gallery, New York, May–June 1938, no. 16; *A Loan Exhibition of Winslow Homer for the Benefit of the New York Botanical Garden*, Wildenstein & Co., New York, 19 February–22 March 1947, no. 23 (as *On the Stairway, Tynemouth*); *Winslow Homer 1836–1910. Eastman Johnson 1824–1906*, organized by Wildenstein & Co., New York; circulated to Los Angeles County Museum of History, Science, and Art, 4–27 February 1949, no. 7; Oklahoma (City) Art Center, 10 April–31 May 1949; Fine Arts Gallery, San Diego, 15 (?) September–16 October, 1949; Museum of Fine Arts, Houston, 6–20 November 1949; Witte Memorial Museum, San Antonio, 18–29 January 1950; Denver Art Museum, 1–28 February 1950; Tacoma (Washington) Art League, March 1950; Seattle Art Museum, 5 April–7 May 1950; *Portraits, Figures, and Landscapes*, Society of the Four Arts, Palm Beach, Fl., 1951, no. 21; *Paintings, Water-*

*colors, and Drawings by Winslow Homer, 1836–1910*, Allied Arts Association, Houston, 17–26 November 1952, no. 12; *Homer and the Sea*, The Mariners Museum, Norfolk, Va., and The Virginia Museum of Fine Arts, Richmond, Va., 27 September–19 October and 30 October–29 November 1964, no. 20; *Winslow Homer 1836–1910: A Selection from the Cooper–Hewitt Collection*, Cooper–Hewitt Museum, Smithsonian Institution, New York, exhibited at Wildenstein & Co., New York, 1972, no. 53a; *The American Experience*, Hirschl & Adler Galleries, New York, 1976, no. 46, ill.; *A Gallery Collects*, Hirschl & Adler Galleries, New York, 1977, no. 39, ill.

References: *New York Times* (25 July 1926), magazine section, 17; Edward Alden Jewell, "Homer's Paintings Placed on Display; Macbeth Galleries Assemble 19 Water-colors and Oils by the Noted Artist," *New York Times* (28 May 1938), 16; Edward Alden Jewell, "Melange of Events; Notable Homer Exhibition— Brooklyn Museum's Half Century—Sculpture," *New York Times* (23 February 1947), x7; Dorothy Adlow, Article 7-no title; *Christian Science Monitor* (20 January 1955), 8, ill.; William H. Gerdts, "Winslow Homer in Cullercoats," *Yale University Art Gallery Bulletin* (Spring 1977), 27, fig. 11; Gordon Hendricks, *The Life and Work of Winslow Homer* (New York, 1979), 156, ill. 152; Tony Harrison, *Winslow Homer in Cullercoats* (Sunderland, England, 1983), 12, ill. 13, 75; Tony Knipe, *All the Cullercoats Pictures* [exh. cat., Northern Center for Contemporary Art] (Sunderland, England, 1988), 66, 72, 109, ill. 93.

Note: 1. Homer is known to have exhibited some of his paintings while abroad, and it is possible that he showed *Sparrow Hall* in London or elsewhere. A label on the back of the frame, which is apparently original to the painting, identifies the framers as Jonathan Anderson and Joshua Parry of Worcester, England. That firm, however, only existed from 1820–1830, and Homer is not known to have visited Worcester (I am grateful to Jacob Simon of the National Portrait Gallery, London, for this information; my thanks also to Nicholas Penny and Martha McLaughlin). It is possible that Homer acquired the frame second-hand, somewhere in the area of Cullercoats, perhaps in Tynemouth or Newcastle. If Homer did have the picture framed in England, it could suggest that he exhibited it publicly, but to date no records have been discovered that verify an exhibition.

## 19
### Seated Man

Eastman Johnson, 1863, pencil on paper, 21.9 x 25.4 (8 5/8 x 10)

Signed and dated, lower center: E.J./1863

Provenance: Collection of Albert Rosenthal, Philadelphia; Whitney Museum of American Art, New York, by 1937; Ferdinand Davis, Truro, Mass., by 1969; [Hirschl & Adler Galleries, New York, 1969]; acquired 1970.

Exhibition: *Eastman Johnson: An American Genre Painter*, Brooklyn Museum, 1940, no. 401.

References: *Catalogue of the Collection*, Whitney Museum of American Art (New York, 1937), 31 [as *Colored Boy*]; John I. H. Baur, *East-man Johnson: An American Genre Painter* [exh. cat., The Brooklyn Museum] (Brooklyn, 1940), 34–35, 79 [as *Colored Boy*]; Patricia Hills, *Eastman Johnson* [exh. cat., The Whitney Museum of American Art] (New York, 1972), 39 [as *Negro Youth*].

## 20
### An Ilex Tree on Lake Albano, Italy

John Frederick Kensett, 1846, oil on canvas, 44.5 x 63.5 (17 1/2 x 25)

Unsigned

Provenance: Judge Elijah Adlow, Boston; estate of Judge Elijah Adlow, Boston; [Hirschl & Adler Galleries, New York, 1968–1980]; Mr. and Mrs. Vincent A. Carrozza, 1980–1991; [Richard York Gallery, 1991]; acquired 1991.

Exhibitions: *The Collection of Paintings of the Late Mr. John F. Kensett*, National Academy of Design, New York, 1873, no. 226; *The American Scene*, Hirschl & Adler Galleries, New York, 1969, no. 56.

References: *Photographs of Paintings by J. F. Kensett* (47 plates of 1873 exhibition of Kensett Collection), pl. 17; *The American Scene* [exh. cat., Hirschl & Adler Galleries] (New York, 1969), no. 56, ill. col.; Czestochow-ski 1982, ii–iv, color ill.; Richard York Gallery, *An American Gallery: Volume VI*, (New York, 1991), no. 7, color ill.

## 21
### Stage Rocks and Western Shore of Gloucester Outer Harbor

Fitz Hugh Lane, 1857, oil on canvas, 62.2 x 99.4 (24 1/2 x 39 1/8)

Unsigned

Provenance: John J. Piper, Gloucester, Mass., 1857; Childs Gallery, Boston, 1960; acquired 1960.

Exhibition: *19th-Century America: Paintings and Sculpture*, The Metropolitan Museum of Art, 1970, cat. 98, ill.

References: Wilmerding 1964, no. 98, 62, as *View of Gloucester Shoreline*; exh. cat., New York, 1970, cat. 98, ill.; Wilmerding 1971, 71–72, pl. viii, ill.; Wilmerding 1973, 21–23, ill. 8; fragment of a letter; Lane to Joseph and Caroline Stevens, 1857, Cape Ann Historical Association.

## 22
### Brace's Rock, Eastern Point, Gloucester

Fitz Hugh Lane, c. 1864, oil on canvas, 25.4 x 38.1 (10 x 15)

Unsigned

Provenance: Michael Lemon, Boston (dealer?); [Harvey F. Additon, Boston, 1944]; [Robert B. Campbell, Boston, 1944]; [Childs Gallery, Boston, 1944]; [Victor Spark, New York, 1944]; Maxim Karolik, Newport, R.I.; Museum of Fine Arts, Boston, M. and M. Karolik Collection; deaccessioned 1966 to help fund purchase of Lane's *Boston Harbor*; acquired 1966.

Exhibitions: *American Paintings, 1815–1816*, organized by Museum of Fine Arts, Boston, for a two-year tour of twelve museums; cat. 113, 78; *The Natural Paradise: Painting in America 1800–1950*, The Museum of Modern Art, New York, 1976, 2 (color frontispiece).

References: *M. and M. Karolik Collection of American Paintings, 1815–1865* (Cambridge, Mass., 1949), no. 184, 412; ill. 413; Wilmerding 1964, no. 113, 64, as "c. 1863"; *American Paintings in the Museum of Fine Arts, Boston* (Boston and Greenwich, Conn., 1969), vol. 1 (text), no. 717, 186, as "Private Collection, N.H."; Barbara Novak, *American Painting of the Nineteenth Century: Realism, Idealism, and the American Experience* (New York, Washington, and London, 1969), 115–117, ill. 117; Barbara Novak, "Grand Opera and the Small Still Voice," *Art in America* 59 (March–April 1971), ill. with detail, 69; Wilmerding 1971, 87–88, pl. x; Novak 1980, 31, ill. fig. 20, 30; Wilmerding, "The Luminist Movement," in exh. cat. Washington 1980; reprint 1989, 111–113, ill. 117.

## 23
### Mount Desert Island, Maine

Jervis McEntee, 1864, oil on canvas, 26.7 x 40 (10 1/2 x 15 3/4)

Inscribed and dated, lower center: Mt. Desert / July 17 '64

Provenance: [Berry-Hill Galleries, Inc., New York, 1999]; acquired 1999.

Exhibitions: *Jervis McEntee, N.A.*, Fifth Avenue Galleries, New York, 1892, no. 89; *McEntee & Company*, Beacon Hill Fine Art, New York, 1997; *Inventing Acadia: Artists and Tourists at Mount Desert*, The Farnsworth Art Museum, Rockland, Maine, 1999.

References: J. Gray Sweeney, "McEntee & Company," *McEntee & Company* (New York, 1998), 7–8, ill.; exh. cat. Rockland 1999, 103, 105, 106, 150, col. ill.

## 24
### Take Your Choice

John Frederick Peto, 1885, oil on canvas, 51.4 x 76.8 (20 1/4 x 30 1/4)

Signed, lower right: J. F. Peto; inscribed, verso: TAKE YOUR CHOICE / ARTIST / PHILA / PA

Provenance: John Barnes, New York, by 1950; [Hirschl & Adler Galleries, New York, sold January 1973]; acquired 1973.

Exhibitions: Possibly *Your Choice*, Pennsylvania Academy of the Fine Arts, 1885; *Williams Alumni Loan Exhibition*, Williams College Museum of Art, Williamstown, Mass., 1962; *Faces and Places: Changing Images of Nineteenth Century America*, Hirschl & Adler Galleries, New York, 5 December 1972–6 January 1973, no. 76, ill.

References: Alfred Frankenstein, *After the Hunt: William Harnett and Other American Still Life Painters, 1870–1900* (Berkeley and Los Angeles, 1969), 21, 22–23, 102; exh. cat. Washington 1983, 130,132–133, 138 n.13.

## 25
### Christmas Card—Snow Storm, Horse and Sleigh

Andrew Wyeth, c. 1949, watercolor on paper, 8.4 x 13.5 (3 5/16 x 5 5/16)

Inscribed on back: Andy and Betsy

Provenance: Hyde Cox, Manchester, Mass., c. 1950; acquired by bequest, 1999.

## 26

### Christmas Card — Pine Tree with Footprints

Andrew Wyeth, c. 1956, ink on paper, 8.6 x 13.5 (3³/₈ x 5⁵/₁₆)

Unsigned

Provenance: Hyde Cox, Manchester, Mass., c. 1950; acquired by bequest, 1999.

## 27

### Christmas Card — Boots and Hanging Jacket

Andrew Wyeth, c. 1950, watercolor on paper, 13.3 x 8.6 (5¹/₄ x 3³/₈)

Unsigned

Provenance: Hyde Cox, Manchester, Mass., c. 1950; acquired by bequest, 1999.

## 28

### A Crow Flew By Study

Andrew Wyeth, 1950, watercolor on paper, 42.1 x 29.5 (16⁹/₁₆ x 11⁵/₈)

Signed, lower right: AW

Provenance: Wyeth Collection, Chadds Ford, Pa.; acquired March 2001, gift of the artist.

Reference: Elaine de Kooning, "Andrew Wyeth Paints a Picture," *ArtNews* 49, no. 1 (March 1950), 38–41, 54–56.

## 29

### View from East End of Bear Island

Alvan Fisher, 1848, pencil on paper, 24.8 x 35.2 (9³/₄ x 13⁷/₈)

Inscribed and dated: View from E end of Bear Is 13 Aug/48 Fog

Provenance: The artist's great-grandson, Sumner Brown; [Vose Galleries, Boston, 1969]; acquired 1969.

References: Fred Barry Adelson, "Alvan Fisher (1792–1863): Pioneer in American Landscape Painting," Ph.D. diss., Columbia Univ., 1982, 563; Wilmerding 1994, 22, 185, ill.

## 30

### Penobscot Bay, Maine

Edward Seager, 1848, pencil on paper, 26.4 x 41.9 (10³/₈ x 16¹/₂)

Inscribed, signed, and dated, lower left: Penobscot Bay Seager 1848

Provenance: Estate of the artist; [Hirschl & Adler Galleries, New York, 1983]; acquired 1983.

Exhibition: *The Drawings of Edward Seager*, Hirschl & Adler Galleries, New York, 1983, no. 34.

References: Sandra K. Feldman, *The Drawings of Edward Seager (1809–1886)* [exh. cat., Hirschl & Adler Galleries] (New York, 1983), 22; Wilmerding 1994, 25, 185, ill.

## 31

### Castine from Wasson's Hill, Brooksville, Maine

Fitz Hugh Lane, 1850, pencil on paper, 23.8 x 69.5 (9³/₈ x 27³/₈)

Inscribed, signed, and dated, upper center: Castine from Wasson's Hill, Brooksville, Me./ Aug. 1850 F.H. Lane del.; lower right: F.H. Lane / Joseph L. Stevens / Josept L. Stevens, Jr.

Provenance: Cape Ann Historical Association; deaccessioned by the association, 1965; acquired 1965.

Reference: Wilmerding 1971, 52.

## 32

### Entrance of Somes Sound, Mount Desert, Maine

Fitz Hugh Lane, 1855, pencil on paper, 27 x 40.6 (10⁵/₈ x 16)

Inscribed, signed, and dated, upper center: Entrance of Somes Sound from back of the Island House / at South West Harbor Mt. Desert; upper right: Sept. 1855 Lane — Hooper — Stevens; lower right center: F.H. Lane del.

Provenance: Cape Ann Historical Association; deaccessioned by the association, 1965; acquired 1965.

References: Wilmerding 1971, 62–63, 68, ill. 65; Wilmerding 1994, 60–61, 186, 52, ill.

## 33

### Rocks at Mount Desert

John Henry Hill, 1856, pencil on paper, 19.7 x 24.5 (7³/₄ x 9⁵/₈)

Signed and dated, lower left: J. H. Hill 1856

Provenance: John William Hill; John Henry Hill; Christian Olsen; Eric Davies, West Nyack, N.Y.; [Washburn Gallery, New York, 1973]; acquired 1973.

Reference: Wilmerding 1994, 126, 189, ill.

## 34

### Frenchman Bay, Mount Desert

Aaron Draper Shattuck, 1858, pencil and colored chalks on paper, 26.7 x 42.6 (10¹/₂ x 16³/₄)

Dated, lower left: August 25, 1858; inscribed, lower center: limestone rocks

Provenance: [Adams Davidson Galleries, Inc., Washington, D.C., 1979]; acquired 1979.

References: John Walker Myers, *Aaron Draper Shattuck, 1832–1898*, "Painter of Landscapes and Student of Nature's Charms," Ph. D. diss., Univ. of Delaware, 1981, 91, 224, ill.; Wilmerding 1994, 126–129, 189, ill.

## 35

### Eagle Cliff, Somes Sound, Mount Desert

William Stanley Haseltine, c. 1859, pen and ink and gray wash on paper, 38.7 x 56.8 (15¹/₄ x 22³/₈)

Signed, lower right: W.S.H.

## Provenance

Provenance: Cape Ann Historical Association; deaccessioned by the association, 1965; acquired 1965.

References: Wilmerding 1971, 62–63, 68, ill. 65; Wilmerding 1994, 60–61, 186, 52, ill.

## 36

### Otter Cliffs, Mount Desert (Looking toward Sandy Beach and Great Head)

William Stanley Haseltine, c. 1859, pencil and white chalk on blue paper, 34.9 x 55.3 (13³/₄ x 21³/₄)

Signed, lower right: W.S.H.

Provenance: Descent through the artist's family to Marshall Haseltine; [Berry-Hill Galleries, 1992]; acquired 1992.

Exhibition: *William Stanley Haseltine: Works on Paper*, Berry-Hill Galleries, New York, 16 April–30 May 1992, no. 8.

Reference: Wilmerding 1994, 111, 114, 188, ill.

## 37

### Thunder Hole, Mount Desert Island

William Stanley Haseltine, c. 1859, pencil and gray wash on paper, 38.1 x 55.3 (15 x 21³/₄)

Signed, lower right: W.S.H.

Provenance: Descent through the artist's family until 1983; [Davis & Langdale Company, Inc., New York, 1983]; acquired 1983.

Exhibition: *William Stanley Haseltine: Drawings of a Painter*, Davis & Langdale Company, Inc. (in association with Ben Ali Haggin, Inc.), New York, 5 March–2 April 1983, no. 4.

References: Descent through the artist's family; [Ben Ali Haggin Fine Arts, New York]; acquired 1985.

References: Wilmerding, "William Stanley Haseltine's Drawings of Maine," 5, 8, 10, ill.; Wilmerding 1994, 107, 111, 188, ill.

References: Exh. cat. New York 1983, no. 4, ill.; Wilmerding, "William Stanley Haseltine's Drawings of Maine," 10, 14, ill.; Wilmerding 1994, 112, 114, 118–119, 188, ill.

## 38

### Wooded Coast, Mount Desert Island, Maine

William Stanley Haseltine, c. 1859, pencil and gray wash on paper, 34.5 x 48.9 (13⁹/₁₆ x 19¹/₄)

Inscribed, signed, and dated, lower left: W.S.H., Mt. Desert, August 1st

Provenance: Descent through the artist's family until 1983; [Davis and Langdale Company, Inc. (in association with Ben Ali Haggin, Inc.), New York]; acquired 1983.

Exhibition: *William Stanley Haseltine: Drawings of a Painter*, Davis & Langdale Company, Inc. (in association with Ben Ali Haggin, Inc.), New York, 5 March–2 April 1983, no. 3.

References: Exh. cat. New York 1983, no. 3; Wilmerding, "William Stanley Haseltine's Drawings of Maine," 15, 16, ill.; Wilmerding 1994, 117, 119–120, 188, ill.

## 39

### Mount Desert

William Trost Richards, 1866, pencil on gray paper, 15.2 x 23.5 (6 x 9¹/₄)

Inscribed and dated, lower center: Mt. Desert Aug 4t 1866

Provenance: [Beacon Hill Fine Art, New York, 1996]; acquired 1996.

## 40

### Rocks at Mount Desert

William Trost Richards, c. 1866, pencil on paper, 15.4 x 23.8 (6¹/₁₆ x 9³/₈)

Inscribed and dated, lower center: July 30, 66; window mat, verso, upper right: B5895; back mat, lower left: William Trost Richards/Estate of C. Nelson Richards, III; lower right: 100388

Provenance: Estate of the artist; C. Nelson Richards III, great-grandson of the artist; [Peridot Gallery, New York, 1972]; acquired 1972.

Exhibition: *William Trost Richards*, Peridot Gallery, New York, June–July 1972.

Reference: Wilmerding 1994, 134, 189, ill.

### 41

### Sailboat at the Dock (probably Mt. Desert)

William Trost Richards, c. 1866, pencil on paper, 15.4 x 23.8 (6¹/₁₆ x 9³/₈)

Inscribed verso, lower right: 12; slight drawing of unknown subject

Provenance: Descent through the artist's family; [Beacon Hill Fine Art, New York, 1996]; acquired 1996.

Exhibition: *William Trost Richards: Rediscovered, Oils, Watercolors, and Drawings from the Artist's Family*, Beacon Hill Fine Art in association with Jill Newhouse, New York, 29 November 1996–11 January 1997.

Reference: Beacon Hill Fine Art in association with Jill Newhouse, New York, *William Trost Richards: Rediscovered, Oils, Watercolors, and Drawings from the Artist's Family*, 1997, 31, 38, ill.

### 42

### Sunrise over Schoodic

William Trost Richards, early 1870s, gouache on paper, 17.5 x 34.9 (6⁷/₈ x 13⁵/₈)

Inscribed verso, lower right: HS4

Provenance: [Berry-Hill Galleries, Inc., New York, 1989]; acquired 1989.

Reference: Wilmerding 1994, 134–135, 189, color ill.

### 43

### The Nubble, Coast of Maine

Ralph Albert Blakelock, c. 1865–1868, pen and pencil on paper, 12.5 x 20.3 (4¹⁵/₁₆ x 8)

Inscribed, lower center: The Nubble Coast of Maine

Provenance: Cora Rebecca Bailey Blakelock (1856–1950), wife of the artist; gift to Allen Osborne Blakelock (1897–1979), son of the artist; gift to David and Susielies M. Blakelock, grandson of the artist, about 1967; by descent, Susielies M. Blakelock, 1976; [Vose Galleries, Boston, by 1981]; acquired 1981.

Exhibition: *Ralph Albert Blakelock N.A., 1847–1919, Drawings*, Vose Galleries, from 15 April 1981, no. 24.

References: *Ralph Albert Blakelock N.A., 1847–1919, Drawings* [exh. cat., Vose Galleries] (Boston, 1981), 3, no. 24; Wilmerding 1994, 148–150, 189, ill.

### 44

### Rocks near the Landing at Bald Porcupine Island, Bar Harbor

Felix Octavius Carr Darley, 1872, pencil and wash on paper, 25.2 x 35.4 (9¹⁵/₁₆ x 13¹⁵/₁₆)

Signed and inscribed, lower left: Darley/Bald Porcupine

Provenance: Pagent Book Company, New York; Collection of E. Maurice Bloch by 1969; Christie's, New York, 9 January 1991, no.152; [Hirschl & Adler Galleries, New York, agent]; acquired 1991.

Exhibition: National Academy of Design, 1874, no. 46.

Reference: Wilmerding 1994, 139.

### 45

### Coastline near Otter Cliffs, Mount Desert Island

Alfred Thompson Bricher, c. 1870s, watercolor on paper, 8.9 x 21.9 (3¹/₂ x 8⁵/₈)

Signed, lower right: AB

Provenance: [Adelson Galleries, Inc., Boston, 1969]; acquired 1969.

References: Wilmerding 1994, 141, 189, ill.

### 46

### Otter Cliffs

George Henry Smillie, 1893, pencil and watercolor on paper, 25.1 x 35.6 (9⁷/₈ x 14)

Inscribed and dated, lower center: Otter Cliffs Mt Desert Aug 2 '93

Provenance: [Childs Gallery, Boston]; E. Maurice Bloch; *Old Master, Nineteenth Century European and American Works on Paper and Paintings from the Estate of E. Maurice Bloch*, Part II, lot 221, Christie's, New York, 9 January 1991; [Hirschl & Adler Galleries, New York, 1991]; acquired 1991.

References: Brucia Witthoft, "George Smillie, N.A.: The Life of an Artist," *American Art Review* (Summer 1992), 140, fig. 22, ill.; Wilmerding 1994, 148, 150, 189, ill.

### 47

### Seal Harbor, Mount Desert

George Henry Smillie, c. 1893, watercolor on paper, 35.9 x 54 (14¹/₈ x 21¹/₄)

Signed, lower left: Geo. H. Smillie/Seal Harbor, Mt. Desert

Provenance: [Hollis Taggart Galleries, New York, 1997]; acquired 1997.

Reference: Wilmerding 1994, 139.

### 48

### Northeast Harbor, Maine

William Stanley Haseltine, 1895, watercolor and Chinese white on paper, 38.4 x 56.2 (15¹/₈ x 22¹/₈)

Signed, lower left: W.S.H.

Provenance: Descent through the artist's family; [Jordan Volpe Gallery, New York]; [Taggart & Jorgensen Gallery, New York, 1984]; [Hirschl & Adler Galleries, New York, 1984]; acquired 1984.

References: Wilmerding, "William Stanley Haseltine's Drawings of Maine," 16, 17, 19, 20 n. 27, ill.; Wilmerding 1994, 120, 122–123, 189, color ill.

### 49

### Northeast Harbor, Maine

William Stanley Haseltine, 1895, gouache on paper, 38.1 x 56.8 (15 x 22³/₈)

Signed, lower left: W.S.H.; inscribed, verso, lower right: North East Harbour, Maine./170 (Series 2)

Provenance: Descent through the artist's family until 1991; [Hirschl & Adler Galleries, New York, 1991]; acquired 1991.

References: Wilmerding, "William Stanley Haseltine's Drawings of Maine," 16–18, 20 n. 27, ill.; Wilmerding 1994, 120, 122, 189, color ill.

### 50

### Entrance of Somes Sound, Mount Desert

John Marin, 1922, watercolor on paper, 12.5 x 20 (4¹⁵/₁₆ x 7⁷/₈)

Signed and dated, lower right: Marin 22

Provenance: Estate of the artist; [Richard York Gallery, New York, 1999]; acquired 1999.

Exhibition: *The Mount Desert Watercolors*, Richard York Gallery, New York, 1999, no. 25.

Reference: Sheldon Reich, *John Marin: A Stylistic Analysis and Catalogue Raisonné* (Tuscon, Ariz., 1970), 503, no. 22.51, ill.

### 51

### View across Somes Sound, Mount Desert

John Marin, 1922, watercolor on paper, 12.5 x 20 (4¹⁵/₁₆ x 7⁷/₈)

Signed and dated, lower right: Marin 22

Provenance: Estate of the artist; [Richard York Gallery, New York, 1999]; acquired 1999.

Exhibition: *The Mount Desert Watercolors*, Richard York Gallery, New York, 1999, no. 21.

Reference: Reich 1970, 506, no. 22.66, ill.

## Bibliography of John Wilmerding's Published Works

### Books

*American Marine Painting.* 2nd ed., New York, 1987.

*American Masterpieces from the National Gallery of Art.* New York, 1980, 1988; 3rd ed., New York, 1993.

*American Paintings: An Illustrated Catalogue.* Washington, 1980.

*American Views: Essays on American Art.* Princeton, 1991.

*Andrew Wyeth: The Helga Pictures.* New York, 1987; editions in French, German, Dutch, and Japanese.

"American Art in the White House." In William Kloss et al., *Art in the White House: A Nation's Pride.* Washington and New York, 1992.

*The Artist's Mount Desert: American Painters on the Maine Coast.* Princeton, 1994.

"Peale, Quidor, & Eakins: Self-Portraiture as Genre Painting." In *Art Studies for an Editor: 25 Essays in Memory of Milton S. Fox.* New York, 1975, 291–308.

*Audubon, Homer, Whistler and Nineteenth-Century America.* New York, 1972; reprint 1975, 1984.

*Compass and Clock: Defining Moments in American Culture: 1800, 1850, 1900.* New York, 1999.

"American Imagery and Visions of the Sea." In *Courses by Newspaper: Oceans, Our Continuing Frontier—Newspaper Articles.* Berkeley, 1976, 15–17.

"Suggested Reading, American Imagery and Visions of the Sea." In *Courses by Newspaper—Study Guide: Oceans, Our Continuing Frontier.* Berkeley, 1976, 25–26.

"Winslow Homer's *Dad's Coming.*" In *Essays in Honor of Paul Mellon, Collector and Benefactor.* Washington and Hanover, N.H., 1986.

*Fitz Hugh Lane.* New York, 1971.

*Fitz Hugh Lane, 1804–1865: American Marine Painter.* Salem, Mass., 1964.

"The Mystery and History of Fritz Scholder's Art." In *Fritz Scholder, Paintings and Monotypes.* Altadena, Calif., 1988.

*The Genius of American Painting,* ed. and co-author. New York and London, 1973.

"Winslow Homer." In *The Great Artists, A Library of Their Lives, Times and Paintings: Book 3.* New York, 1977.

"The End of Growth in America? A View Through the Arts." In *Growth in America,* Chester L. Cooper, ed. Westport, Conn., 1976, 154–172.

Foreword to *Monotypes by Maurice Prendergast in the Terra Museum of American Art* by Cecily Langdale. Chicago, 1984.

*The Pelican History of Art: American Art.* Harmondsworth and New York, 1976.

*Pittura Americana dell'Ottocento.* Milan, 1969.

Foreword to *Portraits in the Massachusetts Historical Society* by Andrew Oliver et al. Boston, 1988.

*Robert Salmon, Painter of Ship and Shore.* Salem, Mass., 1971.

*Signs of the Artist: Signatures and Self-Expression in American Paintings.* New Haven, 2003.

*Winslow Homer.* New York, 1972.

Foreword to *The Work of Augustus Saint-Gaudens* by John H. Dryfhout. Hanover, N.H., and London, 1982, ix–xxii.

### Exhibition Catalogues

*100 American Drawings from the J. D. Hatch Collection.* Exh. cat., National Gallery of Ireland; Heim Galleries, London and Paris; Walker Art Gallery, Liverpool; Fitzwilliam Museum, Cambridge. London, 1976.

"American Art at Randolph-Macon Women's College." In *American Art, American Vision: Paintings from a Century of Collecting.* Exh. cat., Maier Museum of Art. Lynchburg, Va., 1990, 26–31.

*Americans at Work and Play.* Exh. cat., Meredith Long Gallery. Houston, 1980.

"American Art at Princeton." In *American Drawings and Watercolors from the Princeton University Art Museum.* Exh. cat., Princeton University Art Museum. Princeton, 2004.

"Thomas Eakins: *Portrait of John Neil Fort,* 1898." In *American Dreams: American Art to 1950 in the Williams College Museum of Art.* Exh. cat., Williams College Museum of Art. New York, 2001, 93–95.

*American Light: The Luminist Movement, 1850–1875,* with others. Exh. cat., National Gallery of Art. Washington and New York, 1980; 2nd ed., Washington and Princeton, 1989.

*American Marine Painting.* Exh. cat., Virginia Museum of Fine Arts and the Mariners' Museum. Richmond, Va., and Newport News, Va., 1976.

*American Paintings of the Nineteenth-Century from the Collection of Mr. and Mrs. Laurence Rockefeller.* Exh. cat., Beaumont-May Gallery, Hopkins Center, Dartmouth College. Hanover, N.H., 1968.

*An American Perspective: Nineteenth-Century Art from the Collection of Jo Ann and Julian Ganz, Jr.,* with Linda Ayres and Earl A. Powell. Exh. cat., National Gallery of Art. Washington and Hanover, N.H., 1981.

*Andrew Wyeth, "Helga."* Exh. cat., Sezon Museum of Art. Tokyo, 1990.

*The Art of Benjamin Rowland.* Exh. cat., Fogg Art Museum. Cambridge, Mass., 1973.

*The Art of Fitz Hugh Lane.* Exh. cat., William A. Farnsworth Library and Art Museum. Rockland, Maine, 1974.

*Art out of the Attic: Nine-teenth-Century American Paintings from Vermont Homes.* Exh. cat., Vermont Council on the Arts. Montpelier, Vt., 1970.

"Bellows' Boxing Pictures and the American Tradition." In *Bellows: The Boxing Pictures.* Exh. cat., National Gallery of Art. Washington, 1982.

"William Michael Harnett: *Nature morte au 'bric-à-brac.'*" In *La Collection Grenville L. Winthrop, Chefs-d'Oeuvre du Fogg Art Museum, Université de Harvard.* Exh. cat., Musée des Beaux-Arts de Lyon. Lyon, 2003, 457–458, 471–472.

"Under Chastened Light: The Landscape of Rhode Island." In *The Eden of America: Rhode Island Landscapes, 1820–1920.* Exh. cat., Museum of Art, Rhode Island School of Design. Providence, 1986, 11–15.

*Fitz Hugh Lane, The First Major Exhibition.* Exh. cat., DeCordova Museum and Colby College Art Museum. Lincoln, Mass., and Waterville, Maine, 1966.

*Fitz Hugh Lane: Paintings and Drawings from the Collection of the Cape Ann Historical Association.* Exh. cat., Cape Ann Historical Association. Gloucester, Mass., 1974.

"Silva Lined Clouds." In *Francis A. Silva (1835–1886): In His Own Light,* with Mark D. Mitchell. Exh. cat., Berry-Hill Galleries. New York, 2002, 9–15.

"Benson & Maine." In *Frank W. Benson: The Impressionist Years.* Exh. cat., Spanierman Gallery. New York, 1988.

*George Bellows: Love of Winter,* with David Setford. Exh. cat., Norton Museum of Art. West Palm Beach, Fla., 1998.

"Bingham's Geometries and the Shape of America." In *George Caleb Bingham.* Exh. cat., Saint Louis Art Museum. Saint Louis, Mo., and New York, 1990, 175–181, 188.

"George Curtis: A Rediscovery in the New England Marine Tradition." In *George Curtis: Coming to Light.* Exh. cat., Peabody Essex Museum Collections. Salem, Mass., 1993, 367–371.

Foreword to *Godly Ships on Painted Seas: Ship Portraiture by Penobscot Bay Artists William P. Stubbs, James G. Babbidge and Percy A. Sanborn.* Exh. cat., Penobscot Marine Museum. Searsport, Maine, 1988.

*Important Information Inside: The Art of John F. Peto and the Idea of Still-Life Painting in Nineteenth-Century America.* Exh. cat., National Gallery of Art. Washington, 1983.

"Drawn to Maine." Foreword to Pamela J. Belanger et al., *Inventing Acadia: Artists and Tourists at Mount Desert.* Exh. cat., The Farnsworth Art Museum. Rockland, Maine, 1999, 11–14.

"Looking at Leithauser's Landscapes of Letters." In *Mark Leithauser: Paintings, Drawings, Prints.* Exh. cat., Coe Kerr Gallery. New York, 1988, n.p.

"Quicksilver: The Art of Mark Leithauser." In *Mark Leithauser: Paintings, Drawings, Prints.* Exh. cat., Coe Kerr Gallery. New York, 1988.

"Dartmouth and American Art." In Barbara MacAdam et al., *Marks of Distinction: Two Hundred Years of American Watercolors and Drawings from the Hood Museum of Art, Dartmouth College.* Exh. cat., Hood Museum of Art. Hanover, N.H., 2004.

"Fitz Hugh Lane: *Ship Starlight,*" "Winslow Homer: *Snap the Whip,*" "Martin Johnson Heade: *Salt Marsh Hay,*" Thomas Cowperthwait Eakins: *The Coral Necklace,*" "John Frederick Peto: *Book, Mug, Candlestick and Pipe,*" "George Wesley Bellows: *Geraldine Lee #2.*" In Irene S. Sweetkind, ed., *Master Paintings from the Butler Institute of American Art.* Exh. cat., Butler Institute of American Art. New York, 1994, 72–73, 97–101, 112–113, 120–121, 128–129, 214–215.

"John Frederick Peto, *Fish House Door with Eel Basket.*" In *Masterworks of American Art from the Munson-Williams Proctor Institute.* Exh. cat., Munson-Williams Proctor Institute. New York, 1989, 94–95.

"Fire and Ice in American Art: Polarities from Luminism to Abstract Expressionism." In *The Natural Paradise: Painting in America, 1800–1950.* Exh. cat., The Museum of Modern Art. New York, 1976, 38–57.

*Nineteenth-Century America: Paintings and Sculpture,* with John K. Howat. Exh. cat., The Metropolitan Museum of Art. New York, 1970.

*Nineteenth-Century American Landscape and Marine Painting.* Exh. cat., Beaumont-May Gallery, Hopkins Center, Dartmouth College. Hanover, N.H., 1966.

*Painters of a Place: Some Artists in Gloucester.* Exh. cat., Cape Ann Historical Association. Gloucester, Mass., 1973.

*Paintings by Fitz Hugh Lane.* Exh. cat., National Gallery of Art. Washington, 1988.

"Ross Merrill's Conserving Art." In *Paintings by Ross M. Merrill.* Exh. cat., Susan Conway Carroll Gallery. Washington, 1988.

"The Art of George Bellows and the Energies of Modern America." In Michael Quick et al., *The Paintings of George Bellows.* Exh. cat., Amon Carter Museum and Los Angeles County Museum of Art. New York, 1992, 1–7.

"The United States," with Wanda Corn. In *Post-Impressionism: Cross-Currents in European and American Painting, 1880–1906.* Exh. cat., National Gallery of Art. Washington, 1980, 219–240.

"William Michael Harnett: *Still Life with Bric-a-Brac*" and "John La Farge: *The Dawn.*" In *A Private Passion: 19th-Century Paintings and Drawings from the Grenville L. Winthrop Collection, Harvard University.* Exh. cat., The Metropolitan Museum of Art. New Haven and London, 2003, 443–444 and 457–458.

"America's Young Masters: Raphaelle, Rembrandt, and Rubens." In *Raphaelle Peale Still Lifes.* Exh. cat., National Gallery of Art. Washington, 1988, and New York, 1992, 72–93.

*Robert Salmon, The First Major Exhibition.* Exh. cat., DeCordova Museum. Lincoln, Mass., 1967.

*Spring Bloom and Autumn Blaze: Topographies of the American Landscape and Character.* Exh. cat., Lowe Art Museum. Miami, 1974.

"Georgia O'Keeffe and the American Landscape Tradition." In *The Sublime Landscapes of Georgia O'Keeffe.* Exh. cat., International Arts. Memphis, Tenn., 2004.

*Thomas Eakins,* ed. and co-author. Exh. cat., National Portrait Gallery, London. London and Washington, 1993.

*The Waters of America: Nineteenth-Century American Paintings of Rivers, Streams, Lakes, and Waterfalls.* Exh. cat., The Historic New Orleans Collection and New Orleans Museum of Art. New Orleans, 1984.

*William Bradford, Artist of the Arctic.* Exh. cat., DeCordova Museum and New Bedford Whaling Museum. Lincoln, Mass., and New Bedford, Mass., 1968.

*William Stanley Haseltine (1835–1900), Drawings of a Painter.* Exh. cat., Davis & Langdale Company. New York, 1983.

"Notes of Changes: Harnett's Paintings of the Late 1870s." In Doreen Bolger et al., *William M.*

*Harnett, 1848–1892.* Exh. cat., The Metropolitan Museum of Art, New York, Amon Carter Museum, and Fine Arts Museums of San Francisco. New York, 1992, 148–159.

"Reflecting on the Payson Homers in Portland." In *Winslow Homer at the Portland Museum of Art.* Exh. cat., Portland Museum of Art. Portland, Maine, 1998, 9–15.

*Winslow Homer in the 1870s: Selections from the Valentine-Pulsifer Collection.* Exh. cat., The Art Museum, Princeton University, and Wadsworth Atheneum, Hartford, Conn. Hanover, N.H., 1990.

"Homer's Maine." In *Winslow Homer in the 1890s: Prout's Neck Observed.* Exh. cat., Memorial Art Gallery of the University of Rochester, Terra Museum of American Art, National Museum of American Art, and the Sterling and Francine Clark Art Institute. New York, 1990, 86–96.

*Winslow Homer's Drawings.* Exh. cat., Cooper-Hewitt National Design Museum. New York, 1972.

*Winslow Homer: The Charles Shipman Payson Collection.* Exh. cat., Coe Kerr Galleries and Portland Museum of Art. New York and Portland, Maine, 1981.

"John F. Peto, *The Writer's Table: A Precarious Moment*" and *"Old Time Letter Rack."* In *American Paintings from the Manoogian Collection.* Exh. cat., National Gallery of Art. Washington, 1989, 108, 114.

## Articles

"American Art through 40 Presidencies: An Inaugural Celebration 1981." Self-guiding tour leaflet, National Gallery of Art, Washington, 1981.

"An American Collection." Introduction to fine arts portfolios, Presidential Inaugural Committee, Washington, 1981.

"American Light: The Luminist Movement, 1850–1875: An Exhibition of the National Gallery of Art." *The Magazine Antiques* 117, no. 4 (April 1980), 847–854.

"The American Painting Collection of the White House." *The Magazine Antiques* 116, no. 1 (July 1979), 135–145.

"American Paintings in the Webb Gallery of the Shelburne Museum, Vermont." *American Art Review* 1, no. 6 (November–December 1974), 110–119.

"An American Perspective: Nineteenth-Century Art from the Collection of Jo Ann and Julian Ganz, Jr., Still Life Paintings." *The Magazine Antiques* 121, no. 1 (January 1982), 270–274.

"*Antiques* Book Preview: Robert Salmon, Painter of Ship and Shore." *Antiques* 94, no. 2 (February 1971), 257–261.

"As Under a Bell Jar: A Study of Quality in Fitz Hugh Lane." *Antiques* 82 (October 1962), 406–409.

"Child Going to Bed" (verse). *New York Times* (2 February 1959).

"Early Marine Views of Boston." *Ellis Memorial Antiques Show Catalogue* (October 1967), 19–25.

"Essential Reading: *The Education of Henry Adams.*" *American Art* 11, no. 2 (Summer 1997), 28–35.

"Fitz Hugh Lane, 1804–1865, American Marine Painter." *Essex Institute Historical Collections* 99 (July 1963), 173–202; and 99 (October 1963), 289–310.

"Fitz Hugh Lane: Imitations and Attributions." *The American Art Journal* 3, no. 2 (Fall 1971), 32–40.

"Fitz Hugh Lane, Painter of Gloucester." *Journey through New England* 3 (1966), 72–74.

"Fitz Hugh Lane's Paintings Down East." *Down East Magazine* (April 1966), 22–25, 43.

"Folk, or Art? A Symposium." *The Magazine Antiques* 135, no. 1 (January 1989), 278–280.

"Four Centuries of American Art." Commentaries on American art stamps, U.S. Postal Service, 1998.

"Fun and Games in American Genre Painting: Time Out for a Fresh Look." *The Walpole Society Note Book* 1976 (1977), 61–73.

"George Caleb Bingham: A New Find." *Antiques* 152, no. 4 (October 1967), 556–557.

"Harvard and American Art." *Apollo* 57, no. 196 (June 1978), 490–495.

"Images of Lincoln in Peto's Late Paintings." *Archives of American Art Journal* 22, no. 2 (1982), 2–12.

"Interpretations of Place: Views of Gloucester, Massachusetts, by American Artists." *Essex Institute Historical Collections* 103 (January 1967), 53–65.

"John F. Peto: Important Information Inside." *Portfolio* 4, no. 6 (November/December 1982), 72–77.

"John Peto 1854–1907: Une nature morte americaine au musée de Blerancourt." *La Revue du Louvre et de musées de France* 6 (December 1986), 403–405.

"The Last Winslow Homer Show?" *The American Art Review* 1, no. 1 (September–October 1973), 59–65.

"The Lithographs of Fitz Hugh Lane." *Old Time New England* 54 (Fall 1963). 21–29.

"Luminism: The Poetry of Light." *Portfolio* 1, no. 2 (June/July 1979), 20–30.

"The National Gallery of Art." *Middlesex School Bulletin* (Summer 1986), 8–16.

"The National Image: American Paintings in the State Department." *The Magazine Antiques* 132, no. 1 (July 1987), 146–159.

"A New Look at Robert Salmon." *Antiques* 87, no.1 (January 1965), 89–93.

"Nineteenth-Century American Landscape Painting, Luminism: The Poetry of Light." *Review* 4, no. 9 (September 1979), 78–88.

"Painting in America." U.S. Information Agency picture book. Washington, 1977.

"The Photographic Eye of Seneca Ray Stoddard." Foreword to Jeanne Winston Adler, *Early Days in the Adirondacks.* New York, 1997, 21–23.

"*Portrait of John N. Fort* by Thomas Eakins." Studies in the History of Art 1. Williams College Museum of Art. Williamstown, Mass., 1978.

"Rediscovery: Fitz Hugh Lane." *Art in America* 53, no. 1 (February 1965), 62–69.

"Robert Salmon's 'Boston Harbor from Castle Island.'" *Arts in Virginia* 14, no. 2 (Winter 1974), 14–27.

"Robert Salmon's Boston Patrons." *Old Time New England* 60, no. 3 (Winter 1970), 86–93.

"Robert Salmon's Early Career." *Scottish Art Review* 13, no. 1 (1971), 20–24.

"Rowing Alone on the River" (verse). *New York Times* (19 October 1958).

"A Selection of Marine Paintings by Fitz Hugh Lane, 1804–1865." *The American Neptune,* Pictorial Supplement 7. Peabody Museum, Salem, 1965.

"A Selection of Paintings by Robert Salmon, 19th Century Artist." *The American Neptune,* Pictorial Supplement 11. Peabody Museum, Salem, 1969.

"Shelburne Museum, The American Paintings." *The Magazine Antiques* 133, no. 2 (February 1988), 462–471.

"Still Life with Breakfast: John F. Peto's House and Studio." *House and Garden* 163, no. 9 (September 1991), 80–82.

"Thomas Cole in Maine."
*Record of the Art Museum,
Princeton University* 49,
no. 1 (1990), 2–23.

"Thomas Eakins' Late
Portraits." *Arts Magazine* 53,
no. 9 (May 1979), 108–112.

"A Timeless Place." *The
Journal of Friends of Acadia*
(Spring 1994), 1, 6–7.

"Walt Whitman and
American Painting." *The
Magazine Antiques* 118, no. 5
(November 1985), 996–1003.

"William Bradford, New
Bedford Artist." *Journey
Through New England* 7
(1970), 53–55.

"William Stanley Haseltine's
Drawings of Maine."
*Master Drawings* 31, no. 1
(1993), 3–20.

"Winslow Homer: Impres-
sive and Solemn Land-
scapes." *Antiques* 52, no. 3
(September 1971), 420–421.

"Winslow Homer's Creative
Process." *Antiques* 108, no. 5
(November 1975), 965–971.

"Winslow Homer's English
Period." *The American Art
Journal* 7, no. 2 (November
1975), 60–69.

"Winslow Homer's *Right
and Left.*" National Gal-
lery of Art, Studies in the
History of Art, vol. 9.
Washington, 1980, 59–85.

"The Winthrop Portraits
Gift to Harvard." *Harvard
Alumni Bulletin* (5 June 1965),
669–670.

"Visual Arts." In *The Micro-
book Library of American
Civilization.* Chicago, 1970,
71–275, 347.

## Reviews

"*Act of Portrayal: Eakins,
Sargent, James,* by David M.
Lubin." *American Quarterly*
38, no. 4 (Fall 1986), 698–702.

"*American Art at the Century,*
by A. Hyatt Mayor and
Mark Davis"; and "*Art
America,* by Mary Ann
Tighe and Elizabeth Lang."
*The Magazine Antiques*
114, no. 6 (December 1978),
1296–1299.

"*American Impressionism,* by
Richard J. Boyle"; "*Albert
Bierstadt, Painter of the
American West,* by Gordon
Hendricks"; and "*The Life
and Work of Thomas Eakins,*
by Gordon Hendricks."
*The Art Bulletin* 58, no. 2
(June 1976), 310–312.

"*American Painting of the
Nineteenth Century,* by
Barbara Novak." *Antiques*
97, no. 3 (March 1970),
322–330.

"*American Paintings and
Drawings in Mystic Seaport
Museum,* by Dorothy E. R.
Brewington." *The Magazine
Neptune* 42, no. 4 (October
1982), 312–313.

"*The Landscapes of Frederic
Edwin Church,* by David
Huntington." *The Massachu-
setts Review* 8, no. 1 (Winter
1967), 208–212.

"*The Life and Work of
Winslow Homer,* by Gordon
Hendricks"; and "*Winslow
Homer's Magazine Engrav-
ings,* by Philip C. Beam."
*Smithsonian* 10, no. 10
(January 1980), 126–128.

"*Lines: A Half-Century of
Yacht Designs by Sparkman &
Stephens,* by Olin J. Stephens."
*The Wall Street Journal* 241,
no. 91 (May 9, 2003), W10.

"*Mr. Peale's Museum: Charles
Willson Peale and The First
Popular Museum of Natural
Science and Art,* by Charles
Coleman Sellers." *The
Magazine Antiques* 118, no. 2
(August 1980), 296–298.

"*The Painters' America, Rural
and Urban Life, 1810–1910,*
by Patricia Hills." *The
New-York Historical Society
Quarterly* 59, no. 4 (October
1975), 373–374.

"The Peale Family." *Apollo*
145, no. 424 (June 1997),
56–57.

"Philadelphia: Thomas
Eakins." *The Burlington
Magazine* 124, no. 954 (1982),
583–584.

"*A Sense of Place: The Artist
and the American Land,*
by Allan Gussow"; and
"*The Hudson River and Its
Painters,* by John K. Howat."
*Art in America* (November–
December 1972), 40, 41.

"*The Shaping of Art &
Architecture in 19th Century
America,* edited by Robert E.
Clark." *Art in America*
(November–December 1973),
136–137.

"*Thomas Eakins,* by Lloyd
Goodrich." *The New York
Times Book Review* 83, no. 1
(2 January 1983), 5, 13.

"*The Thomas Eakins Collec-
tion,* by Theodor Siegl." *The
Pennsylvania Magazine* 104,
no. 3 (July 1980), 402–403.

"Thomas Eakins in Phila-
delphia." *Apollo* 155, no. 480
(February 2002), 52–53.

"Winslow Homer in
Washington, DC." *Apollo*
143, no. 410 (April 1996),
58–61.

## Films

*American Light, The Luminist
Movement,* with Rosamund
Bernier. Camera Three
Productions. New York, 1980.

*Collecting America: Folk Art
and the Shelburne Museum,*
with Ann Sothern. Byron
McKinney Associates. New
York, 1988.

*Important Information Inside,
John F. Peto: The Idea of
Still-Life Painting.* National
Gallery of Art Extension
Programs, 1984.

*John J. Audubon: The Birds
of America.* National Gallery
of Art Extension Programs,
1985.

*Thomas Eakins: Scenes of
Modern Life.* WHYY. Phila-
delphia, 2001.

*Winslow Homer: The Nature
of the Artist.* National
Gallery of Art Extension
Programs, 1986.

# Index

## A

Achenbach, Andreas, 41, 44, 124

Adams, John Quincy, 84

Agassiz, Louis, 127, 133

Allston, Washington, 21

*American Light: The Luminist Movement, 1850–1875* (exhibition), 21, 21–22

*An American Perspective: Nineteenth- and Twentieth-Century Art from the Collection of Jo Ann and Julian Ganz, Jr.* (exhibition), 22

*An American Sampler: Folk Art from the Shelburne Museum* (exhibition), 4

*Andrew Wyeth: The Helga Pictures* (exhibition), 26

*Apple Blossoms and Hummingbird* (Heade), 70

*Apple Blossoms in a Vase* (Heade, cat. 13), 67–71, 69

*Appleton's Journal*, 140

*The Architect (John Joseph Borie, III)* (Eakins), 25

*The Art Journal*, 139

*The Artist Sketching at Mount Desert, Maine* (Gifford), 97–98, 98

Association for the Advancement of Truth in Art, 63, 120, 132

## B

Bailey, Cora Rebecca (Mrs. Ralph Albert Blakelock), 135–136

*Ballou's Pictorial* (newspaper), 77

Barr, Alfred, 100–101

Baur, John I. H., 68, 85

Bedell, Rebecca, 127

Bernier, Rosamund, 22

Bierstadt, Albert, 11, 16, 89, 124, 141

Bingham, George Caleb: *Boatman, 34; Mississippi Boatman* (cat. 1), 11–12, 32–37, 33; *The Squatters, 35; Watching the Cargo, 32, 34*

*Blackboard* (Homer), 78

Blakelock, Ralph Albert: *The Nubble, Coast of Maine* (cat. 43), 135, 135–136

*Blue Venice* (Manet), 4

*Boatman* (Bingham), 34

Böcklin, Arnold, *Island of the Dead*, 148, 149

Bowlen, William C., 76

*Brace's Cove, Eastern Point* (Lane), 93

*Brace's Rock, Eastern Point, Gloucester* (Lane, cat. 22), 16, 91–95, 93

*Brace's Rock* (Lane, drawing), 93

*Brace's Rock* (Lane, painting), 95

Bradford, William, 13, 22

Brandeis University, 13

Bricher, Alfred Thompson, *Coastline near Otter Cliffs, Mount Desert Island* (cat. 45), 139, 139–140

Brooks, Alfred Mansfield, 7

Brown, Angela, 5

Brown, Carter, 5, 17, 19, 21, 29

*The Brown Family* (Johnson), 20, 21

Brown, Jeffrey, 140

Bryant, William Cullen, 98, 129

Bunce, O. C., 129

Burchfield, Charles, 9

## C

*Caius Marius Amidst the Ruins of Carthage* (Vanderlyn), 35

Campbell, William P., 19

Cape Ann Historical Association, Gloucester, Massachusetts, 6–7

Carles, Arthur B., 148

Casilear, John, 87

Casilear, William, 137

*Castine from Wasson's Hill, Brooksville, Maine* (Lane, cat. 31), 117, 117–119

*Castine, Maine* (Lane), 118

*Cattleya Orchid and Three Brazilian Hummingbirds* (Heade), 20, 21, 68

Cézanne, Paul, 147–148

Champlain, Samuel de, 110

Champney, Benjamin, 88

*The Chaperone* (Eakins, cat. 9), 25, 60, 60–62

Childs, Charlie, 8, 14

Childs Gallery, Boston, 8

*Christmas Card—Boots and Hanging Jacket* (Wyeth, cat. 27), 105, 105–107

*Christmas Card—Pine Tree with Footprints* (Wyeth, cat. 26), 102, 103–104

*Christmas Card—Snow Storm, Horse and Sleigh* (Wyeth, cat. 25), 102, 103–104

*Christmas Card* (Wyeth), 104

Church, Frederic Edwin, 14, 16, 67, 89, 97, 110, 113, 131–132, 137; *Fog off Mount Desert* (cat. 3), 27, 40, 40–45; *Mt. Desert Island from Bald Porcupine Island, 43; Mt. Desert Island from Great Porcupine Island, 43; Mt. Desert Island from Sheep Porcupine Island, 43; Newport Mountain, Mount Desert* (cat. 4), 27, 40–45, 42, 45 (det.); *Newport Mountain, Mount Desert Island, 43; Otter Creek, Mt. Desert, 41, 42; Portrait of Thomas Cole* (cat. 2), 38, 38–39; *Thomas Cole, 39; Twilight, Short Arbiter 'Twixt Day and Night, 37*

Cikovsky, Nicolai, Jr., 10

Clark, Bishop Thomas March, 72

Clarke, Thomas B., 47

Claude Lorrain (Claude Gellée), 88, 113, 115

Clay, Henry, 36–37

*Coastline near Otter Cliffs, Mount Desert Island* (Bricher, cat. 45), 139, 139–140

Cole, Thomas, 16, 19, 38, 38–39, 39, 40–41, 64, 87, 110, 141

Cook, Clarence, 92, 132

Coolidge, John, 4, 8, 10

Cooper, James Fenimore, 113

Copley, John Singleton, 11

Corot, Jean-Baptiste-Camille, 3, 88

Cox, Hyde, 103–105

*The Crayon* (journal), 121, 122, 132

Cropsey, Jasper Francis, 89, 137; *Autumn on the Hudson River, 19; The Spirit of War, 18, 19*

*A Crow Flew By Study* (Wyeth, cat. 28), 105–107, 107

*A Crow Flew By* (Wyeth), 106

Crowell, Kathrin, 51

Currier Gallery of Art, Manchester, New Hampshire, 14

## D

Darley, Felix Octavius Carr, *Rocks near the Landing at Bald Porcupine Island, Bar Harbor* (cat. 44), 137, 137–138

Dartmouth College, 13, 16

David, Jacques-Louis, *The Lictors Bring Brutus the Bodies of His Sons*, 35, 36

Decker, Joseph, *Still Life with Crab Apples and Grapes* (cat. 5), 28, 46, 47

DeCordova Museum, Lincoln, Massachusetts, 13

Degas, Edgar, 3

Demuth, Charles, 9

Dietrich, Adelheid, *Still Life of Flowers* (cat. 6), 28, 48–49, 49

Dietrich, Eduard, 48

Dix, Charles Temple, 139

Doughty, Thomas, 110, 113

Dove, Thomas, Jr., 81

*Dr. John Warren* (Rembrandt Peale), 24

*Dr. Peter Guernsey* (Phillips), 57

*Dr. William Thomson* (Eakins), 56

*Drifting* (Eakins, cat. 7), 29, 50, 50–53, 53 (det.)

Dunlap, William, 112

Dupont, H. F., 106

Durand, Asher B., 87, 89, 113, 122

E

*Eagle Cliff, Somes Sound*
(Fenn), *129*
*Eagle Cliff, Somes Sound,
Mount Desert* (Haseltine,
cat. 35), 124–129, *125*
Eakins, Thomas, 16, 21,
28–29; *The Architect (John
Joseph Borie, III)*, *25*; *The
Chaperone* (cat. 9), 25, 60,
60–62; *On the Delaware*,
*51*; *Dr. William Thomson*,
*56*; *Drifting* (cat. 7), 29,
50, 50–53, *53* (det.);
*Portrait of Dr. William
Thomson* (cat. 8), 29, 54–
59, *55*; *Ships and Sailboats
on the Delaware*, *51*, 51–52;
*Ships and Sailboats on
the Delaware: Study*, *51*;
*William Rush Carving
His Allegorical Figure
of the Schuykill River*, *61*,
61–62
Emerson, Ralph Waldo, 84
*Entrance of Somes Sound from
Southwest Harbor* (Lane),
*118*
*Entrance of Somes Sound,
Mount Desert, Maine*
(Lane, cat. 32), 117–119, *119*
*Entrance of Somes Sound,
Mount Desert* (Marin,
cat. 50), *147*, 147–149

F

Farrer, Henry, 65
Farrer, Thomas Charles,
132; *Mount Holyoke*, *64*;
*Mount Tom* (cat. 10), 28,
*63*, 63–65
Feld, Stuart, 10, 15–16
Fenn, Harry, *Eagle Cliff,
Somes Sound*, *129*; *Thunder
Cave*, *127*
Ferber, Linda, 131, 133
Fisher, Alvan, 110; *New
England Coast*, *113*;
*View from East End of
Bear Island* (cat. 29),
*112*, 112–114, *114* (det.)
Fleischman, Larry, 12, 14
*Fog off Mount Desert*
(Church, cat. 3), 27, *40*,
40–45
*Forest Interior with a Painter,
Civita Castellana*
(Giroux), 88, *89*

Foster, Kathleen, 53, 56
*Fragment of the Alps*
(Ruskin), *121*, 133
Frankenstein, Alfred, 16, 47,
100–101
Fremont, John C., 138
*Frenchman Bay, Mount
Desert* (Shattuck, cat. 34),
*122*, 122–123
*Fresh Water Cove from
Dolliver's Neck, Gloucester*
(Lane), *7*
Fuller, Henry Melville, 14

G

Ganz, Jo Ann and Julian, Jr.,
22
Gellée, Claude. *See* Claude
Lorrain
Gerdts, William H., 10, 13,
14, 82, 123
Gérome, Jean-Léon, 52
*Giant Magnolias on a Blue
Velvet Cloth* (Heade), *68*
Gifford, Sanford, 89, 97–99;
*The Artist Sketching at
Mount Desert, Maine*,
97–98, *98*
Giroux, André, *Forest
Interior with a Painter,
Civita Castellana*, 88, *89*
*Gloucester Harbor at Sunset*
(Lane), *92*
Greenough, Horatio, 6
*Gremlin in the Studio*
(Heade), *73*, 74
Gross, Samuel D., 56

H

Harnett, William Michael,
16, 100–101
*Harper's New Monthly
Magazine*, 139
*Harper's Weekly* (newspaper),
77–78
Hartley, Marsden, 111
Harvard University, 4, 5,
8–12
Haseltine, William Stanley,
139; *Eagle Cliff, Somes
Sound, Mount Desert*
(cat. 35), 124–129, *125*;
*Northeast Harbor, Maine*
(gouache, cat. 49),
144–146, *145* (det.), *146*;
*Northeast Harbor, Maine*
(watercolor, cat. 48), *144*,

144–146; *Otter Cliffs, Mount
Desert (Looking toward
Sandy Beach and Great
Head)* (cat. 36), 124–129,
*126*; *Thunder Hole, Mount
Desert Island* (cat. 37),
124–129, *126*; *View of
Mount Desert*, *128*, 129;
*Wooded Coast, Mount
Desert Island, Maine*
(cat. 38), 124–129, *128*
Hatch, John Davis, 14, 24
Havemeyer, Henry
Osborne, 3
Havemeyer, Louisine
Waldron, 3
Hawthorne, Nathaniel, 84
*Head of a Boy* (Homer,
cat. 17), *77*, 77–79
Heade, Martin Johnson, 11,
22, 75–76, 140; *Apple
Blossoms and Humming-
bird*, *70*; *Apple Blossoms in
a Vase* (cat. 13), 67–71, *69*;
*Cattleya Orchid and Three
Brazilian Hummingbirds*,
*20*, 21, 68; *Giant Magnolias
on a Blue Velvet Cloth*, 68;
*Gremlin in the Studio*, *73*,
74; *Roses and Heliotrope in
a Vase on a Marble Table-
top* (cat. 12), *66*, 67–71;
*Still Life with Roses,
Lilies, and Forget-Me-Nots
in a Glass Vase* (cat. 14),
67–71, *69*; *Still Life with
Wine Glass* (cat. 11),
*66*, 67–71; *Sunlight and
Shadow: The Newbury
Marshes* (cat. 15), 15, *72*,
72–74
Healy, George Alexander, 97
Hicks, Thomas, 88
Hill, John Henry, *Rocks at
Mount Desert* (cat. 33),
*120*, 120–121
Hill, John William, 120
Hirschl and Adler Galleries,
New York, 16, 29
Hoeber, Arthur, 139
*Home, Sweet Home* (Homer),
*77*, 78
Homer, Winslow, 23;
*Blackboard*, *78*; *Head of a
Boy* (cat. 17), *77*, 77–79;
*Home, Sweet Home*, *77*, 78;
*Mending the Nets*, *82*;
*Sparrow Hall* (cat. 18), 17,
*80*, 81–83, *83* (det.);
*Sparrow Hall, Cullercoats*
(photograph), *82*

Hoopes, Don, 22
Hopper, Edward, 9
Hughes, H. Stuart, 10
Huntington, David, 12, 14

I

*An Ilex Tree on Lake Albano,
Italy* (Kensett, cat. 20),
27–28, *87*, 87–90
*Important Information Inside:
The Still-Life Paintings
of John F. Peto* (exhibi-
tion), 23
Indiana, Robert, 29
Irving, Washington, 137
*Island of the Dead* (Böcklin),
*148*, 149

J

Jacobs, Nellie, 142–143
Jarves, James Jackson, 10
Johns, Elizabeth, 10
Johnson, Eastman: *The
Brown Family*, *20*, 21;
*Seated Man* (cat. 19), *84*,
84–86; *Sunday Morning*,
85
Johnson, James Arthur, 135
Johnson, Reuben, 85

K

Kandinsky, Wassily, 148
Karolik, Maxim, 6, 10, 14
Kennedy Galleries, New
York, 12
Kensett, John Frederick, *An
Ilex Tree on Lake Albano,
Italy* (cat. 20), 27–28, *87*,
87–90
King, Clarence, 121, 132
Koerner, Hermann, 135

L

Lambdin, George Cochran,
67
Lane, Fitz Hugh, 5–9, 13,
22, 110; *Brace's Cove,
Eastern Point*, *93*; *Brace's
Rock* (drawing), *93*; *Brace's
Rock, Eastern Point,
Gloucester* (cat. 22), 16,
91–95, *93*; *Brace's Rock*
(painting), *95*; *Castine
from Wasson's Hill,
Brooksville, Maine* (cat. 31),

*117*, 117–119; *Castine,
Maine*, *118*; *Entrance of
Somes Sound from
Southwest Harbor*, *118*;
*Entrance of Somes Sound,
Mount Desert, Maine*
(cat. 32), 117–119, *119*;
*Fresh Water Cove from
Dolliver's Neck, Gloucester*,
*7*; *Gloucester Harbor at
Sunset*, *92*; *Lumber
Schooners at Evening on
Penobscot Bay*, *18*;
*Southwest Harbor, Mount
Desert*, *118*; *Stage Rocks
and Western Shore of
Gloucester Outer Harbor*,
*92*; *Stage Rocks and
Western Shore of Gloucester
Outer Harbor* (cat. 21),
8–9, *91*, 91–95, *94* (det.)
Lapham, W.B., 97–98
Leutze, Emanuel, 85
Lichtenstein, Roy, 29
*The Lictors Bring Brutus
the Bodies of His Sons*
(David), 35, *36*
*Life* (magazine), 103
Lindenschmidt, Wilhelm, 47
Longfellow, Henry
Wadsworth, 84, 93, 94
Loper, Ben, *106*
*Lumber Schooners at Evening
on Penobscot Bay* (Lane), *18*

M

MacLeish, Archibald, 4, 10
Madison, Dolley, 84
Manet, Edouard, 3; *Blue
Venice*, *4*
Marin, John, III; *Entrance
of Somes Sound, Mount
Desert* (cat. 50), *147*,
147–149; *View across Somes
Sound, Mount Desert*
(cat. 51), *147*, 147–149
Matisse, Henri, 147–148
McEntee, Jervis, *Mount
Desert Island, Maine*
(cat. 23), 27, *96*, 97–99
*Mending the Nets* (Homer),
*82*
Metropolitan Museum of
Art, New York, 3, 8
Miller, Perry, 10
*Mississippi Boatman*
(Bingham, cat. 1), 11–12,
32–37, *33*
Monet, Claude, 3

Morrison, Samuel Eliot, 10, 111
Mount Desert Island, Maine, 108–111
*Mount Desert Island, Maine* (McEntee, cat. 23), 27, 96, 97–99
*Mount Desert* (Richards, cat. 39), *130*, 130–134
*Mount Holyoke* (Farrer), *64*
*Mount Tom* (Farrer, cat. 10), 28, 63, *63*–65
Mount, William Sidney, 32
*Mt. Desert Island from Bald Porcupine Island* (Church), *43*
*Mt. Desert Island from Great Porcupine Island* (Church), *43*
*Mt. Desert Island from Sheep Porcupine Island* (Church), *43*
Murray, Samuel, 56
Museum of Fine Arts, Boston, 6, 10–11

N

National Gallery of Art, Washington, D.C., 17–27
*New England Coast* (Fisher), *113*
*The New Path* (journal), 132
*New York Evening Mail* (newspaper), 141
*New York Times* (newspaper), 139, 142
*Newbury Marshes* (cat. 16), *75*, 75–76
Newman, Harry Shaw, 14
*Newport Mountain from Bald Porcupine* (Smillie), *24*
*Newport Mountain, Mount Desert* (Church, cat. 4), 27, 40–45, *42*, *45* (det.)
*Newport Mountain, Mount Desert Island* (Church), *43*
Nichols, George Ward, 110
*Northeast Harbor, Maine* (Haseltine, gouache, cat. 49), 144–146, *145* (det.), *146*
*Northeast Harbor, Maine* (Haseltine, watercolor, cat. 48), *144*, 144–146
Norton, Charles Eliot, 64
Novak, Barbara, 10, 13
*The Nubble, Coast of Maine* (Blakelock, cat. 43), *135*, 135–136

O

Olana (Frederic Church house), New York, 14, *15*
Olmsted, Frederick Law, 73–74
*On the Delaware* (Eakins), *51*
*Otter Cliffs, Mount Desert (Looking toward Sandy Beach and Great Head)* (Haseltine, cat. 36), 124–129, *126*
*Otter Cliffs* (Smillie, cat. 46), *141*, 141–143
*Otter Creek, Mt. Desert* (Church), 41, *42*

P

*Paintings by Fitz Hugh Lane* (exhibition), 26
Parkhurst, Charles, 19
Parsons, J.B., 64
Peale, Rembrandt: *Dr. John Warren*, *24*; *Rubens Peale with a Geranium*, 25–26, *26*
Pendleton, William S., 91
*Penobscot Bay, Maine* (Seager, cat. 30), *115*, 115–116
Peto, John Frederick, 16; *Take Your Choice* (cat. 24), 22, *100*, 100–101
Phillips, Ammi, *Dr. Peter Guernsey*, 57
*Portrait of Dr. William Thomson* (Eakins, cat. 8), 29, 54–59, *55*
*Portrait of Thomas Cole* (Church, cat. 2), *38*, 38–39
Prang, Louis, 139
Pratt, Henry Cheever, 40
Preyer, Johann Wilhelm, 48
Princeton University, 26–27
Prown, Jules, 10, 11, 12
Pyle, Howard, 103

Q

Quidor, John, 16

R

Rand, Benjamin Howard, 54
Reade, Charles, 82
Richards, I.A., 10
Richards, William Trost, 139–140; *Mount Desert* (cat. 39), *130*, 130–134; *Rocks at Mount Desert* (cat. 40), 130–134, *131*; *Sailboat at the Dock (probably Mt. Desert)* (cat. 41), 130–134, *132*; *Sunrise over Schoodic* (cat. 42), 130–134, *133*, *134* (det.)
*Rocks at Mount Desert* (Hill, cat. 33), *120*, 120–121
*Rocks at Mount Desert* (Richards, cat. 40), 130–134, *131*
*Rocks near the Landing at Bald Porcupine Island, Bar Harbor* (Darley, cat. 44), *137*, 137–138
Roesen, Severin, 48
Rollins, James S., 32
Rosenberg, Jakob, 10
*Roses and Heliotrope in a Vase on a Marble Tabletop* (Heade, cat. 12), *66*, 67–71
Rossiter, Thomas, 87
Rowland, Ben, 9–10
*Rubens Peale with a Geranium* (Rembrandt Peale), 25–26, *26*
Rush, William, 25, 60–62
Ruskin, John, 63, 94–95, 120–121, 123, 131–133; *Fragment of the Alps*, *121*, 133

S

*Sailboat at the Dock (probably Mt. Desert)* (Richards, cat. 41), 130–134, *132*
Salmon, Robert, 13, 16, 91
Sargent, John Singer, 60–61
Schlesinger, Arthur, 10
Schreiber, Henry, 51, 52
*Scribner's Monthly*, 139
Seager, Edward, *Penobscot Bay, Maine* (cat. 30), *115*, 115–116
*Seal Harbor, Mount Desert* (Smillie, cat. 47), 141–143, *142*
*Seated Man* (Johnson, cat. 19), *84*, 84–86
Shattuck, Aaron Draper, *Frenchman Bay, Mount Desert* (cat. 34), *122*, 122–123
Shelburne Museum, Vermont, 3, 6, 7
Shinn, Earl, 52
*Ships and Sailboats on the Delaware* (Eakins), *51*, 51–52
*Ships and Sailboats on the Delaware: Study* (Eakins), *51*
Silva, Francis, 22
Slive, Seymour, 4, 10
Smillie, George Henry: *Newport Mountain from Bald Porcupine*, *24*; *Otter Cliffs* (cat. 46), *141*, 141–143; *Seal Harbor, Mount Desert* (cat. 47), 141–143, *142*
Smillie, James David, 141–142
*Southwest Harbor, Mount Desert* (Lane), *118*
Spark, Victor, 14
*Sparrow Hall, Cullercoats* (Homer, photograph), *82*
*Sparrow Hall* (Homer, cat. 18), 17, *80*, 81–83, *83* (det.)
*The Spirit of War* (Cropsey), *18*, 19
Spurzheim, Johann Gaspar, 112
*The Squatters* (Bingham), *35*
*Stage Rocks and Western Shore of Gloucester Outer Harbor* (Lane), *92*
*Stage Rocks and Western Shore of Gloucester Outer Harbor* (Lane, cat. 21), 8–9, *91*, 91–95, *94* (det.)
Stebbins, Theodore E., Jr., 10, 11, 13, 14, 23, 68, 70, 71, 73, 75–76
Stein, Roger, 132
Stevens, Joseph, 92, 93–94, 117–119
Stieglitz, Alfred, 147–149
*Still Life of Flowers* (Dietrich, cat. 6), 28, 48–49, *49*
*Still Life with Crab Apples and Grapes* (Decker, cat. 5), 28, *46*, 47
*Still Life with Roses, Lilies, and Forget-Me-Nots in a Glass Vase* (Heade, cat. 14), 67–71, *71*
*Still Life with Wine Glass* (Heade, cat. 11), *66*, 67–71
Stuart, Gilbert, 21
*Sunday Morning* (Johnson), *85*
*Sunlight and Shadow: The Newbury Marshes* (Heade, cat. 15), 15, *72*, 72–74

*Sunrise over Schoodic* (Richards, cat. 42), 130–134, *133*, *134* (det.)

T

*Take Your Choice* (Peto, cat. 24), 22, *100*, 100–101
Testorf, Helga, 26
*Thomas Cole* (Church), *39*
Thompson, John Alexander, 38
Thomson, William, 54, *54*, *55*, 56, 56–58
Thoreau, Henry David, 73–74
*Thunder Cave* (Fenn), *127*
*Thunder Hole, Mount Desert Island* (Haseltine, cat. 37), 124–129, *126*
Tuckerman, Henry, 38, 39, 70, 90, 124
Turner, J.M.W., 120
*Twilight, Short Arbiter 'Twixt Day and Night* (Church), *37*
291 gallery, 147–148

U

*Uncle Tom's Cabin* (Stowe), 85

V

Valentine, Lawson, 78
Vanderlyn, John, 87; *Caius Marius Amidst the Ruins of Carthage*, 35
*View across Somes Sound, Mount Desert* (Marin, cat. 51), *147*, 147–149
*View from East End of Bear Island* (Fisher, cat. 29), *112*, 112–114, *114* (det.)
*View of Mount Desert* (Haseltine), *128*, 129
Vose, Bob, 14
Vose Gallery, Boston, 8, 11–12
Vose, Morton, 14

W

Wadsworth, Daniel, 38
*Watching the Cargo* (Bingham), 32, 34
Webb, Electra Havemeyer, 3, 6, 7, 8
Weber, Paul, 124, 131, 132
Webster, Daniel, 115

Weimann, Bob, 14
Weld, Eloise, 6
Weld, Phillip, 6–7
Whistler, James A. M., 23
Whittier, John Greenleaf, 72
Whittredge, Worthington,
    97, 124
*William Rush Carving His*
    *Allegorical Figure of the*
    *Schuykill River* (Eakins),
    *61*, 61–62
Williford, Graham, 14
*Wooded Coast, Mount Desert*
    *Island, Maine* (Haseltine,
    cat. 38), 124–129, *128*
Wyeth, Andrew, *106*;
    *Christmas Card, 104*;
    *Christmas Card—Boots*
    *and Hanging Jacket*
    (cat. 27), *105*, 105–107;
    *Christmas Card—Pine*
    *Tree with Footprints*
    (cat. 26), *102*, 103–104;
    *Christmas Card—Snow*
    *Storm, Horse and Sleigh*
    (cat. 25), *102*, 103–104;
    *A Crow Flew By, 106;*
    *A Crow Flew By Study*
    (cat. 28), 105–107, *107*
Wyeth, Newell Convers
    (N.C.), 103

    Y

Yale University, 5, 12

## Photographic Credits

### Catalogue

cat. 1, fig. 3, photograph © 2003 Museum of Fine Arts, Boston; fig. 5, photograph Erich Lessing/ Art Resource, New York

cats. 3, 4, fig. 1, photograph © 2000 Museum of Fine Arts, Boston

cat. 7, fig. 3, photograph Graydon Wood, 1999

cats. 11–14, fig. 2, © Addison Gallery of American Art, Phillips Academy, Andover, Massachusetts

cats. 21, 22, figs. 1, 5, National Gallery of Art, Photo Archives

cats. 27, 28, fig. 1, All rights reserved, The Metropolitan Museum of Art; fig. 2, photograph courtesy Wyeth Collection

cats. 31, 32, fig. 1, photograph © 2003 Museum of Fine Arts, Boston

cat. 33, fig. 1, Photographic Services © 2003 President and Fellows of Harvard College

cat. 43, fig. 1, PhotoArk Digital Archiving

cats. 50, 51, fig. 1, All rights reserved, The Metropolitan Museum of Art

### Essay

fig. 2, © Shelburne Museum, Shelburne, Vermont

figs. 3, 4, photograph © 2003 Museum of Fine Arts, Boston

fig. 5, photograph Andy Wainwright

fig. 12, photograph Kathleen Buckalew

fig. 16, © 2003 Trustees of Dartmouth College, Hanover, New Hampshire

fig. 18, photograph Kathleen Buckalew